Profitable Photography

Profitable Photography

Start and run a money-making business

Geza Szurovy

TAB Books

New York San Francisco Washington, D.C. Auckland Bogotá Caracas Lisbon
London Madrid Mexico City Milan Montreal New Delhi San Juan
Singapore Sydney Tokyo Toronto

pbk 5 6 7 8 9 FGR/FGR 9 9
hc 1 2 3 4 5 6 7 8 9 FGR/FGR 9 9 8 7 6 5

Library of Congress Cataloging-in-Publication Data

Szurovy, Geza.
 Profitable photography : start and run a money-making business /
by Geza Szurovy.
 p. cm.
 Includes index.
 ISBN 0-07-063022-4 (pbk.)
 1. Photography—Business methods. I. Title.
TR581.S98 1994
770'.68—dc20 94-24271
 CIP

Acquisitions editor: Jeff Worsinger
Editorial team: Laura J. Bader, Editor
 Susan Kagey, Managing Editor
 Joanne Slike, Executive Editor
 Joann Woy, Indexer
Production team: Katherine G. Brown, Director
 Ollie Harmon, Coding
 Janice Stottlemyer, Computer Artist
 Wanda S. Ditch, Desktop Operator
 Nancy K. Mickley, Proofreading
Design team: Jaclyn J. Boone, Designer
 Katherine Stefanski, Associate Designer 0630224
Photographs by author unless otherwise noted. WK2*

For Kuching

Acknowledgments

I would like to thank two people in particular for their valuable contribution to this book: Martin Berinstein and Bob Hyzen. Martin has been working for more than two decades as a professional advertising and corporate photographer both in the United States and abroad, and he was most gracious in sharing his expertise and experiences. Martin is also a talented artist, blending photography, twenty-first-century computer technology, and an ancient press that could have been used by Gutenberg to create the uniquely haunting and timeless images that are his passion.

Bob Hyzen of Hyzen Photography, Sudbury, Massachusetts, has been serving the communities west of Boston for many years. Despite a hectic schedule of weddings and portrait sittings that would be the envy of most photographers, he gave of his time generously and without hesitation to initiate me into the nuances of serving the retail market.

Thanks also to Kim Tabor at McGraw-Hill for her early and enthusiastic support. Though I have received much advice and encouragement in writing this book, any errors and omissions are my fault entirely.

Introduction

To take stunning photographs you need good equipment, the right film, excellent technical skills, and that elusive eye for original images that will propel your work beyond the avalanche of snapshots taken by the herd. But to make a living taking stunning photographs, you have to be more than just a good photographer. You also have to be a competent businessperson. In spite of photography's perceived promises of liberation from the drudgery of the business world, there is no escape: profitable photography is business. And it comes with its own share of financial, marketing, and legal challenges. In fact, there are so many good photographers out there that more often than not the difference between making a good living or being the proverbial starving photographer is a function of your business abilities.

This book is not about taking better photographs. There are thousands of other books that already do that. This book is about business. It provides you with all the business skills and guidance you need to transform yourself from the proverbial starving photographer into a successful self-employed photographer.

The good news is that the business of starting and running a photography business is far less onerous than most photographers

imagine. All it takes is a little common sense, the ability to use a calculator, and a bit of discipline to keep up with the recurring administrative and marketing demands of the business. If discipline is a problem, that too can be easily handled by knowing where to get occasional professional help for a modest fee.

Let's begin by applying a bit of common sense. When you think about it, starting and running a photography business boils down to a handful of key elements:

➤ Possessing the skills to take professional-quality photographs that can hold their own in the market.

➤ Starting with enough money to pay your bills until you begin to receive enough money for your photographs to be self-sufficient (start-up capital).

➤ Having a plan; defining your goals and how you will attain them (business planning).

➤ Taking photographs customers want (market research and product development).

➤ Finding a sufficiently large number of customers who want your photographs (marketing).

➤ Selling your photographs at a price that leaves enough money in your pocket after expenses to fairly compensate you for your time (pricing).

➤ Keeping a book with two columns in it: the left one to record cash paid out for every expense, the right one to record cash received for photographs delivered (bookkeeping on a cash basis). If you prefer, also keep a record of cash coming in and going out in the near future (bookkeeping on the accrual basis).

➤ Continuing to find enough customers to give you assignments to keep your business prospering (more marketing).

➤ Paying your taxes, and paying them on time (a little more bookkeeping).

That, in a nutshell, is all it really takes. The trick is to consistently meet these objectives as you start and run your photography business. How to do that is what this book is all about. Unlike generic business texts, this book is written expressly for photographers. It directly addresses the business needs of photographers in the language of photographers and makes extensive use of examples drawn from the real world.

Before you can set up your business you have to identify the options available to the photographer in a vast, diverse, and intensely competitive field. You also have to define your personal goals and assess your ability to meet them based on the market's demands, and your preferences and skills. The first two chapters guide you through this evaluation to define your niche in the business. You will be introduced (in chapter 1) to the many branches of the profession: advertising, portrait, nature and wildlife, wedding, news and sports, and such specialty markets as travel, architecture, real estate, aerial, and pet photography. You will learn about the business potential of each field; the characteristics and rules of the market; the skills, equipment, and facilities required; competitiveness; earnings potential; and the opportunity for creative work.

The next step (chapter 2) is a thorough self-examination of your professional aspirations, abilities, and financial goals. You will evaluate what type of photography most appeals to you and ask yourself why that is so. You will realistically assess the skills you have to compete in the fields you prefer. You will learn to judge your earnings potential in general terms and compare it to your financial objectives. Out of this self-analysis will come a definition of a niche business in which you will maximize the opportunity to do the photography you prefer and make a living doing it. You will be shown how to compromise between bread-and-butter photography to pay the bills, and shooting on the edge to feed your creative urge.

At this stage you will have a clear general idea of what you should realistically aspire to, and you will be ready to get down to the specifics of planning and setting up your business. The chapter on finance (chapter 3) presents a typical financial profile of a photography

Introduction

Figure I-1

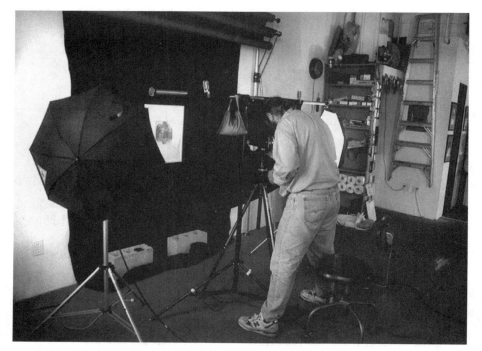

The goal

business derived from a composite record of many actual businesses. This composite profile is used to explain everything you need to know about financial figures and their analysis to understand and run your business. You will also learn about the most common and expensive pitfalls of starting a business. The chapter on marketing (chapter 4) introduces you to the basics of this crucial art without which no business succeeds. You will learn about developing marketing information, pricing, assembling and maintaining customer lists, direct mailing, networking, hiring and using an agent, and more.

Chapter 6 puts your newfound financial and marketing skills to work to develop your business plan, a fundamental requirement of starting any business. You will learn how to develop a business plan that will

> ➤ Define in great detail the products you will offer in your chosen market niche.

➤ Analyze, in view of the market's pricing practices, the amount of net profit you can expect to make per product, identified by some appropriate unit of measurement: per photograph, per hour, per day.

➤ Develop a realistic pricing schedule per product line.

➤ Define the amount of personal income you should realistically expect per year.

➤ Define the amount of sales you need to make per year to attain this level of income.

➤ Develop a marketing plan: define your specific market in detail, assess market demand, define how much of the market you can expect and need to capture to meet your financial goals. Identify a list of marketing prospects and key accounts. Set achievable marketing and sales goals and timetables.

➤ Identify marketing costs (promotional material, marketing database, mailing costs, advertising, etc.).

➤ Assemble into a financial plan the information you have developed on expected sales, income, and expenses.

➤ Define the capital you need to fund the start-up period in view of projected expenses and the timetable of expected income.

➤ Define the legal structure of your business that best suits your particular circumstances.

➤ Identify key administrative tasks, estimate the amount of time they require, and identify computer and software needs.

It is time-consuming to do a business plan, but it is worth every moment of effort because there is no better way to get a handle on the business you are about to start. If the business plan is flawed—and this becomes apparent during its implementation—the whole venture could be threatened. If the business plan is right on target, success is practically assured. Expect to do a lot of thorough revisions, reassessments, and restructuring until all the numbers and target dates make sense and have your full confidence.

Once the business plan is complete, it is time to get down to business. But where do you start? This is the topic of the next few chapters. You will learn in plain lay language everything you need to know about personal computers and their indispensability to the modern photographer. You will be guided through developing a striking business identity at minimum cost to maximize your marketing plan's chances of success. You will learn how to most economically acquire the equipment you need, how to go about arranging for a studio if you need one, how to establish the bank accounts that best suit your needs, and how to develop marketing and promotional materials to get the most bang for the buck. You will also be guided through the various options for establishing your legal business identity at the lowest expense.

As your marketing plan begins to yield results, you will begin to settle into the day-to-day routine of running a going concern. Several chapters will guide you in managing the all-important cash cycle to remain solvent, and meeting administrative obligations, such as the maintenance of sales and financial records, tax records, marketing records, sales tax requirements, and copyright requirements. You will also learn how to manage your time for maximum effect, and how to recognize the need for and use professional bookkeeping, accounting, and legal help.

You will be shown techniques for monitoring how well your business is doing, and how closely it is tracking to your business plan. Through a set of canned reports available from the business records in your computer, you will know instantly if you are on target of, ahead of, or behind your plan. You will learn to recognize the early warning signs of potential business problems and what to do about them.

You might be surprised to learn that too much success too soon can also lead to financial disaster. A chapter on managing growth explains the risks and how to deal with them. You will learn to assess if you are ready for a line of credit, what to use it for, and how to get one.

As your business prospers, you might begin to think about hiring employees. You will have to think carefully, because an onerous set of

Introduction

government rules covering a business's record keeping and reporting obligations on full-time employees might saddle you with so much paperwork that it might not be worth the effort. A chapter on employees (chapter 10) helps you find your way through the government's paper blizzard and sorts out the best hiring options. Temporary help, subcontracting, and full-time hiring are all addressed.

Chapter 11 is dedicated to the subject everybody loves to hate: taxes. But don't knock taxes totally. After all, if there are taxes to be paid, there must be income. Proof positive that you are making it! This chapter will help you make sure that you don't pay more than your fair share. It provides guidance on tax strategies and the preparation of tax returns, and also shows you techniques and tactics to take the dread out of a tax audit.

A popular choice of photographers is starting and running a part-time business, often as a means of transition to full-time photography. Although most of the principles are the same as those that apply to full-time businesses, there are some special considerations that part-time photographers need to take into account. These issues are addressed in chapter 12.

And that's about all there is to starting and running a money-making photography business. With careful planning and just a bit of discipline to keep ahead of business demands, you will maximize your chances of making a healthy profit and minimize the time spent away from your cameras. So read on, do your homework, and when you step behind the lens, remember to savor the very rare pleasure of making a living doing what you like best.

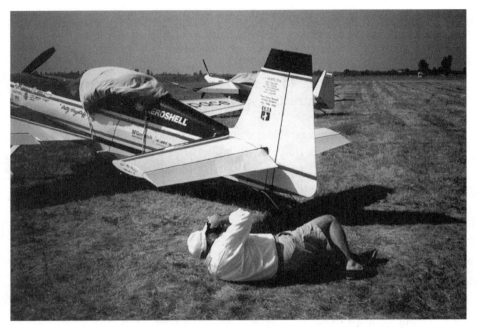

On assignment

Introduction

1

The field and the importance of a good product

THE photographer's playing field is enormous. The players range from occasional part-timers freelancing for the local weekly with barebones equipment to the handful of superstars who command fees of $10,000 per day. In between are thousands of photographers intensely competing in every niche imaginable. Just take a look at your local yellow pages. A recent glance at a small suburban listing yielded seventy-eight photographers advertising their services for weddings, commercial photography, portraits, catalogs, brochures, product photography, public relations, passport photos, school photography, sports teams, model portfolios, aerial photography, legal photography, conventions, architectural photography, christenings, bar mitzvahs, reproductions, proms, and more. In such a vast field there has to be a niche for every hard-working and competent photographer. The question is, where? To begin to get an answer, it is helpful to briefly review the possibilities.

In addition to subject matter there are many other helpful ways to distinguish between various types of photographic activity. At the most basic level professional photography falls into two broad categories: assignment photography and stock photography.

Assignment photography

Assignment photography is any photography commissioned by a client. There was a time when all work was done on assignment, and assignment photography continues to be a major way of doing business today. Assignment photography can be thought of as custom photography, done to meet a client's unique needs. Advertising of specific products, executive portraits, weddings and other special functions, sporting events, school photography, and many other images are shot on assignment. Most photographers will spend their entire career shooting on assignment.

A very attractive aspect of assignment photography is that the photographer is not required to incur any significant financial risk up front. No money is expended by the photographer until a contract is

signed, and if the contract is properly structured, financial risk to the photographer is further minimized by the receipt of a hefty advance.

Stock photography

Stock photography is photography shot on speculation, in advance of being sold. Stock photography got its start as an outlet for the hundreds of thousands of photographs taken on assignment. Enterprising photo marketers formed stock agencies to market a wide selection of these generic photographs. The market slowly realized that a photographer who shot a "great waterfalls of the world" assignment ended up with a lifetime supply of unused waterfall shots that could be made available at a fair price for generic uses. And the uses can be many: articles, advertising, travel brochures, encyclopedias, calendars, and the list could go on. To assign a shoot for each of these purposes would cost an arm and a leg, beyond the capacity of most of the budgets available. Having the images available as stock gives clients a lower-cost (but fairly priced) option. It gives consumers (be they buyers of a product or readers of a magazine article) a high-quality visual experience that they might otherwise miss. And, best of all, it gives the photographer the opportunity to earn income from photographs that otherwise would stay in a drawer forever. Everybody wins.

That is a rosy picture, and a valid one. The consequence has been that as clients caught on to using stock photographs, stock agencies were flooded with images. So even as the business of stock photography grew explosively, supply was steadily outpacing demand, and the field became even more competitive. Stock image quality has risen, and shooting specifically for stock has replaced the concept of using the stock agency as a place for surplus photographs.

Today many photographers spend part of their time shooting specifically for stock, taking advantage of the opportunities provided by being on location for an assignment. Other photographers specialize exclusively in shooting for stock. Stock photography can

be a lucrative outlet for photographers, but given its intensely competitive nature some rules for maximizing your chances of success are worth keeping in mind:

> ➤ Your photographs have to stand out from the mass of images in the stock files. Unusual locations, stunning composition, and a sufficiently generic, undated image go a long way to ensuring repeated success.

> ➤ The more images you have on file the greater your chances of success.

> ➤ Your ability to constantly refresh your stock images is crucially important. In fact, stock agencies worth their salt will insist on it.

There is always the case of the dream stock photograph, the cash cow, the one that keeps right on selling. It is not unusual for photographers with reasonably well-developed stock portfolios to realize thousands of dollars from the resale of a single image. Quite a few images have generated tens of thousands of dollars in resales over the years.

The big risk of shooting exclusively for stock is significant up-front expenses with no guarantee of any sales. In fact, inexperienced, unknown photographers take a tremendous financial chance if they embark on a self-funded stock shooting expedition. It is much less risky to build a stock portfolio part time alongside an assignment practice, expanding more heavily into stock as you gain experience and become known.

 # Markets

Perhaps the most useful way to look at photography is by markets. You will be selling to specific markets, and to be successful you need to understand their specific needs and characteristics. It is customary to distinguish between four major markets:

> ➤ Advertising

> ➤ Corporate

The field and the importance of a good product

➢ Editorial

➢ Retail

Advertising photography

Advertising photography's sole purpose is to sell a product or
service. It is the most lucrative field of photography because the total
dollar amounts realized on the sales of products and services are
enormous, marketing is a major expense in generating sales, and
advertising is a major item in marketing budgets. A multimillion
dollar annual ad budget leaves plenty of room for $10,000-a-day
photographers. Sure, that is an extreme, but not as much as you
might think. Even your run-of-the-mill midsize industrial company will
readily pay four-figure daily rates to a competent photographer. The
great majority of photographers you hear about with six-figure
incomes are advertising photographers.

Most advertising photography is assigned by ad agencies, but
advertising work is also readily available through many in-house
advertising departments. This is especially true of smaller firms.
While advertisers are increasingly using stock images, especially in
times of economic austerity, their needs are often so specific that
high-budget assignment photography will continue to be a major
source of income for the foreseeable future.

A rather controversial issue with serious implications for advertising
photographers is electronic image manipulation. Electronic fine-
tuning of pockmarks and wrinkles has been around for years, but
now advertisers are using electronic image manipulation in a major
way. Elements of several photographs are blended to create the
desired effect, and entire areas of an image can be created
electronically. More importantly, electronic image manipulation
raises weighty copyright questions with serious implications for the
photographer's income.

Markets

◎ Corporate photography

Corporations have a variety of photo needs, chief among them being the annual report. The annual report is a report card to a very wide and critical audience, including shareholders, potential investors, investment analysts, the business media, and public interest groups. In addition to presenting the financial reports required by law, annual reports are also a tremendous public relations opportunity to portray success or conceal failure, and photographs play a major role. When, for example, a bank makes aggressive high-tech and real estate loans, you will have a field day shooting bank officers next to futuristically lit silicon chips and towering skyscrapers. When, in a year or two, those loans go down the drain, expect to shoot bank officers playing big brother and big sister to the deprived children of the community.

While corporate photography is not as lucrative as advertising photography, big bucks are also budgeted for corporate image engineering, and it does pay considerably better than other markets. Public relations brochures, executive portraits, and corporate events also present profitable opportunities for corporate photography.

Figure 1-1

Shooting for the annual report. M. Berinstein

The field and the importance of a good product

Editorial photography

Editorial photography is perhaps the most visible market to novice photographers and might appear to be among the most glamorous. Editorial photography meets the voracious appetite for photographs of thousands of magazines and newspapers, as well as books. Editorial opportunities run the gamut from illustrated how-to books through encyclopedias and special interest and general consumer magazines to *Time, Life,* and the tabloids.

The big appeal of editorial photography is the belief that, unlike advertising and corporate photography, there is a pristine, factual reporting aspect to it. This is only partly true because many editorial photographs sell a product: the paper or magazine in which they appear. While often factual, these photographs are selected by the publisher to fit an image that might not accurately represent underlying facts. You can't always rely on an image in a travel magazine to accurately portray the appearance of a place. At times careful composition and heavy filter use deliberately conspire to present an image that sells vacations, not the one that will be seen upon arrival. There is nothing wrong with this; it is what the people who buy these magazines demand, presenting the photographer with a pleasant challenge.

While there are still considerable opportunities for obtaining assignments, especially at the relatively high-budget, large circulation, general interest magazines, the editorial market has become a major user of stock photographs. Photographs appearing in the little-known but largest segment of the editorial market, textbook publishing, are acquired by publishers almost exclusively on a stock basis.

The biggest drawback to editorial photography is that with few exceptions you can't make a living at it because of dismally low rates. Photography being so much fun, supply rears its ugly head once again and runs far ahead of demand, depressing prices. Also, contrary to what their glossy covers and exotic content suggest,

many editorial publications are low circulation, shoestring affairs for whom the only option is to print inexpensively obtained photographs.

In spite of this dismal outlook, there are photographers who make a reasonable living doing editorial photography exclusively. They are the stars of their profession, who shoot for glossy, general interest magazines with circulations sufficiently large to pay a decent rate or one of the big news photo distributors. Most likely they could be making three or four times as much doing advertising photography, but they are slaves to the photographer's first cardinal rule: they love what they do.

Many photographers who enjoy editorial work earn their living in other markets, but make occasional forays into the editorial market for personal pleasure. After a hard season of catalog work who wouldn't enjoy a Caribbean cuisine assignment for a food magazine?

For the novice photographer the benefit of editorial work is exposure. At the low-budget specialty magazines, assignments are relatively easy to pick up (all the experienced photographers are engaged in greater money-making propositions) and offer a chance to get published credits. There are some who question the value of these credits in leading to higher paying work, claiming that your portfolio alone will do the trick; but it can't hurt to have a magazine cover credit or two along with your portfolio. Conducting business with these publications will also give most novice photographers valuable experience and much needed confidence in cold-calling and negotiating. The important thing to remember is not to get bogged down in these low-paying trenches, and not to get discouraged by the low compensation for the amount of work required.

Retail photography

Retail photography can be summed up as providing professional photographs to the general public for personal use. It encompasses a wide variety of specializations including wedding and other special occasion photography, portrait photography, pet photography, and

school photography. Retail photographers might operate out of a studio (and most established ones do), or they might shoot on location. For professional purposes many retail photographers who rely on the local community for clientele tend to be more involved in community activities than do other photographers.

The retail market is a highly specialized one, with its own professional standards, marketing techniques, and pricing practices. Many retail photographers opt for this market segment because they are first and foremost people photographers who prefer interacting with private individuals to dealing with ad agencies, companies, and the media.

Specializations

Having reviewed the various markets available to photographers it now remains to take a brief look at the various branches of photography by subject matter, thinking about what markets each branch serves. A preference for shooting particular subjects is, after all, the name of the game, but to make a living you have to have some idea of the markets in which to sell the results.

You will find that many branches of photography are complementary and serve more than one market. You can then begin to develop more specific ideas concerning where to concentrate your talents. You can also start to consider the possibilities of working in a number of related branches, with the objective of casting your marketing net as wide as possible to maximize income generating opportunities.

Fashion photography

➢ Markets: Advertising, editorial

➢ Major buyers: Agency creative directors, art directors, and art buyers; editorial art directors

Fashion photography is the glamour occupation of the profession. It is intensely competitive and pays well. The main market is advertising, but there are also editorial opportunities. While the highest visibility opportunities with the fashion and lifestyle magazines might seem inaccessible to photographers just starting their careers, there is a low end to the business that is quite accessible to any competent and properly marketed photographer. This is the world of newspaper fashion ads, department store sales flyers, and retail catalogs. It is not fancy business, shot on a formula basis, but it is an excellent way to get started in the field.

Figure 1-2

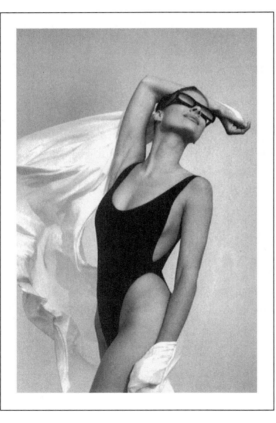

Fashion photography is rewarding in many ways.
M. Berinstein

The field and the importance of a good product

Fashion work in the advertising market is available through ad agencies and through the advertising departments of major garment retailers. In the editorial market work is available through the editorial offices of the various publications.

Medium- and large-format equipment, and access to a well-equipped studio is the rule.

Portrait photography

> Markets: Retail, corporate, editorial

> Major buyers: The general public, corporate communications directors, public relations firms, editorial art directors

Portrait photography is the bread-and-butter product of the typical retail photographer. Individuals, families, and children are all staple subjects, but there is also a need for both formal and informal portrait photography in the corporate and editorial markets. Portraits are frequently required of business executives, entertainers, sports figures, and other celebrities. Any photographer regularly shooting people should consider offering portrait photography as a distinct product. In the editorial market portrait shots frequently accompany articles and reports on people in entertainment, lifestyle, business, and in-flight magazines. Many of these publications frequently assign portrait shots rather than use the publicity shots made available by the subject.

As a rule equipment is medium- and large-format, except for some candid on-site portraits which might be shot in 35mm. Access to a studio greatly increases the photographer's flexibility and is especially important in the retail market. But many portrait sessions are done on location, and marketing location portraiture as a specialty can get the photographer a steady stream of assignments.

Figure 1-3

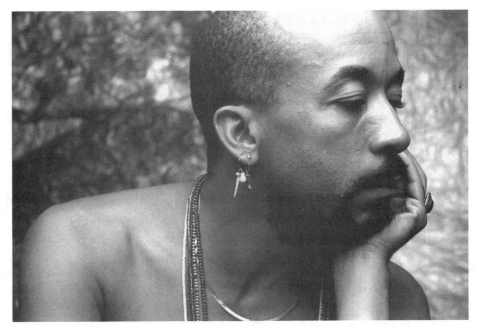

A studio is not a prerequisite for creative portrait photography. M. Berinstein

 # News photography

➤ Markets: Editorial

➤ Major buyers: Picture editors, art directors, wire service and agency picture buyers

News photography used to be a real glamour job, with armies of photographers on the staffs of the myriad of dailies and weeklies around the world. Some of those jobs still exist, but much of the work is done by freelancers working for the wire services or represented by agencies specializing in news photos. The pay is generally poor, and on a freelance basis steady work is uncertain, so you have to be in love with running around town or the world. Old news is no news, so the successful news photographer has to have a knack for being at the right place at the right time, preferably ahead of other photographers, and has to have excellent channels of distribution.

There is always the chance that you will be the only photographer on site when a major war, revolution, insurrection, or natural disaster occurs, but don't count on it!

News photography is done primarily with 35mm equipment.

Wedding photography

- ➤ Markets: Retail
- ➤ Major buyers: General public

Wedding photography is another staple segment of the retail market. For most people their wedding is one of the most special events in their life, and they are willing to spend fairly large sums on wedding photography. Weddings are also planned months if not over a year in advance, so the photographer's workload is predictable fairly far ahead, providing a nice sense of stability.

Wedding assignments typically consist of formal portraits, as well as candids of the entire event. Much if not all of the assignment is shot on location, but many people prefer a studio setting for formal portraits, so having a studio is a distinct advantage. The majority of wedding photographers use medium- and large-format equipment, and this should be the rule for anyone contemplating a decent long-term income from professional wedding photography. Some photographers specializing in low-end budget packages manage to scrape by with 35mm equipment. A popular related service offered by many wedding photographers is the wedding video.

Travel photography

- ➤ Markets: Editorial, advertising
- ➤ Major buyers: Advertising and editorial art directors, picture editors, picture buyers

Travel photography is a favorite field for photographers who love to wander the world. Any photography that promotes travel through either an editorial piece or advertising can be considered travel photography. A picture story on the open air markets of Mauritius and a shoot for a Mauritius Tourist Board brochure are both travel photography. What's more, both assignments can be completed on the same trip. An important element of travel photography is an ability to shoot candids of people. While it might seem logical that scenics and architectural shots of exotic places should be in great demand, the essence of professional travel photography is to bring alive for the viewer the experience of a different culture, a different people. That can only be accomplished by photographing people and by bringing the scenics and buildings alive by populating them.

Figure 1-4

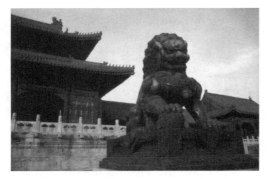

Travel is an ideal subject for stock portfolios, but the field is very competitive (Forbidden City, Beijing, China).

While there is steady demand for travel photographs, much is being supplied by stock agencies these days, and increasingly assignments are given to local or regional photographers instead of flying one around to various points on the globe. Thus, it might be difficult to make it on travel photography alone. It is, however, an excellent complementary activity to other fields, and readily lends itself to shooting stock.

Most editorial travel photography is shot with 35mm or medium-format equipment. Travel photography for advertising purposes might occasionally require large-format equipment.

The field and the importance of a good product

 # Nature and wildlife photography

> Markets: Editorial, advertising

> Major buyers: Art directors, picture editors, picture buyers

This is a favorite specialization for photographers who are nature lovers, and there is a big editorial and advertising market for the subject matter. Nature magazines, travel magazines, wildlife picture books, calendars, textbooks, and reference books all come to mind. In the advertising field the many faces of nature are a popular vehicle for evoking identification with a product. In addition to assignments, a great deal of nature and wildlife photography is shot for stock. While it might be practically impossible to make a living from nature and wildlife photography at the outset, many dedicated photographers can turn to the subject full time as they develop the special knowledge of the wilderness it requires, gain experience, and build a reputation. Aggressively pursue every opportunity to do it because you love it, and eventually you'll be making a living from it.

Equipment needs range from 35mm to large-format, depending on the subject and the intended use. Wildlife and nature reporting for magazines is often done with 35mm equipment, while pictures for calendars and coffee table books (where people want to see every single leaf) are shot with medium- or even large-format equipment.

Real estate photography

> Markets: Advertising, corporate

> Major buyers: Real estate marketing offices, marketing departments of architectural offices, some advertising agencies

Real estate photography is narrowly defined here to mean photography serving the needs of the commercial and residential real estate industry. Most of the opportunities are in the high end of real estate marketing. There are innumerable glossy, heavily illustrated

marketing brochures published by the real estate industry, and expensive residences and estates and elaborate commercial properties all require high-quality exterior and interior photography. Again, this is a field which alone might not offer a living, but it can be one lucrative offering in a photographer's product line.

Depending on the level of quality required, equipment can be 35mm or medium-format.

Architectural photography

> Markets: Editorial, advertising, corporate

> Major buyers: Art directors, picture editors, picture buyers, communications directors, editorial departments, ad agencies, and in-house corporate communications or advertising departments

This artistically rewarding specialized field provides opportunities for the photography of interiors and exteriors in the editorial, advertising, and corporate markets. There is a wide range of specialized magazines dedicated entirely or significantly to architecture and related trades such as interior design and landscaping. Popular topics include the construction of exceptional new residences, total restoration, interior renovation, innovative space expansion, and more. Many lifestyle magazines and even some travel magazines also have significant architectural content. Advertisements often require architectural images to get across a concept, whatever the underlying product might be, and corporate communications departments often have architectural photography needs for annual reports and other uses.

Equipment can range from 35mm to large-format depending on the image use. Some specialized equipment is required to adjust for the distortions caused by attempting to capture large structures from extreme angles (for example, a skyscraper from street level).

◎ Catalog photography

> ➤ Markets: Advertising

> ➤ Major buyers: Art directors, ad agencies, in-house advertising departments

There is a great and ongoing demand for catalog photography. Products have been sold via catalogs for decades, and consumer catalogs are flooding our mailboxes in ever-increasing numbers as the nation is gripped by mail-order fever. For a catalog business to be effective, the catalog has to be issued several times a year.

Catalog work can be very demanding because the image has to be shot to very precise dimensions and very specific positioning specs to fit into the catalog layout. Some catalogs have to be shot with a large-format camera through a grid used to precisely position the products.

Catalog work can also be boring. Imagine shooting the definitive catalog of the National Sprocket Corporation or the Great American Nut, Bolt, and Screw Company. But even the boring ones are bread-and-butter repeat business, good experience, and good exposure to people who may very well put you on to bigger and better things.

◎ Pet photography

> ➤ Markets: Retail and some editorial and advertising

> ➤ Major buyers: General public, breeders, art directors of specialized pet magazines, and art buyers at ad agencies

This is another specialized business (though it has many similarities to infant photography) that is great fun for those who love animals and photography. It is an ideal sideline for the retail photographer who enjoys working with pets. Some photographers specialize in going from pet show to pet show. Because most pet shows are held

Specializations

on weekends, the pet show photo booth can be an ideal part-time opportunity.

In addition to pet owners, breeders and specialized pet magazines also have photo needs. Pets regularly turn up in advertising as well. Medium-format equipment gives the best results at reasonable cost.

Aerial photography

> ➤ Markets: Editorial, corporate, advertising
>
> ➤ Major buyers: Editorial art directors, corporate communications directors, agency art buyers

Aerial photography is a highly specialized field that consists of a number of subspecialties. The most common of these is aerial surveying. This is a highly technical profession serving the needs of the earth sciences, the environmental sciences, urban planning, and mining and other extractive industries. Special cameras are mounted in aircraft that have to fly very precise courses at high altitude. Today the aircraft controls and cameras are linked to the aircraft's navigational system and everything is done automatically.

Another branch is oblique air-to-ground photography for commercial as well as artistic purposes. The most common use is commercial real estate photography for site planning prior to construction and for the marketing of a structure. Then there is taking pictures of the ground entirely for the pleasure of it. There is a ready market for aerial scenic portraits suitable for framing. Cityscapes, sport stadiums, famous buildings and monuments, and nature are especially well liked. Aerial picture books have become very popular, and there is always the odd editorial and advertising need. This type of photography is a demanding specialty. Your pilot has to fly low and slow, the weather and the lighting have to be just right, and you have to get supersharp images from a moving airplane. For any image that is going to be substantially enlarged for display, medium-format equipment is highly recommended. A gyro-stabilizer will do wonders to free the camera from the effects of airplane vibration and wind gusts.

The field and the importance of a good product

Air-to-air photography is another exciting specialization. Demand for it is largely limited to a handful of aviation magazines, aircraft manufacturers, and specialty book publishers. There is also some demand by aircraft owners for in-flight portraits of their airplanes. Air-to-air photo missions have to be conducted very professionally by all concerned to be safe. The aircraft have to be in very close proximity for good results and only a second or two may be available to correct any pilot error. The pilots of both the camera plane and the target airplane have to be excellent formation pilots and should be carefully briefed before every sortie. Air-to-air sessions are expensive to arrange and can be dangerous, but for the photographer who loves airplanes, few things are more satisfying than shooting an airplane in flight.

Figure 1-5

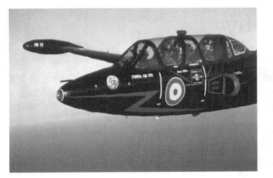

The air-to-air photographer needs to have well-founded confidence in the pilots (French Fouga Magister jet).

Art portfolio photography

> Markets: Retail, corporate

> Major buyers: Artists, corporate art curators

A fairly popular product offered by many professional photographers is art portfolio photography. All artists need photographs of their work for presentation purposes, and for the photographer such assignments are good filler for slow periods (it is not very lucrative). It can also bring good exposure for the photographer as the artist's portfolio makes the rounds. A better paying but rare proposition is

the photography of a corporation's art collection (many large corporations have big art collections and might need a photographic record).

Actor and model portfolios

➤ Markets: Advertising

➤ Major buyers: Actors, models

Aspiring actors and models all need portfolios. For the beginning photographer such assignments can be great experience, even though the fees are low. Also, the quality of the portfolio might catch the eye of someone important.

School photography

➤ Markets: Retail

➤ Major buyers: School administrators, athletic program directors

Schools have a variety of photographic needs that can present substantial opportunities for the retail photographer: class portraits, team portraits, teacher portraits, and so on. In a big school such assignments can mean hundreds of photographs, which can also lead to individual portrait sessions with students.

Copying and reproductions

➤ Markets: Editorial, retail

➤ Major buyers: Editorial art buyers, general public

There are many photographs that need copying (one-of-a-kind family portraits, rare historic photographs) or reproduction (paintings, lithographs, drawings, etc.). Needs are editorial (art books, art magazines) and retail. Fees are not lucrative (especially retail), but this form of photography can be a good secondary source of income.

 ## Sport photography

➤ Markets: Editorial

➤ Major buyers: Editorial picture buyers

A photographer keen on sports would be in fan heaven if he could make it as a sports photographer. While a few do, the road to *Sports Illustrated* is long, hard, and uncertain. Covering sports events as part of a wider practice, however, has much greater possibilities. Do it because you love it—who knows? The best possibilities for getting started are on local papers covering community, high school, and collegiate events. Expect dismal fees, keep shooting, spread around the results, and network! All you really need is 35mm equipment.

Where do you fit in?

Where you fit in is the $64,000 question that only you can answer. There are as many combinations and permutations of the various fields and markets as there are photographers. This review was intended to make you aware of the possibilities out there and to help you organize your thinking about your goals and objectives. Remember, whatever you do has to be fun, but it has to earn you a living. Before you go on to the next chapter, jot down on a piece of paper the markets you think you would like to serve and the specializations you would like to practice. Determine if there are any other specializations that overlap with your preferences. Read the next few chapters and come back periodically to this one to refine your thinking. The ultimate objective is to distill the photographer's world and your place in it.

Goals, aspirations, and abilities

A self-analysis

EMBARKING on your own business is a big commitment in every respect, and the outcome is by no means certain. When you start your own business you are essentially dedicating your entire life to it (at least in the beginning), and probably most if not all your resources, too. So you better know what you are getting into, you better like it, and you better be able to do it. This calls for a lot of honest soul-searching before it is too late.

There are a whole host of complex reasons why people become photographers and why they choose certain areas of specialization, but two points in particular are worth keeping in mind. First, like what you are going to do. Turn photography into a profession because you love it. Choose those branches of photography that you can never get enough of.

If you aren't passionately in love with the profession and your chosen field in it, you are asking for trouble if you start your own photography business. The novelty will soon wear off (it might even take a year or two), and then it will be just another dreary job. You'll go to bed every night dreading the following day's encounter with yet another temperamental creative director, packaged bride and groom, or drooling child. Even within your chosen fields of photography some types of assignments are certain to become repetitive and less challenging over time. All the more reason to love what you do.

Second, have the professional skills to do what you set out to do. An honest, objective understanding of your abilities is essential. If you can't do the quality of work demanded by the marketplace, you will struggle to get assignments. If you do manage to get assignments as the result of savvy marketing and ultimately can't deliver what is expected, you won't be in business for long.

Goal-oriented analysis

How successful you are in setting goals to maximize your potential greatly depends on your attitude. An aggressive, goal-oriented attitude works best. It drives you to first define exactly what you want

(out of your job and out of life) and then to move heaven and earth to make it happen. This focused, positive state of mind yields the best results, because its central premise is, "This is what I want, what do I need to do to achieve it?" Sure, once you begin to mesh your stated goals with the possibilities in the marketplace, you will encounter obstacles, but your whole state of mind will be primed to find ways around them. You might have to revise the time schedule you outlined to realize your goals. You might have to temporarily engage in additional activity on which you didn't plan, or for which you don't particularly care, but which will hasten your path to your ultimate objectives. You might have to acquire additional skills to get where you want to be. But you will have a goal—a vision—and you will be working to attain it. You will be in control.

Avoid the alternative of gazing about yourself to see what there is, and then poking around among the possibilities for something you can do. The people who wander into this reactive approach (and there are many) don't really know what they want. They are hoping that a goal will find them. They are the type who take the easiest way out, settle for second best, and run into a serious mid-life crisis down the road.

An aggressive, goal-oriented attitude also sets the mental stage for conducting your photo business, once it is up and running. If you get into the habit of clearly defining what you want and then seeking ways to make it happen, you will find it easier to establish the worth of your work, you will approach marketing with greater self-confidence, you will know when to say no, and you will find it natural to keep setting new goals.

Everyone's personal goals are a unique and private matter. No book can set goals for you. But books can help in guiding you through the process of setting goals. For the photographer, as for many other people starting a small business, it is helpful to evaluate objectives and set goals in three areas:

➤ professional goals,

➤ personal life-style goals, and

➤ financial goals.

Goals, aspirations, and abilities

The first two categories are self-explanatory. The last category helps you figure out how much money it will take to support your chosen life-style, and therefore, how much net income you must generate.

Since the process of evaluating your objectives and setting your goals consists of asking yourself a series of questions, each section is best examined in a question and comment format. The questions will also help you clarify your feelings about certain issues. You might think you have a preference for something, but as you probe deeper, you might realize that you weren't entirely right in your opinion.

Professional goals

What kind of photography do you enjoy the most, and are keen to do for the foreseeable future?

Be unconstrained in answering this fundamental question. The answer is really the summary statement of your photographic goals. All the other questions flow from this one and fill in the details. After your first stab at addressing all the issues raised in this chapter, you'll return to this question and make modifications based on what you found out; but for now be completely unrestrained.

Do you primarily view photography as a form of art or as a professional trade?

Many people are at first attracted to photography because they view it as a form of art, not as a trade. They think they can make a living as a photographer by either compromising to do work demanded by the marketplace, or believing that their works of art will sell. The point is that their emphasis is on the art in photography. They quickly become disenchanted once they start to compromise. They also have a hard time selling as much of their art work as they expected. You have to explore your feelings on this issue at some length. Whatever they are is fine. If you conclude that photography as art is why you are in the game and you would have a hard time compromising, then that is the goal for which you should strive.

Do you feel comfortable with creating photographs to the specifications of others (clients), and are you comfortable incorporating the opinions of others (including revisions) into your creative ideas?

Photography as a trade is really a service, requiring the constant interpretation of the needs of your clients, and providing exactly what they want, regardless of how you might feel about the subject. Sure, your clients will look to you for reasoned guidance and advice, but within their parameters. There is tremendous scope in professional photography for pursuing the perfect image, but a client who is not on your exalted wavelength can't be brushed aside. You have to be able to compromise and develop final-image concepts through consensus if you want to make it running your own photography business. Some photographers have a great deal of difficulty understanding this.

Define in a few words the service your chosen branch of photography delivers and to whom.

Begin to clarify any vagueness in the summary statement of your goals as a photographer. Explore what it is that you actually have to deliver per assignment and who the clients are. By spending some time thinking about this, you will be progressing from a conceptual understanding of what you would like to do to an appreciation of what your day-to-day photographic activities will actually be.

Delivering services requires a lot of flexibility, accommodation, and good humor toward clients, as well as a veritable army of people involved in shepherding an assignment along its path from concept to delivered product. How do you feel about that?

Photography is a people business. To some extent you must interact and get along with a great variety of people to get the job done. Will this be a problem for you?

Goals, aspirations, and abilities

Do you enjoy working with others?

This question is distinct from the previous one. You might have the abilities to be a real charmer, yet you might loathe every minute of being one. In that case you might have to work hard at minimizing interaction with a broad range of people, relying on a few trusted intermediaries (an agent, perhaps), or you might judge it worthwhile to try and overcome your dislike of working with others.

Are you outgoing? Do you find it easy to develop a rapport with strangers?

This question has important implications for your ability to sell. If you find it easy to approach complete strangers, selling should be a natural activity for you. If you don't, you'll have to work at it as well as rely on professional help, such as a good agent.

Do you prefer to work in solitude?

If your work is good and you strongly prefer to shoot by yourself, there certainly are branches of photography, such as catalog work and nature photography, that allow you to go it alone to a much greater extent than do other branches of photography.

Do you thrive on uncertainty? How well do you handle stress?

The uncertainty of where the next job will come from is a constant fact of life for all photographers. If you are uncomfortable with that concept you might be better off being an employee than running your own business. To a greater extent in some branches of photography than others, the day-to-day operation of a business is rife with uncertainties. Pulling off a big, weather-dependent fashion assignment with a cast of dozens is fraught with uncertainties that can cause enormous pressure. Doing a jewelry layout in your studio without models has fewer uncertainties and is therefore less stressful. Traveling on assignment in volatile, unpredictable countries has its own demanding brand of uncertainty and stress. Somewhere in the

Professional goals

spectrum there is surely room for you. Know your levels of tolerance for uncertainty and stress, and don't get in over your head.

Are you comfortable with the idea that running your own business means actually taking photographs not much more than 25 to 30 percent of the time you spend at work?

When you run your own small business, you are every department all at once. At some point you might have administrative help or an assistant, but in the beginning you are likely to be on your own. Even when you are in a position to delegate tasks, you still have to spend a considerable amount of time managing the business. That means spending a lot of time working but not shooting. Most self-employed photographers rarely spend more than 25 to 30 percent of their time shooting. Think long and hard about what you think of that.

Are you instinctively mobile or immobile?

This question is important in relation to the degree of mobility demanded by the type of work you enjoy. Even if you like being on the road you might have constraints on your mobility, such as family obligations. Again, you have to match preferences and job requirements to find a happy medium.

Figure 2-1

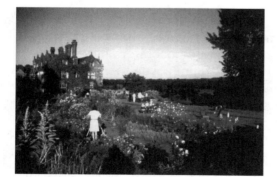

On assignment (Gravetye Manor, near East Grinstead, Sussex, England)

Goals, aspirations, and abilities

Do you prefer to work in a studio or on location?

You might have a strong technical preference for a particular branch of photography, but may not be consciously aware of your feelings about its location demands. Now is the time to think about it.

Do you like exotic, faraway locations?

This is another work-style question to help you focus on the details of your conceptual preferences.

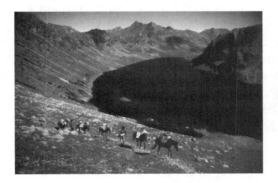

Figure 2-2

The wilderness photographer's studio (climbing to the Tarsar Pass, Indian Himalayas)

Do you like working with elaborate sets and equipment, or do you prefer working with small-format cameras?

This question will help you clarify any ambiguities you might feel regarding the images you like to create and what it takes to create them.

How would you like to see yourself develop as a photographer?

One of photography's great pleasures is that you never stop learning and exploring. Although much of your development as a photographer will emerge subconsciously over time as your creativity is constantly put to the test, it is also helpful to give the future some conscious thought and to have a general plan to head in that direction.

Professional goals

Where would you like to be professionally in five years? In ten years?

Write a brief summary of where you would like to be as a professional photographer in five and ten years. It will help you focus on your career aspirations and will lay the foundations of a strategic plan.

Do you look forward to putting in 18-hour workdays, six or seven days a week, for as long as it takes to become an established photographer?

This is one of the most important questions for anyone hankering to be self-employed. Profitable self-employment requires endless grueling days. The most successful entrepreneurs are the ones who can't wait to get up every morning and dive right in where they left off the night before. Experience has shown that if you can't do that, you simply won't be able to generate sufficient income to make it as a going concern. Sustaining the pace necessary for business success is one major reason why you have to love what you are going to do.

Personal lifestyle goals

Having developed some idea of your professional goals and aspirations, you have to go through the same exercise for your personal life to see how well your professional and personal aspirations complement each other.

Follow the unconstrained approach in answering them. First, you need to know what you would really like out of life without any strings attached. Then you can put a lot of energy into making it happen. If you have a spouse or family, keep their interests in mind when you go through your personal goals. Better still, work on this section together.

Describe in a few words what you would consider to be an ideal personal life.

Goals, aspirations, and abilities

Where would you like to live geographically?

What kind of community would you like to live in?

What kind of a home would you like to live in? Is it important?

Would you like to own the home you want to live in?

Do you have or are you planning to have a family?

How much time do you think you should spend with your spouse/family?

How much time does your spouse/family think you should spend with them?

Do you want to see the world? Do you enjoy being on the road, away from home, and if so, how often and for how long?

Is automobile ownership a necessity? Do you (and your spouse, if applicable) have a thing about expensive cars, boats, RVs?

Do you have any expensive consumer habits, or a lot of little, inexpensive consumer habits that add up?

Do you need a lot of free time? How do you like to spend it?

Does your spouse/family generally share your opinions regarding these life-style questions?

If not, what is there that your spouse/family wants from your life-style that you feel you should strive for on their behalf?

Where do you see your personal life in five years? In ten years?

Personal life-style goals

Financial goals

Your financial goals are a function of what it will cost to realize your personal lifestyle goals. They directly tie into your business activities in that they establish how much net personal income you need to meet your financial goals. When thinking of financial goals it is helpful to distinguish between your present financial needs, your objectives a few years down the road, and your long-term financial goals.

Do you have any idea how much it costs to realize your personal life-style goals?

Not everybody is well informed about the specific costs of their life-style. Many people only know that by the end of the month the money is all gone, and they are not quite sure where it all went. Gathering such information is the first step to establishing what your financial needs and spending patterns are and what you are likely to need to realize additional financial goals.

Have you ever done a personal budget?

The easiest way to get a handle on your financial needs is to prepare a personal budget. Budgets can be prepared for any length of time, but monthly budgets are the most useful for tracking expenses because most personal bills have to be paid monthly. Annual budgets are useful for monitoring and forecasting annual financial needs.

Take a first stab at a personal expense budget by filling out this monthly budget form. Multiply everything by 12 to get a budget for the year. Add categories of your own, as appropriate.

Mortgage or rent
Insurance
Telephone
Utilities
Auto loan
Auto operating expenses

Goals, aspirations, and abilities

Credit card interest and fees
School fees, education
Taxes
Groceries
Clothing
Dining out
Entertainment
Gifts
Misc. household

Now do an annual estimated expense budget for each of the next three years, factoring in any anticipated increases in expenses.

How much of the expense budget is nondiscretionary (that which you have to pay to sustain your basic lifestyle), and how much is discretionary (entertainment, dining out, etc.)?

It is useful to identify those budget items that can't be avoided (such as rent, utilities, and loan payments), and those items that can (such as nights on the town, shopping for the sake of shopping, and recreational travel). Once the distinction is made, you will have a better idea of what you have to work with to better allocate your financial resources.

Are any of the expense budget items reducible, or do you have your heart set on what they provide?

There are two ways to handle strains on your budget: decrease expenses or increase income. Once you've determined what you can't do without, make a determined effort to increase income.

How much do you think you should save per year, and how did you arrive at that amount?

Logic tells us that we should all save something. Summarize in a few words your current thinking on savings.

What are you saving for? More goodies? Rainy days? Retirement?

Financial goals

Savings are a means to build up money for planned future expenses, but can also be a reserve for when you do not generate enough money to meet expenses. Typical savings needs include your children's education, a down payment on a house, a vacation, to tide you over during periods of unemployment, and retirement. Financial advisors are in agreement that it is tremendously shortsighted not to save. For the self-employed it can mean the difference between being able to ride out a crisis and having to get a job.

With this in mind, take a stab at defining and quantifying your savings needs. Calculate how much you should be saving per month and incorporate this amount into your monthly budget.

Do you anticipate any educational expenses for children, and if so, what do you estimate them to be?

This is an important question to help you focus on saving for future needs.

How will your annual budget need to increase to fit in with your life-style objectives five years from now? Ten years from now?

Take a look at where you would like to see your lifestyle evolve in five and ten years, and estimate how much income growth you are likely to require to meet those needs.

What's the bottom line? How much would you like to make per year?

Go through your monthly budget carefully once more. When you are satisfied that it represents all your needs, total it up, multiply the total amount by 12 and you will have the annual personal net income your photography business will need to generate to give you the life-style you want.

Note that not all income has to come from your photography. You might have other sources of income, such as the income of a spouse. If you have such income, your photographer's income has to only

Goals, aspirations, and abilities

make up the difference between total needs and other income. Also bear in mind that you will live off your savings initially, until your business becomes self-sustaining. (Your savings is your capital with which you will start the business.)

 # Skills

By now you have a good idea of what you would enjoy doing, and how much you will have to earn to sustain your desired life-style. Now is the time to look yourself in the eye and ask if you have the skills it takes to do it. What are you going to do about acquiring the skills you lack?

List the skills you feel are necessary to run your photography business, and identify the ones you have.

To get things started and put in perspective, begin by summarizing what skills you think you should have to be a successful self-employed photographer. Identify the skills you believe you have.

What are you doing about the skills you don't feel you have?

Outline a plan of action to acquire or otherwise handle the need for the skills you don't have.

Did you include financial, marketing, and administrative skills on your list?

Remember, you'll be lucky to be shooting 25 to 30 percent of your time at work. The rest will be finance, marketing, and administration. Have you listed any of these skills? Do you have any of them? Don't worry if you are flummoxed. Finance, marketing, and administration for the photographer is what most of the rest of this book is all about.

What makes you think you are a good enough photographer in your chosen field to hack it with the professionals?

Skills

Summarize what you admire about the work and skills of the professionals with whom you are proposing to compete. Summarize why you think you can do what they do.

Have qualified professional photographers with independent, objective opinions evaluated your photography skills and confirmed your opinions? Have they told you what you lack? Are you doing anything about it?

Your own opinion is one thing, but it is best submitted to a reality check by an experienced, profitably self-employed photographer whose work you and your target market admire.

Do you work well with others?

This is a skill as much as a goal. Do you?

Can you develop a rapport with strangers?

Again, a skill as well as a goal. Your abilities in this regard are an indication of your chances of successful marketing and selling.

Do you have a sense for numbers? Do you balance your checkbook regularly?

Such abilities are indicative of an inclination to handle finance and administration well.

Are you deliberate and methodical, inclined to finish things you start without outside prodding?

As a self-employed businessperson you are your own boss. One of the benefits of being an employee is that the good boss is always there to motivate. In your own business you have to be self-motivated, able and eager to finish what you start.

Are you good at doing many different types of tasks simultaneously?

Goals, aspirations, and abilities

Multitasking is another essential skill of the self-employed (and is also required of many employees). Evaluate your multitasking abilities honestly.

Do you enjoy administrative work, or at least have the discipline to slog through it regularly?

Administration is perhaps the driest task of any working person, self-employed or not. Some people take to it naturally, some find it a welcome refuge from more demanding tasks, some slog through it with good humor, and others make a complete mess of it. If you have the tendency to do the latter (many photographers do), be sure to seek professional assistance (this book will tell you how).

Making sense of it all

The questions in this chapter are intended to enable you to make good progress in analyzing your goals, aspirations, and abilities, but they are by no means complete. In fact, you should carefully go through each section and ask questions of your own, tailored to your own specific circumstances.

When you have answered all the questions, it is time to synthesize the results:

> ➤ Go back to the first question in each section and formulate one final summary statement of your professional, personal, and financial goals.

> ➤ Ask yourself if the goals in the three areas are compatible, and keep reworking things until they are.

> ➤ Note how much annual net income you will need to sustain a life-style acceptable to you.

> ➤ Make a final inventory of all the skills you think you should have, the ones you do have, and the ones you don't have, and make a plan for getting them.

Now you are ready to move on. It is time to learn more about the business aspects of starting and running a photography business. You will rely heavily on what you accomplished in this chapter when you prepare your business plan.

Goals, aspirations, and abilities

3

Photographer's finance 101

IT cannot be stressed enough that to be a successful photographer you have to make money, and to make money you have to be a competent businessperson. The world of business tends to be intimidating to someone with little or no business experience. However, the fact is that anyone with common sense and some self-discipline can easily acquire the modest bag of tricks required to successfully run a small business.

In many respects, running a small business isn't all that different from the act of taking photographs. The financial, marketing, and administrative techniques are your tools—your film and camera. The profits are the photograph—the goal to be realized with the tools. Just as a photograph has to first be a vision in your mind before being carefully planned and turned into reality, so too the level of profits you seek has to first be established in your mind. Only then can you carefully craft a plan to attain your goal, and bring the tools of business to bear to achieve it.

Financial terminology is the language of business and money is its unit of measure. What you earn (income), what you spend (expenses), and what is left over (profits) are all expressed in dollars and cents. Your assets (the equipment you own, the money your clients owe you, and the money you have in the bank), your liabilities (money you owe the bank and suppliers), and capital (the money that remains yours after your liabilities are subtracted from your assets) are all expressed in dollars and cents. Thus, it is a crucial first step in starting a profitable business to be able to set realistic income goals, develop a credible plan to achieve them, and recognize and handle any events that would threaten your financial success. To be able to do that, you have to understand the structure of your business in dollars and cents, and value your business activities in dollars and cents.

Knowing the ins and outs of your business in financial terms is important for other reasons. It gives you the credibility you need to secure credit from suppliers and banks. It enables you to work smoothly with your accountant. It takes the dread and fog out of dealing with income tax returns. Most importantly, it reveals to you

Photographer's finance 101

techniques of financial management that can maximize your income and make the difference between business failure and success.

The analytical process

How can you best gain an understanding of basic financial terminology, become familiar with the financial structure of the typical small business, and come to comprehend the relationships between the various financial components of the business? The usual way to acquire such knowledge is to take a generic small business course or work your way through a generic small business book. That is a dreary thought for most aspiring photographers, who would much rather be taking pictures than listening to an accountant lecturing them about some hypothetical widget seller or trying to relate the contents of a generic book to their profession. There is a much more effective way to learn, one that will keep you interested and motivated. It is learning by example from the real world of photography.

Several business organizations develop composite financial profiles for hundreds of types of businesses, among them a photography business. Each profile is assembled from data supplied by a representative sample of businesses from a particular field of activity. The profiles reveal what the typical business in a particular field should look like. Suppliers, bankers, investors, and others compare the composite profiles to the financial profiles of their specific clients to assess the client's financial viability. The composite profiles are also extremely useful for entrepreneurs aspiring to set up a particular business, and as a learning tool.

A composite financial profile of a typical photography business can be used to accomplish three objectives:

➤ Learn the basic financial terminology you need to know

➤ Become familiar with the financial structure and needs of the typical successful photography business

The analytical process

> Use this information to develop realistic financial goals to start your own successful business

Bear in mind that the composite financials include a wide spectrum of successful photography businesses, large and small. Thus, the aggregate size of sales, profits, and the balance sheet are considerably above the levels a beginning photographer can reasonably expect. However, the relationships between the financial components are generally the same and should be your focus. Also, you should find the healthy sales and profitability levels taken from real life something to be encouraged by and aspire to.

Financial structure

There are two methods for keeping track of financial structure. One method is very easy, but provides little financial information beyond the present. The other method is a bit more complex, but shows you the big picture you need to effectively manage your business. They both have to do with what you record about income and expenses. These two methods are called cash basis and accrual basis.

Cash basis

The *cash basis* is simply a record of income and expenses when the cash is actually received or disbursed. It gives you an up-to-the-minute cash position for your business. It is easy to set up and quite similar to your personal checkbook. Few things could be simpler than setting up a system to track income and expenses on a cash basis. Divide each page of a notebook vertically into two halves. Label the left half *expenses* and the right half *income*. Record the money you start with as the opening balance of the income column, and make an appropriate entry every time you pay for something or receive a payment from someone. Note the date, the entity to which you made payment or from which you received payment, the purpose of the payment, and the amount. Periodically deduct expenses from income to know how much money you've made or

Photographer's finance 101

lost. You can calculate the balance after every transaction, or on a weekly, monthly, quarterly, or annual basis, depending on the level of business activity and your particular needs.

The best way to set up such a system is to simply open a checking account exclusively for your business (which you have to do anyway), run every transaction through it, maintain the checkbook meticulously, and end up with an up-to-the-minute record of cash out and cash in. Unfortunately, that is all you end up with. There is so much that this method doesn't tell you about the financial structure of your business that it puts you at a serious disadvantage in figuring out what is going on. It is suitable only for the simplest photography businesses with low levels of activity. To be able to fully grasp what is happening to your business financially and to make effective financial plans, you have to keep track of a little more information. You also have to estimate the cash expected to flow in and out in the near future.

Accrual basis

The *accrual basis* method provides another layer of information beyond the cash basis method. In addition to actual cash in and cash out it also records

➤ cash that is due your business but not yet delivered (accrued from clients to whom you have sent invoices)

➤ cash that is owed by your business but not yet paid (accrued by your suppliers who have sent you invoices)

The accrual method provides accurate information not only on the present cash position of your business, but also on inflows and outflows expected in the near future (usually the next 30 to 90 days). It makes more accurate day-to-day financial planning possible, and it is the tool for developing the financial projections that are the heart of your business plan. The accrual method also has implications for valuing inventory (materials on hand to produce the business's product).

Financial structure

Don't be deterred by the apparent complexity of the accrual basis method of tracking the financial structure of your business. Even if you are tempted to opt for the easier cash basis method, and you may elect to file your taxes on a cash basis (as will be seen later), you still have to keep track of the invoices you send out to clients, as well as the bills (invoices) you need to pay. It is a small extra step to enter them into your financial records (made practically automatic by that indispensable modern tool of small business, the personal computer). The effort is far outweighed by the benefit of the additional financial information you will have to make your business a success. It is on the accrual basis that the financial structure and performance of a successful photography business is discussed in this book.

Composite financial profile

The financial structure of a business is recorded by two main financial tools: the income statement and the balance sheet. Following is the composite income statement and balance sheet of a typical photography business, based on the financial records of 226 commercial photographers compiled by a major financial information-gathering organization for 1992. Scan the financials before I discuss them in detail, and bear in mind two things.

First, the numbers are composite averages. They provide an idea of the financial figures you can reasonably expect to see in a successful photography business. You could exceed the average or be substantially below it. As a beginning photographer your level of financial activity will be lower.

Second, more revealing than the actual dollar amounts are the percentages of each appropriate subcategory in comparison to corresponding total sales, total assets, or total liabilities and net worth. If, for example, you see that the industry average after-tax income (profit) is 7 percent of total sales, then you can quickly estimate the level of sales you would have to realistically achieve to make a certain amount of after-tax income. If you see that on the balance sheet net worth slightly exceeds liabilities then you have an

idea of capital needs *relative to* the level of liabilities (including borrowing).

INCOME STATEMENT

Sales	470,958	100%
Operating Expenses	428,055	91%
Operating Income	42,903	9%
Interest Expense	705	0.1%
Income Tax Expense	9,231	2%
Net Income	32,967	7%

BALANCE SHEET

ASSETS			LIABILITIES		
Current Assets			**Current Liabilities**		
Cash	25,889	18%	Accounts Payable, Trade	13,807	9%
Accounts Receivable	36,821	25%			
Inventory	6,041	4%	Short-Term Debt	7,336	5%
Other	10,068	7%	Other	21,718	15%
			Total Current Liabilities	42,861	30%
Total Current Assets	78,819	54%			
Long-Term Assets			**Long-Term Debt**	23,157	16%
Net Property and Equipment	48,758	34%	**Total Liabilities**	66,018	46%
			Net Worth	77,812	54%
Other Assets	16,253	11%			
Total Assets	143,830	100%	**Total Liabilities and Net Worth**	143,830	100%

Composite financial profile

Now let's take a look in detail at the various components of the financials of a typical photography business. In addition to discussing each component, you are also encouraged to think of them in perspective as they relate to the operation of the business. This will get you into the mind-set necessary for constantly considering the financial implications of your actions as you plan and run your business.

Income statement

The income statement records the amount of income earned by your business over a period of time. In this case, as is customary, the income statement covers a period of one year. The income statement shown is an extremely simple one, providing a broadbrush summary of income and expenses.

✳ Sales

Sales are the total billings for the time period covered by the income statement. This figure is the cumulative amount of all the individual billings you sent out to clients for each job you performed. It includes every item on the invoices you sent: charges not only for your services (your daily or hourly rate), but also charges for film, processing, assistants, location fees, and everything else being billed to your clients. All expenses have to come out of sales to arrive at the net profit; therefore, sales are 100 percent on the income statement, and expenses and profit are looked at as a percentage of sales.

Note: The annual sales of the average photography business was $470,948. If you got 150 jobs during the year, how much would you have to bill per job (your fee plus all expenses) to make the sales figure? The answer is $3,140. That is a lot of photographs. Suppose you could do 300 jobs (unlikely in a one-person operation, given the number of days in the year and the time you need to spend on the business not taking photographs). In that case you could bill $1,570 per job to make your sales. These numbers indicate the desirability of seeking high-return assignments, such as high-end wedding packages,

Photographer's finance 101

or high daily rates. Spending an afternoon with a guy who wants one 3-by-4 glossy for his girlfriend's wallet is not going to keep you in business for long, even if you charge him $100. Bear this in mind for now. I will return to this theme when I discuss pricing and the business plan.

✳ Operating expenses

Operating expenses are all the expenses incurred by your business as a result of performing jobs for your clients. Operating expenses also include your salary. Every successful photographer should draw a regular salary, just like any other employed person. Operating expenses do not include interest expenses on any loans your business may have or income taxes.

Expenses are recorded in a variety of suitable categories. Within a framework dictated by tax record requirements, the photographer has considerable leeway in custom tailoring a set of expense categories and choosing the degree of detail that best suits individual circumstances. The important thing is to be sure to capture all expenses in some category or other. Here is a representative list of expense categories that is generally useful not only for running a photography business and for tax records, but also for your business plan:

> ➤ Film, materials, processing

> ➤ Equipment, equipment rental

> ➤ Subcontracted services (stylist, makeup, assistant, etc., hired per job)

> ➤ Photographer's salary (the profits of the business should be over and above your salary, as a return on your investment in the business, ideally available to grow the business)

> ➤ Employee wages (if you have full-time or part-time help instead of subcontracted services per job)

> ➤ Occupancy expense (rent, lease, mortgage)

> ➤ Utilities

Composite financial profile

- Telephone
- Postage/freight
- Advertising
- Insurance
- Legal and accounting
- Vehicle expenses
- Travel
- Business meals
- Professional dues, subscriptions
- Conference fees, continuing education
- Office supplies
- Miscellaneous
- Depreciation expense (A curious tax deduction designed to leave cash accumulating in your business to replace aging equipment. It will be discussed in detail in chapters 6 and 11.)

In some businesses, where there is a significant need for all kinds of raw materials to produce a product, it is customary to break out the cost of these materials as *cost of goods sold*. In complex organizations such a distinction is useful to accurately monitor expenses and pinpoint the potential need for expense control. However, for photographers, the cost of goods sold is not a major expense, and separating cost of goods would be complicating things unnecessarily. The vast majority of photographers keep negligible amounts of film on hand and directly pass on film and processing costs to their clients with a small markup.

Note: Several of the expenses listed previously have to be paid, regardless of the amount of income. These expenses are often referred to as *overhead*. The big ones that tend to be constant for a going concern are occupancy, insurance, advertising, utilities, telephone, legal and accounting, and your salary. Let's assume (not

unreasonably) that these expenses amount to $100,000 per year in the composite income statement. If you do 150 assignments per year, you will have to charge $667 per job just to meet your overhead. For 100 assignments per year, it would be $1,000 per assignment. To this you have to add all film, material, processing, travel, and other costs, as well as any profit you want to make on the job.

✳ Operating income

Operating income is the income left over after operating expenses are subtracted from sales.

✳ Interest expense

Interest expense is the amount of interest paid during the period covered by the income statement. Once you qualify as a borrower, you are likely to have two types of loans: a short-term line and a long-term loan. A short-term line, also called a working capital line, allows you to borrow up to a certain limit, pay down as you receive payment for your work, and reborrow as needs arise. It works much like a credit card line, except it has to be renewed every year. A long-term loan is usually lent to purchase specific equipment or property. It has a maturity beyond one year (typically three to seven years for equipment and more for property mortgages), and is on a regular repayment schedule. Reborrowing to the original amount is not permitted.

✳ Income tax expense

Income tax expense is your income tax payment for the period covered by the income statement. I'll talk a lot more about income taxes in chapter 11.

✳ Net income (profit)

Net income is the bottom line. It is over and above the salary you pay yourself. It is the return on your investment as a business owner. You can take it out of the business (a dividend), but ideally you will leave most of it in the business (retained earnings) to accumulate to pay for future growth.

Composite financial profile

Balance sheet

The balance sheet is a snapshot of your business's financial structure. It is a static picture. It shows financial structure at a moment in time. The structure might have been different immediately before the data was compiled, and it might be different immediately after.

The balance sheet has three components: assets, liabilities, and net worth (also called equity). The reason it is called a balance sheet is because there is a balance between assets on one side and liabilities and net worth on the other side. The equation is as old as accounting:

$$assets = liabilities + net\ worth$$

Briefly, *assets* are what the business owns, *liabilities* are what the business owes, and *net worth* is what the owners of the business can keep from the assets after meeting the business's liabilities from the value of total assets. Each individual asset amount always has a corresponding (offsetting) liability or net worth amount. Any asset increase on the balance sheet has to be accompanied by a corresponding liability or equity increase (depending on whether additional credit or an addition to net worth was used to increase assets) to maintain the balance between assets on the one side and liabilities and net worth on the other side. Let's take a look at the balance sheet of the typical photography business.

✳ Assets

Assets are everything a business owns, including items acquired on credit (even though you used borrowed money to acquire something, the acquired item belongs to you). Following is the asset side of the composite balance sheet:

ASSETS

Current Assets

Cash	25,889	18%
Accounts Receivable	36,821	25%
Inventory	6,041	4%
Other	10,068	7%
Total Current Assets	78,819	54%

Long-Term Assets

Net Property and Equipment	48,758	34%
Other Assets	16,253	11%
Total Assets	143,830	100%

Cash Cash is the money your business has in the bank, on-site, or wherever you choose to keep business cash. It can be the cash received in payment for completed assignments, cash received as a deposit to start a job, cash put into the company from your personal resources, cash from additional borrowing, or cash from any other legitimate source. It is often referred to as a liquid asset because it is available for use by your business immediately.

Accounts receivable Accounts receivable is money coming to you from your clients for jobs completed, but not yet paid by them. When you send out an invoice to a client it immediately becomes a receivable. Traditionally, photographers have a fair amount of receivables, because while they get a deposit to begin a job, they bill for the rest of the job only upon completion. They then have to wait to get paid. The composite balance sheet shows receivables to be 25 percent of total assets.

Composite financial profile

Note: For the day-to-day operations of your business, receivables do little good, because until they are actually collected by you from your clients (turned into cash) you can't use their value to buy things or to pay bills. Thus it becomes important to have each individual receivable collected as soon as possible. You should expect your clients to pay you in a maximum of 30 days. A receivable not collected in 30 days should be considered past due, and you should chase your client for it.

Inventory Inventory is the amount of raw material or finished product a business has on hand to enable it to meet its sales commitments to clients. Inventory for photographers is primarily film, and processing materials and chemicals if any processing is done in-house. Photography businesses tend to have very little inventory, since most film is bought for a particular job and few photographers do any large-scale processing in-house. Note that inventory in the composite balance sheet amounts to only 4 percent of total assets.

Note: Inventory has to be purchased. It ties up cash. All businesses should strive to maintain as little inventory as possible. Large amounts of inventory sitting on the shelf for a long time tie up large amounts of cash that could otherwise be used for other, income-generating purposes.

The assets described thus far—cash, accounts receivable, and inventory—are collectively known as *current assets* because they are usable by the business immediately or in the near future (the rule of thumb is under one year). A catchall category—other current assets—captures any current assets missed in the other categories.

Property, plant, and equipment Property, plant, and equipment for a photographer are cameras, props, and a studio, if one is owned (rented premises are not an asset because they don't belong to the photographer). On the balance sheet these items are recorded at the original acquisition value minus the accumulated depreciation that has been deducted over the years as an expense (see chapters 6 and 11 for a detailed explanation of depreciation). Property, plant, and equipment are sometimes called *fixed assets,* a term that has gone

out of style in the accounting profession because the assets are not really fixed.

Other assets This is a catchall category for long-term assets not classified otherwise. Typically they can be the value of a photographer's portfolio or long-term investments.

✳ Liabilities

Liabilities are what a business owes. Below is the liability and net worth side of the composite balance sheet.

LIABILITIES

Current Liabilities

Accounts Payable, Trade	13,807	9%
Short-Term Debt	7,336	5%
Other	21,718	15%
Total Current Liabilities	42,861	30%
Long-Term Debt	23,157	16%
Total Liabilities	66,018	46%
Net Worth	77,812	54%
Total Liabilities and Net Worth	143,830	100%

As there are short-term assets, so there are *current liabilities,* which are expected to be taken care of by the business (and replaced by new short-term liabilities) in under one year. There are two short-term liabilities the photographer usually encounters: short-term debt, also referred to as notes payable, and accounts payable. Other

Composite financial profile

current liabilities capture current liabilities missed by the other categories.

Accounts payable Accounts payable are bills you owe your suppliers and providers of various services. Typical payables are invoices for film you bought on account, telephone bills, utility bills, bills for the services of stylists or models, etc.

Note: How quickly you pay your bills has a lot to do with how willing suppliers are to let you buy on account (meaning that you take what you need up to a limit and are billed once a month). Just as you should give no more than 30 days to your clients to pay their bills, you should pay your own bills in 30 days or less. If you don't, your suppliers could get skittish, considering you a bad risk. You might find them demanding cash on delivery just as you are about to start a big job. As you can see, most photographers must pay quite promptly, because accounts payable accounts for only 9 percent of total liabilities on the composite balance sheet.

Short-term debt Short-term debt (borrowings) is used to fund short-term cash needs while receivables are being collected. Specific borrowings under a credit line are expected to be paid down in under one year (usually not more than 90 days); at which time, the entire amount up to the limit of the credit line can be reborrowed. These borrowings are the grease in the wheels of your business, but you better have incoming cash to pay them down.

Long-term debt Long-term debt is debt you use to buy (finance) assets that you plan to use over many years. For photographers this means cameras and related equipment, and their premises if they are lucky enough to be in a position to buy their own studio. Debt is considered long term if it has a maturity (repayment period) over one year. A 4-year loan to buy a digital portrait camera or a 15-year mortgage to buy a studio are examples of long-term debt.

Other liabilities This is a catchall miscellaneous category for long-term liabilities not covered otherwise.

✳ Net worth

Net worth is one of the most important, and if you are doing things right, most pleasing components of the balance sheet. It tells you how much of the business is really yours. Sure, you have a heap of assets, but offsetting them is a heap of liabilities. Net worth is what is left for you once the liabilities are taken out of total assets (remember: assets = liabilities + net worth).

The initial net worth of your business is the money (the capital) you put into it when you establish it. Additions to net worth come from two sources: the amount of annual net profit you choose to leave in the business (retained earnings), and any additional money of your own that you choose to put in (capital infusion). Generally, a capital infusion is done only if a business can't generate enough profits to keep going. Any business that needs repeated capital infusions won't last long.

⬤ Cash flow statement

The third and very important tool of financial analysis and management is the cash flow statement of the business. It is a record of net cash inflows and outflows over a period of time, and the resulting net cash available to the business at a particular point in time. The purpose of the cash flow statement is to get a handle on the problems caused by receivables and payables. Any significant mismatch in inflows and outflows can cause a serious cash crunch, and must therefore be anticipated and a plan put in place (short-term borrowing, for example) to deal with it.

Accountants prepare an annual cash flow statement when they compile the annual financial statement of a business, but it is not presented here because the calculation is somewhat involved, and on an annual basis it is actually quite meaningless for the day-to-day management of the business by the nonfinancial proprietor. The cash flow statement that is very useful to the proprietor in managing the business is the monthly (or even weekly) *cash budget*—a projection of cash flow, matched by the actual cash flows during the course of operations. I will address the cash budget in chapters 6 and 9.

Composite financial profile

The operating cycle

Now that you have become acquainted with the financial structure of a photography business, the next step is to see how the various components of this structure interact during the normal day-to-day operation of the business. The intent is not to make an accountant out of you (your computer and accountant will take care of your books, except for some very simple entries you have to make in your record-keeping system as you conduct business), but to give you a sense of the financial flows in your business. As you run your business, you'll quickly develop a sense for these financial flows. This introduction will put you on the right track.

Every business functions on what is commonly referred to as an operating cycle. The photographer offers to take photographs, secures an assignment, receives a deposit, spends money for film, performs the work, and (hopefully) gets paid in full for the assignment. This, in essence, is the operating cycle, repeated transaction after transaction. It has a beginning and an end, and goes through a number of phases in between. Each stage of the operating cycle has financial consequences. Understanding the cycle and its financial consequences is key to understanding and successfully running your business.

Let's go through the operating cycle of a typical transaction and examine its financial consequences at every stage. In this example the photographer is hired to shoot photographs for a power-tool company's new catalog.

❶ Receive photo assignment and deposit to start the job.
 • Income statement: The deposit represents sales. It should therefore be registered on your income statement as sales. Note that no additional sale is registered for the balance of the assignment's value, even though you have contracted to do it, because the balance is not due until you finish the job and present the invoice to the client with the delivery of the finished product.

- Balance sheet: The deposit is cash, most likely in the form of a check. It represents an increase in assets. It is an additional asset you did not have before. On your balance sheet this increase in assets is represented by an increase in cash. But if the asset side of your balance sheet increases, the liability and net worth side has to increase too. Which entry do you think should increase? No liability has been incurred in exchange for the deposit (sure, you will use the deposit later, at which time a liability account might be affected, but for the moment there is no increase in liability); it is net worth that increases.

❷ Buy the film required to perform the job.
- Income statement: You have an account with a photo supply store. You buy 20 rolls of film for $200 on account. It is an expense, recorded as such when you receive the invoice (bill) for it, along with the film.
- Balance sheet: The film represents $200 dollars worth of additional assets. It is inventory (raw material to be used to produce the product you sell); therefore, the inventory account of assets should increase by $200. But as the asset side increases, so does the liabilities and net worth side. You acquired the film on account. You are billed by the photo supply store (you are given an invoice with the film), but have to actually pay only in the near future. For now, when you receive the bill, you have an additional account payable. Therefore, your accounts payable (liability) increases by $200 to match the asset increase.

 Note that if you paid for the film in cash (an asset), there would not have been a net increase in total assets, only a shift from one asset account (cash) to another asset account (inventory). The cash account would have decreased by $200 and the inventory account would have increased by $200. Total assets would have remained unchanged, and the liability and net worth side would not have been affected.

❸ Contract the services of a stylist to set up the tools.
- Income statement: Contracting the services of a stylist is an expense. The expense is incurred when demand for payment is

The operating cycle

made by the stylist. If the stylist demands a partial advance payment, that payment is recorded as an expense on the income statement when the stylist is given the check. The balance is recorded when the stylist invoices you (sends you a bill) for it.

- Balance sheet: When you are invoiced by the stylist upon completion of the job, accounts payable increases by the cost of the stylist. There is no corresponding asset that is a source for this liability. The source is the wealth of the business, its net worth. Therefore, net worth decreases by an amount corresponding to the cost of the stylist. The total amount of liabilities and net worth (and the total amount of assets) remains unchanged.

❹ Take the photographs and have them processed.
- Income statement: The processing represents another expense. Therefore, record an expense on the income statement.
- Balance sheet: While the processing is an expense, unless you write the lab a check on the spot, it is not an immediate cash outlay. In this example, the processing lab bills you for processing the film. When you are billed, your liability to the lab is an account payable. Accounts payable increases by the amount of the processing costs. The offsetting entry is, again, a decrease in net worth. Total liabilities and equity remain unchanged, as does total assets.

Remember how net worth increased when you received the deposit for the job? Well, here is where the deposit is going—to buy film and the services of the stylist, and to have the film processed.

❺ Deliver the completed photographs and invoice the client.
- Income statement: When you deliver the finished work, you also send an invoice to the client for the balance of the money owed you. This is sales, so you record it on the income statement as sales (although it is not cash available to you until the invoice is paid).
- Balance sheet: On the balance sheet the invoice represents an asset due you but not yet received. It is, therefore, an increase in accounts receivable on the asset side. It is also an increase in total assets, not a shifting of assets from one category to

Photographer's finance 101

another, so there has to be a corresponding increase in total liabilities and net worth. No corresponding liability is incurred, so it is an increase in net worth.

❻ Receive payment from the client.
- Income statement: You already recorded as income the money owed you on this job when you invoiced the client for it upon completion of the job. When the client pays you (usually by a check), there is no effect on the income statement.
- Balance sheet: When you receive payment from the client for an invoice that was recorded as an account receivable, there is a shift in assets. The accounts receivable is reduced by the amount received, and cash increases by the amount received.

❼ Pay stylist, photo supplier, and processing lab.
- Income statement: Actual payment of your outstanding liabilities completes the operating cycle for this job. But you already recorded these expenses on the income statement when you received the invoices from the stylist, the photo supplier, and the processing lab. So now, when you actually pay, there is no effect on the income statement.
- Balance sheet: When you pay the outstanding invoices you are handing over an asset (cash) to extinguish a liability (accounts payable). There is a decrease in total assets when you reduce the cash account by the amount of the payment, and there is a corresponding decrease in total liabilities and net worth when you reduce accounts payable (liability) by the amount of the payment.

The operating cycle for this transaction is complete. The total income (sales) and corresponding assets that the transaction generated have all been recorded, and all the expenses and corresponding liabilities created by the generation of the income and assets have been deducted. If you priced the job right, total income exceeded total expenses. You are left with an increase in income on the income statement, and an increase in net worth on the balance sheet.

The operating cycle

The sum of the operating cycles of all your assignments is the core income generator of your photography business. Note that the income generated from operations has to be high enough to meet additional indirect operating expenses that you have during the year (with their associated effects on the balance sheet), such as advertising, occupancy expenses, utilities, etc., as well as nonoperating expenses, such as interest on loans. For the business to be profitable, your profits per job have to be high enough, and you have to get enough jobs per year to exceed these additional expenses. Keep this in mind for pricing and business planning.

The trick to successfully running your photography business is to keep those profitable assignments coming and to juggle the timing of all the financial inflows and outflows smoothly to avoid any bottlenecks where you might not have sufficient cash to keep going. To that end always know

> ➤ your cash on hand

> ➤ your cash expected in the next 30, 60, and 90 days

> ➤ your expenses to be paid immediately

> ➤ your expenses to be paid in the next 30, 60, and 90 days

There is no need for alarm. By now you must be thoroughly freaked out at the thought of having to make all these accounting entries left, right, and sideways every time pieces of an assignment flow through your business. You can relax! You will not be called upon to do such things. All you will be required to do is track cash in and cash out via a checkbook, and place bills and copies of invoices in their proper piles. If you take the sensible route and use a bookkeeping program on a personal computer, entries in the electronic checkbook will automatically trigger all the associated entries throughout your financial records. If you stick with the old-fashioned manual method, for a modest fee a bookkeeper will periodically make the appropriate entries and reconciliations for you on your business ledgers.

Measuring financial performance

There are a handful of simple financial relationships between various components of the income statement and the balance sheet that are useful in periodically measuring financial performance and health. They should be monitored on an ongoing basis (lenders base lending decisions on such analyses). But they should be understood even before the first step is taken to start a business because they provide valuable insight into financial performance. Typically, a small business will find it useful to track the following performance measures:

> ➤ Profitability (income statement)

> ➤ Liquidity (balance sheet, income statement)

> ➤ Leverage (balance sheet)

> ➤ Return on investment (balance sheet)

Let's take a closer look at these measures of performance and examine the ratios for the composite photography business (see the balance sheet, income statement, and associated ratios following).

INCOME STATEMENT

Sales	470,958	100%
Operating Expenses	428,055	91%
Operating Income	42,903	9%
Interest Expense	705	0.1%
Income Tax Expense	9,231	2%
Net Income	32,967	7%

BALANCE SHEET

ASSETS			LIABILITIES		
Current Assets			**Current Liabilities**		
Cash	25,889	18%	Accounts Payable,	13,807	9%
Accounts Receivable	36,821	25%	Trade		
Inventory	6,041	4%	Short-Term Debt	7,336	5%
Other	10,068	7%	Other	21,718	15%
Total Current Assets	78,819	54%	**Total Current Liabilities**	42,861	30%
Long-Term Assets			**Long-Term Debt**	23,157	16%
Net Property and Equipment	48,758	34%	**Total Liabilities**	66,018	46%
			Net Worth	77,812	54%
Other Assets	16,253	11%			
			Total Liabilities and Net Worth		
Total Assets	143,830	100%		143,830	100%

Profitability

Profitability is commonly measured by looking at operating and net income as a percentage of total income (sales). Sure, you need an absolute amount of net profit to survive, but to see how lucrative your business is, you have to see how much operating and net income it is able to generate *as a percentage of total sales*. This measure is often referred to as the profit margin. If, in comparison to industry standards, you are not generating a sufficiently high margin, you are doing something wrong. Maybe you are not charging enough, or maybe your expenses are too high in relation to sales.

✳ Operating margin

The operating margin is the operating income of your business as a percentage of sales. The composite income statement reveals a 9 percent operating margin, which is not bad in comparison to other small businesses.

✳ Net margin

The net margin is net income as a percentage of sales. The composite income statement's net margin is 7 percent. Again, this is a respectable margin, given the nature of the photography business. Any photographer who pays all bills, draws a modest but adequate salary, and manages to realize a net margin of 5 percent is doing all right.

◉ Liquidity

Liquidity is a measure of how much cash is available to the business immediately or in the near future. It is the balance between current resources (current assets) and current obligations (current liabilities).

✳ Current ratio

The current ratio is a comparison of current assets to current liabilities. It is derived by dividing current assets by current liabilities. The general idea is that current assets should exceed current liabilities so that the business is in a position to meet current liabilities at all times. Any value greater than one means that current assets exceed current liabilities; any value less than one means that there are more current liabilities than current assets. This might be a sign of trouble.

Think back to the operating cycle. Current liabilities, such as accounts payable, are reduced during the operating cycle by reducing a current asset, such as by using cash to pay your film supplier. Thus, current assets can be said to *support* current liabilities. To ensure sufficient support, current assets should at least equal, or preferably exceed, current liabilities. The current ratio for the composite photography business is 1.8 (78,819 ÷ 42,861), a reasonable coverage and just about where suppliers, lenders, and other creditors expect to see it.

✳ Days receivable

Receivables are money to come. The rate at which it can be expected to come is therefore of great interest. If you know the amount of

receivables you have on hand (balance sheet) and your total sales for the year (income statement), you can calculate the average number of days it has taken to collect receivables. The results are ballpark and assume that the receivables amount on the balance sheet is an average amount, representative of the receivables amount outstanding throughout the year. The calculation is done in two steps:

❶ sales ÷ accounts receivable = receivables turn

This formula calculates how many times receivables turned over (were paid down and replaced) during the period. For the composite balance sheet the amount is

$$470{,}958 \div 36{,}821 = 12.8$$

Thus, if the receivables amount on the balance sheet is representative of receivables outstanding on any given day of the year, the receivables of the composite company turned over 12.8 times per year. Now you can calculate days receivables.

❷ days in period ÷ receivables turn = days receivables

For the composite balance sheet it was

$$360 \div 12.8 = 28 \text{ days}$$

This means that the composite photography business collected its receivables on average every 28 days. This is under the net 30-days term in which payment is expected, indicating that the clients of the composite company were paying their bills promptly.

Bear in mind that this is an average for the year. It does not mean that all receivables were paid promptly. What this number tells you, and any outsider who might be interested, is that for the year as a whole you were doing all right on collections. Only close daily receivables monitoring will tell you how you are doing day to day.

Note that you can calculate days receivables for sales periods of any length (quarterly calculations are popular). Be sure to use only the sales realized for the number of days for which you are calculating days receivables.

✳ **Days payable**

Days payable are similar to days receivable, except this is a calculation of how quickly on average you pay your bills (your payables). This too is calculated in two steps:

❶ operating expenses ÷ accounts payable = payables turn

This formula tells you how many times payables turned over (were paid down and replaced) during the period. For the composite balance sheet the amount is

$$428,055 \div 13,807 = 31 \text{ times}$$

Thus, if the payables amount on the balance sheet is representative of payables outstanding on any given day of the year, the payables of the composite company turned over 31 times per year. Now you can calculate days payables.

❷ days in period ÷ payables turn = days payables

For the composite company this was

$$360 \div 31 = 11.6 \text{ days}$$

The composite photography business is a very prompt payer indeed, paying its bills on average in 11.6 days. Again, though, keep in mind that this is just an average.

◎ Leverage

Leverage tells us the ratio of liabilities a business has in comparison to its net worth. It is an indication of how much margin for error there is in relying on assets to extinguish liabilities (remember: assets − liabilities = net worth). If, for example, liabilities equal net worth, then you know that there is plenty of room for error in asset valuation to cover liabilities, because if assets were liquidated at only half their indicated value, all liabilities would still be covered. The calculation of the leverage ratio (also referred to as the debt:worth ratio) is

total liabilities ÷ net worth

For the composite photography business this would be

$$66,018 \div 77,812 = 0.8$$

Measuring financial performance

A leverage ratio of 0.8 is outstanding, indicating that net worth exceeds liabilities. This business is worth more than it owes, a sign of great financial strength. Lenders and other creditors love to see a liabilities:net worth ratio of 1 or less, and usually get nervous if it exceeds 1.5 to 2.0.

Return on investment

The owner of any business has invested money in it, and is rightly anxious to know how his or her investment is doing. Return on investment is usually measured by relating income to investment. There are two simple ways to look at it: return on assets and return on net worth (more commonly called return on equity).

✳ Return on assets
Return on assets examines net income for the year in relation to the total assets of the business. It is calculated by expressing annual net income as a percentage of total assets. The idea is to see what level of income the assets of the business were able to generate, and compare the return to returns of similar businesses. The composite photography business had a return on assets of 22.9 percent, a respectable return for most small businesses.

✳ Return on net worth
Return on net worth compares the business's net worth to annual net income. It is calculated by expressing net income for the year as a percentage of net worth. The composite photography business had a return on net worth of 42.4 percent.

That just about sums it up. As you begin to run your business with the requisite attention paid to financial matters, all the financial information presented here will become much easier to sort through and work with. Your newfound financial skills will also be a big help when you prepare your business plan.

By now you must have had your fill of financial analysis, but if your interest in financial affairs has been piqued, you might want to consult *The Guide to Understanding Financial Statements, Second Edition*, by S. B. Costales and Geza Szurovy, McGraw-Hill, 1994.

4

Photographer's
marketing 101

IT is tempting to think that outstanding photographs will sell themselves, but the fact is that without a comprehensive, well-planned marketing effort even the best photographer won't be in business for long. At the same time, an average photographer who is a skilled marketeer can easily do better financially than more-experienced colleagues who do a poor job of promoting and selling their services. Marketing is as crucial to the success of a photography business as good financial management.

For the photographer, marketing is essentially the art of self-promotion. A successful marketing program is made up of many elements and requires the application of a variety of skills and techniques. Assessing the chances of success is a big challenge, because marketing is at the whim of so many fickle human factors. Some fields of photography require subtlety, while others require a not so subtle approach. Marketing costs money; a lot of money. One beginner's mistake is not realizing just how much money a successful marketing campaign can consume, and not budgeting enough to get a credible effort off the ground. Another pitfall is optimistically pouring a great deal of money into the wrong type of campaign and ending up with a devastatingly expensive fizzle.

How to find the fine line in between? Many novice marketeers make the mistake of using their own perceptions and values regarding what potential clients want or should want. They are disappointed when they realize that their own preferences are not generally shared by their clientele. Yet there are well-established marketing principles and techniques derived by the profession from decades of experience catering to clients' demands. Why not minimize the risk of costly marketing mistakes by benefiting from these principles and techniques to develop and implement your marketing program?

The marketing process is really quite simple and doesn't take much more than a good dose of common sense. You have to do market research to establish that a sufficiently large market exists for your product. You have to price your product to be competitive in the marketplace. You have to identify the customers to whom you will market your product. This pool of customers should be sufficiently

Photographer's marketing 101

large to yield a sufficient number of assignments to provide you with a living. You have to devise a variety of innovative marketing approaches to create a flow of client inquiries, and then convert those inquiries into sales. Finally, you have to maintain an ongoing marketing program to ensure a continuing stream of assignments, and develop a core clientele to sustain your business.

Within this framework marketing programs can be broken down into a number of distinct elements:

> Market information

> Pricing

> Direct mailing

> Advertising

> Public relations

> Networking

> Photographers' representatives

Each element of the successful marketing program will be discussed including general strategy, techniques, practices, and skills. I'll also look at the special marketing demands of the various branches of photography, as appropriate. Note that marketing gets potential clients interested. To secure an assignment, you have to sell the idea in person to these interested potential clients. Selling is quite distinct from marketing and is covered in chapter 9.

Market information

Developing solid information about the target market is the first step of every good marketing program. Market information means the market size, sales potential, an assessment of your competition, and information on pricing and market practices. Product development was addressed in an earlier chapter and I will return to it in chapter 6. Bear in mind the chicken and egg argument: What comes first,

the product, or the assessment of market demand for various products? As I've said before, you shouldn't be in this business if you aren't happy doing the work you choose, so define your product first. But what you choose to offer might have to be substantially revised in view of market demographics. Revise if you must, but don't lose sight of your goal of personal satisfaction and end up with just another boring job.

Reference sources

There is a whole industry out there dedicated to providing information on where to get information. It is the reference industry, and its publications are found in your local library's reference section. Dreary as it might sound, time in the reference stacks is well spent, and an excellent starting point for gathering market information.

Reference sources can be used to provide direct information about the photography business. These sources will give you a laundry list of information sources relevant to photographers. One of the most useful reference works is the *Small Business Sourcebook.* One of the chapters on small businesses is the "Photographic Studio." Among the many useful categories included in this chapter are the following:

➢ Startup information

➢ Primary associations

➢ Educational programs

➢ Directories of educational programs

➢ Reference works

➢ Statistical sources

➢ Trade periodicals

➢ Trade shows and conventions

➢ Franchises and business opportunities

Browsing in any of these categories yields further information on where to seek information on your chosen field of photography. Of particular use is the section on Primary Associations. These professional support groups are generally organized by specialization and are excellent sources of information. The guide briefly states the membership profile of each organization, its purpose, and any publications it offers. Among the many listed organizations is Wedding Photographers International, which publishes a quarterly *Marketing and Technical Manual,* and the Photo Marketing Association International, which puts out a variety of marketing publications. Contact the applicable associations for guidance and information. Many of them have in-house publications and materials on marketing that they will be pleased to share or sell.

Other important reference works provide useful information about specific industries or institutions that might be good potential clients for photographers. Among them are various directories of companies by industry, directories of advertising agencies, and magazine and book publishing directories. A particularly useful directory is the *Photographer's Market,* which is a comprehensive listing of major buyers of photography. One drawback of industry references is that they are such vast depositories of information that sometimes it is hard to be selective.

Professional associations

Professional associations are an excellent source of market information. Providing such material is, in fact, a main reason for their existence. The type of information you can typically get from associations includes market size, guidelines on estimated market size required per photographer, professional practices, and marketing guidance. Some associations even provide directories of major buyers of photographs, such as ad agencies and stock houses. Every association has a directory of members, many of whom are willing to network. Many associations also commission market studies, which can be a gold mine of information. Some associations also put on marketing seminars.

Chambers of commerce

The local chamber of commerce in a photographer's territory is a good source of information on potential clients. Many member firms and organizations have photo needs. Chamber activities are an excellent way to gain an introduction and pave the way for assignments without having to resort to "hard sell" tactics. Chambers of commerce sponsor numerous community events that can provide even more leads. Chamber of commerce member directories can also be a good mailing list foundation.

Newspapers

The newspapers serving your community are a surprisingly good source of market information. They are loaded with news items that alert the vigilant photographer to potential assignments. Announcements of new businesses opening in a community might be indicative of photo needs. The arrival of a big new employer in town might prompt people to move to your community, increasing your potential market. Announcements of upcoming conventions, sporting events, or other special events can lead to assignments. The list of businesses advertising regularly in the local paper can be a good source of additions to your mailing list. Reports on economic conditions and trends in your community can give you some indication of whether or not to expect your own business volume to grow.

Photographers

Many photographers are very willing to share market information on their industry and personal experiences, especially if the person approaching them is not going to be in direct competition with them. If you are planning to work in a particular community, contact photographers in nearby communities. Another good idea is to talk to photographers whose careers have moved beyond the stage where you are, and who might be willing to share their experiences with

someone on the way up. Photographers love to attend professional gatherings and seminars, where there is great willingness to share experiences and opinions freely. Eventually these contacts can lead to sound personal friendships and a real network of information.

In retail photography, a good way to get pricing information is to obtain the price lists of area photographers. While it is unethical to pose as a potential customer seeking information, it is perfectly all right to politely ask what they charge. Some might bristle, others might make helpful comments about ballpark figures, and others might give you their whole package of price lists. It is always worth a try.

Pricing

Pricing is a crucially important element of the marketing program. If you price yourself out of the market, your entire marketing effort will be a big flop, no matter how good your work is and how convincing you are. If you price yourself too low, not only are you losing money, but you are also hurting the entire profession by giving clients reason to expect services for prices that are unprofitable. Pricing is a sensitive subject among photographers. On the one hand, nobody is particularly anxious to divulge any perceived or real pricing secrets (in fact, any open discussion of prices among photographers can quickly bring charges of price fixing and is illegal). On the other hand, established photographers are perpetually concerned that inexperienced newcomers will try to compete on price and will end up ruining the market for everyone.

Remember two guiding principles as you set out to price your products. First, you are running a *for profit* business, not a charity. The most important message of this book's financial section is "income minus expenses equals profits." You simply have to charge a sufficient amount of money for your work to make a reasonable profit. Or, as one photographer likes to put it, "If you are interested only in the red, white, and blue ribbons you'll always be a starving artist. To stand a chance of running a successful business, you also have to be interested in the green ribbons."

Second, it doesn't make economic sense to compete on pricing. Why should you charge less than what is being charged for the same work by other photographers? If you can't get work at that price, it most likely means that the market in which you wish to compete is saturated. If, in response to not getting a sufficient amount of work, you undercut the competition's price to get market share you will just end up torpedoing everybody's livelihood. You are better off carefully doing your market demographics analysis and "going rate" homework and establishing yourself in a market that has a sufficiently large pool of potential clients to support you. Generally, try to compete on service and quality of work, not on price.

There are two basic elements to pricing: pricing technique, and the actual amount charged within the framework of the applicable technique. Together they can be thought of as pricing standards. All fields of photography have ballpark pricing standards. In some fields, such as wedding photography, published price lists are the norm. Some buyers, such as textbook publishers or magazines, might provide published rates they are willing to pay based on photo type, size, usage, and other criteria. In other fields, while rates are not necessarily published, the range of generally accepted pricing standards for a particular type of assignment becomes known from experience to photographers active in the field.

You should consider pricing standards a point of departure for setting your own pricing, rather than the gospel to be rigidly followed. You will find that there is often room for departure from the norm. Skillful negotiation and a creative application of pricing techniques might create good opportunities to increase the pricing of particular products and services beyond the ballpark standards.

The concept of selling rights to your photographs

Before I get into how to gather pricing information and how to price your products and services, I have to make a fundamental point that has an important bearing on pricing: What is a photographer actually

selling? To the novice the obvious answer is photographs, but this is not entirely right. As a rule, most photographers sell only the *rights* to their photographs. This means that the client acquires the right to use the photograph only a limited number of times and for a limited time period. You should never sell the copyright to your work, because by doing so, you give up all rights to it (see the chapter on matters of law). Consider these fairly commonly used terms between photographer and client:

> ➤ An advertiser may use an image once, for one particular ad campaign, for the specified period during which the ad campaign runs.

> ➤ A book publisher may use an image in one book, with the understanding that as soon as the book appears, the photographer is free to use the photograph again as he or she sees fit.

> ➤ A couple may purchase a set of prints of their wedding, but the photographer retains the negatives, and if they want additional prints at a later date, they must purchase them from the photographer.

The reason for selling limited rights rather than the original image is simple and important. The photographer has the opportunity to earn additional income from the image. Repeat sales can be a very big source of income, and the photographer who sells the original images instead of limited rights to the images is throwing money away. There can be as many creative ways to define rights as clever photographers and clients can think of. Here are some commonly used definitions:

❋ Exclusive unlimited use

This arrangement is also referred to as a *buyout*. It allows the client to use the images in any way and any number of times, and does not allow the photographer to resell the same image. It does not, however, allow the client to resell it to third parties, which is the main difference between this form of buyout and the outright sale of the copyright.

Figure 4-1

Don't sell exclusive unlimited rights to this image if you want to profit from secondary sales (Taj Mahal, Agra, India).

✳ **Exclusive limited use**

The client may use the image exclusively but for only a limited purpose.

✳ **Nonexclusive unlimited use**

The client may use the photograph for any purpose any number of times, but so may the photographer.

✳ **Nonexclusive limited use**

The client may use the photograph only for a specified purpose, and the photographer may use it any time for any purpose.

✳ **Time and geographic limits on use**

The rights outlined previously can be further controlled by placing time limits and geographic limits on them. Beyond a specified time limit and outside specified geographic limits the photographer is free to make any additional use of the image. A good example is "First North American Rights," an assignment of rights commonly used by magazines. It means that the magazine has exclusive rights to the image in North America, for the issue in which the image is used. Once the issue is out, or at any time outside North America, the

photographer has unlimited use of the image. This ensures that in the magazine's market nobody will see the image until it appears in the magazine (which might be many months after the image is taken), and at the same time it also gives the photographer maximum flexibility in using it.

✳ Rights and the retail photographer

The retail photographer who wants to maximize income on his or her work is able to do so by retaining the negatives of each assignment. If the clients want any additional prints of their wedding, portraits, or special events, they have to buy them from the photographer. This should be spelled out up front in the contract, along with the pricing information for additional future prints. Retail photographers who sell their negatives are unnecessarily foregoing additional income. Receiving the negatives is practically never the deciding factor for clients in the selection of a photographer for their special event.

◉ Pricing practices

Pricing information (industry practices and actual prices) can be fairly easily developed from a variety of sources, depending on the kind of photography you do. One of the best sources are the professional associations for those branches of photography that have them. However, these associations are sensitive to potential charges of price fixing, so they are very careful to point out that they are not providing guidelines, but merely making public the survey information voluntarily provided by their membership. Other good sources of information are reference works, such as the *Photographer's Market,* which quote typical ballpark prices. Following are some observations on specific pricing practices for assignment photography in the advertising, corporate, editorial, and retail fields, as well as a separate section on stock photography.

✳ Advertising photography

Pricing in this branch of photography is the hardest to get a handle on because there is such a large variation in assignment types,

advertising budgets, and the skill levels and creative effort demanded of photographers. The fundamental concept is the day rate plus expenses. However, photographers have recently begun to look for ways to increase their basic day rate based on the type of assignment. The larger the advertising budget, the greater the potential for higher day rates and additional fees.

The advertising budget is a function not only of the firm's financial clout and station in the pecking order of the business world, but also of how large an audience the proposed advertising is expected to reach for how long, how technically demanding the assignment is, what rights are being bought, and other elements. From these factors emerges a range of fees and expenses various firms are willing to pay for various jobs; but it is difficult to generalize, because the permutations are endless. You have to narrow the field to the type of advertising assignments you want to do, and seek comprehensive information on your choice. For example, if you have a chance to shoot for a local catalog and a high-tech firm, research pricing practices for local catalog photography as well as a shoot for a one-time national advertisement of a high-tech product in a trade magazine.

Figure 4-2

A national advertising campaign will pay much more for this image than an editorial user. Sell to both and know your prices (Bora Bora).

The typical well-thought-out pricing scheme for advertising photography consists of several elements:

> ➤ basic daily fee,
> ➤ creative fee,
> ➤ usage fee, and
> ➤ expenses plus margin.

The basic daily fee is the minimum day rate a photographer feels he or she must charge to meet overhead and make a reasonable profit for the day. It can (and should) be more than the photographer's minimum, if established practice is to pay more.

The creative fee is the opportunity to increase the basic rate by convincing the buyer that the photographer's creative talent is worth an additional expense. On many assignments advertising agencies and departments provide the photographer with very specific instructions for image composition (usually developed and managed by a creative director). But there are also a lot of instances when the photographer is given a fair amount of creative discretion, opening the door for a hefty creative fee. The creative fee also provides an opportunity to account for different skill levels on the "what you pay for is what you get" principle.

The usage fee is an opportunity for further price differentiation depending on how the photographs are used. The more they are used the higher the fee. Some photographers quote a dollar rate for usage fees, while others set them as a multiple of the basic fee (for example, exclusive limited use might be set at 1 times the basic fee, while exclusive unlimited use might be 3 times the basic fee).

Expenses plus margin are all the out-of-pocket expenses associated with the shoot, plus a percentage margin added to the cost of any items or specialized services that have to be bought by the photographer, such as film, the services of models and stylists, or prop rentals. Clients often resent the margin, asking for all expenses to be passed on at cost. They should be made to understand,

however, that the margin is simply reasonable compensation for the time and effort you have to exert to obtain the products and services. Travel and food expenses are generally passed on at cost. Following is a partial list of typical billable expenses for a big, multiday advertising photo assignment on location:

- ➤ Film and processing
- ➤ Assistant
- ➤ Stylist
- ➤ Models
- ➤ Wardrobe
- ➤ Props
- ➤ Location scout
- ➤ Location fee
- ➤ Airline tickets or other transportation
- ➤ Hotel
- ➤ Meals
- ➤ Rental vehicles
- ➤ Gasoline
- ➤ Tolls and parking
- ➤ Telephone, fax, courier, and other miscellaneous expenses

For outdoor work it is customary to bill a certain amount for days washed out by the weather. This is only logical, since the delay is not the photographer's fault, and he or she is incurring expenses on those days and should be compensated. The amount should be in line with unavoidable expenses particular to the shoot.

✳ Corporate photography

The pricing practices of corporate photography are very similar to advertising photography. The field is lucrative, though even the best assignments tend to pay somewhat less than well-paid advertising

assignments, because the use of the photographs is more limited and the budgets available for photography are smaller. Corporate photography is generally priced on a daily rate plus expenses basis.

There are especially good opportunities to increase income through creative fees. Contrary to advertising clients, in many instances corporate clients rely on the photographer rather than a separate creative director for the creation of the images (composition, props, conveyance of corporate image, etc.), and they should be willing to pay for it. Usage fees are also an important consideration in some cases, because they can work to the photographer's advantage in reverse. A corporate client might not want to pay an additional usage fee, and might be willing to agree instead to very restricted usage of generic corporate shots (shop floor, trading room, silicon chip production process). This can give the photographer the opportunity for highly profitable secondary sales.

✳ **Editorial photography**

Well-established, well-connected, and lucky photographers do get specific editorial assignments on a fee plus costs basis, but increasingly the industry norm is to pay per photograph and meet photo needs from the stock images of photographers or stock agencies. The tens of thousands of glossy magazines mushrooming in the magazine racks of newsstands everywhere provide a somewhat misleading image of lucrative opportunities for photographers. The great majority of these magazines are highly specialized small-circulation affairs run on shoestring budgets. The prices they pay for photographs are rock bottom, they rely on stock sources, and they seize every opportunity to use free photographs from publicity departments. Typically only the highest circulation consumer magazines dole out regular assignments, and only if their needs for a story are so specific that they can't meet them from stock sources. Even these magazines are on the lookout for ways to cut costs. For example, a glossy travel magazine that in the recent past regularly flew U.S.-based photographers to the Far East on assignment, now relies mostly on the very capable photographers permanently stationed in the region.

Pricing

The editorial assignments given out by major publications are compensated on a *fee plus expenses* basis, which can be horse-traded in the manner of advertising and corporate photography. Shoestring operations on the other hand might specify an all-inclusive sum they can pay for one-time nonexclusive use of a specific photograph (say an assigned cover shot). It is up to the photographer to try to negotiate an increase, take it, or leave it, bearing in mind the *income − expenses = profit* equation.

Lavishly illustrated glossy coffee table books, which seem to be produced regularly in spite of often dubious profitability prospects, acquire photographs both on an assignment basis and on a stock basis. There are two common forms of compensation for these assignments. The photographer receives a one-time flat fee, or is paid royalties on the book. The royalty route is similar to book contracts between authors and publishers. The photographer is paid a royalty per copy sold and is given an advance against future royalties. While some publishers are willing to pay expenses separately, most expect the advance to cover expenses.

Textbook publishing, a mundane sounding field that turns out to be one of the financially more rewarding areas of editorial photography, acquires images almost exclusively from stock sources.

✳ Retail photography

Retail customers expect to see an all-inclusive price for a product. In their world a pound of apples costs w, a jacket costs x, a gallon of gas costs y, and a photograph should cost z. They don't want to hear about creative fees, processing costs, mileage, or any other boring details of the photographer's expenses. "I want an 8-by-10, how much is it?" is all they want to know. The typical retail photographer requires a modest nonrefundable session fee. If the session is outside the photographer's studio (at the client's home, for example), an additional location fee is usually charged. The nonrefundable session fee is an effective hook. Once agreeing to pay it, most people would hate to get nothing in return, so they are highly motivated to place at least some order as the result of a sitting.

Since the session fee doesn't even come close to paying for the photographers' time invested in the job, a substantial margin has to be factored into the prices per photograph to make a profit. This can be trickier than it sounds. You can't place exorbitant prices on individual photographs, but if you spend hours marketing, shooting, and processing a portrait sitting, and in the end all the client wants is one 11-by-14 for grandma's den, you can bet your Nikon that you've lost money. Volume is the key; orders of many prints per session. And there are ways to encourage high volume.

Human psychology is again on the photographer's side. If people take the time and trouble to get decked out for a portrait sitting, they will most likely want a fair number of photographs. When they see good results, they will most likely become even more enthusiastic about getting prints of a number of poses. At the initial discussion the photographer can also subtly suggest planning on a variety of prints to meet different needs.

On bigger assignments, such as weddings or other special occasions, the stakes are considerably higher. Greater time and expenses faced by the photographer call for a more accurate predictability of the eventual order size. There are several ways to increase the predictability of anticipated income from such assignments. One common technique is to set a flat fee per hour (over and above any photographs ordered) and require a minimum dollar order for photographs for every hour the photographer spends covering the event. The fee and the amount of the minimum order per hour of coverage should be set to ensure that you break even. An additional technique to ensure fair compensation for surprise cancellations is to require a nonrefundable payment for up to four hours of the minimum per hour order when the retainer agreement is signed, followed by another significant advance payment two weeks prior to the event.

Some photographers go even further in ensuring income predictability by offering a variety of fixed price packages for weddings and special events. The bottom line is a set number and size of prints per package. The drawback to this approach is that it puts clients in a

mind-set to view the package cost as the limit of their photo expenses, and ends up encouraging them to make do with the package contents instead of ordering additional prints. Requiring only a minimum order is a slightly bigger risk, but in the experience of many photographers it is more lucrative on average than package deals.

Another human characteristic of the retail buyer is a passionate love of specials and discounts. Retail photographers can often increase sales volume by offering special sales, or discounts on volume orders. A favorite hook is a free print of sizable proportions for orders beyond a certain dollar amount. Fixed-price packages are a popular pricing structure for children's portraits and graduation pictures.

Retail photographers require full payment upon completion of an assignment prior to delivery of any photographs. For special events an up-front deposit of at least 50 percent of the estimated gross income is required. Retail customers can be very slow payers, and will on occasion stiff the unwary retail seller. Many photographers learned the hard way to demand payment in full prior to handing over the pictures.

✳ And now for something completely different: stock photography

The pricing practices I have discussed so far all have to do with assignment photography. The pricing of stock photographs is an entirely different matter. Stock photographs are priced by the photograph. The amount paid depends on a whole host of factors. In recent years stock photography has become a major source of photographs in advertising, corporate, and editorial photography. And as users across the board seem to be on a perpetual cost-cutting campaign, stock photographs will capture an ever-increasing segment of the market.

The market has become so flooded with stock photographs that for average images there are fairly well-established price levels beyond which buyers are unwilling to pay. Many photographers bristle at the suggestion that they are at the mercy of the buyers. But the fact is that unless you've succeeded in snapping some royal couple in the

act, you'll have little leverage to demand a substantially higher price than what is being offered. If you don't like the going rate for your Sunset on Bali, the travel magazine will just spend the offered sum on someone else's Sunset on Bali. The point is, if your stock photographs are truly exceptional you *can* negotiate individual deals, but otherwise you have little leverage over the buyer.

The major factors that determine stock photo prices are

➤ What is the price range acceptable to the buyer? An ad agency assembling a well-financed national ad campaign will pay far more for "man and woman embracing in the surf on secluded beach" than a Caribbean villa rental broker putting together a marketing brochure. Will you take $3,000 from the ad agency? Sure you will. Will you take $200 from Villa Vanilla? You better! That's $200 you might as well burn if you leave the photograph in the drawer instead. But here's the bottom line: never, never, NEVER take $200 from the ad agency when the going rate is $3,000. Know your prices!

➤ What is the intended usage? How many people will it reach and for how long? Print advertising and editorial price ranges are defined by the circulation numbers of the medium in which the photograph is used and the size of the photograph in the publication (starting with one-quarter page).

➤ What rights are being sold?

➤ How unusual is the photograph?

Following are some guidelines for distinguishing between uses for the purposes of establishing different prices for stock photographs. Actual figures are not quoted because these change with ebbs and flows in supply and demand and many other economic factors. Get in touch with associations offering advice on stock photography (such as ASMP), stock agencies, and photographers active in stock sales to establish current going rates.

➤ Print advertising and editorial use, magazines

Circulation: 3,000,000+
1,000,000–3,000,000
500,000–1,000,000
250,000–500,000
100,000–250,000
50,000–100,000
20,000–50,000
< 20,000

Printed image size: Cover
Back cover
Full page
¾ page
½ page
¼ page

➤ Print advertising and editorial use, daily newspapers

Circulation: 250,000+
< 250,000

Printed image size: Cover
Back cover
Full page
¾ page
½ page
¼ page

Note: The advertising pay scale is much higher than the editorial pay scale, but both use the same method for distinguishing between circulation and pay size.

➤ Editorial, textbooks and encyclopedias

Print run: 40,000+
< 40,000

Printed image size: Cover
Back cover
Full page
¾ page

½ page
¼ page

➤ Corporate, annual reports

Print run: 500,000+
250,000–500,000
100,000–250,000
50,000–100,000
20,000–50,000
5,000–20,000
< 5,000

Printed image size: Cover
Back cover
Full page
¾ page
½ page
¼ page

➤ Corporate, brochures and other editorial (external and internal)

Print run: 1,000,000+
500,000–1,000,000
100,000–250,000
50,000–100,000
20,000–50,000
5,000–20,000
< 5,000

Printed image size: Cover
Back cover
Full page
¾ page
½ page
¼ page

Pricing

Pricing your products and services

So what to make of this smorgasbord of pricing information? Where do you fit in? It all comes down to a pricing strategy designed to keep you in control of determining how much you are going to get for your work. This is based on your analysis of what your work is worth in comparison to the other work being offered.

On the one hand, there is the economic cost of producing the product, including a reasonable margin for making a profit beyond total expenses. On the other hand is supply and demand in the market, which often has little to do with the economic costs of producing individual images. If the market is already awash with stunning stock images of castles in the air, it will be hard to convince a client to send you on an expensive assignment to shoot yet another stunning image of a castle in the air. Regardless of the value you place on your photography skills, in this example the total sum of such skills on the market has produced a supply of the product that outstrips demand. Therefore, the price the market is willing to pay for the product falls. What is the rational response of the producer (the photographer)? It is to lower the price of his or her product, but *only to the point at which his or her minimum profitability goals are still met.* If the price the market is willing to pay falls below minimum profitability goals the only rational course of action is to exit the market and concentrate on other, more profitable markets. This is an economic reality many photographers simply refuse to understand. "I am an immensely talented photographer of castles in the air, yet the cruel world refuses to fairly compensate me," they say dejectedly as they continue to shoot castle pictures and give them away at prices that will never pay the mortgage. Talent alone is not enough. Demand for that talent has to exceed supply for compensation to approach anything close to what the photographer believes is fair. The only business-minded solution is to work in those market segments of photography where that is the case.

In spite of the many branches of photography, the strategic approach to pricing is quite universal:

➤ Ascertain that a market exists.

➤ Assess the market's size and compensation structure.

➤ Determine your profitability objectives and the cost structure of each product you are offering (including compensation for your time).

➤ Determine the minimum price you have to charge per product (including compensation for your time) to meet your minimum profitability objectives.

➤ Compare your minimum price to the range of prices on the market.

➤ If your minimum price is below the market range, increase your price immediately to market level.

➤ Maximize your price by developing credible arguments to convince buyers that your product's value is at the high end of what the market has to offer.

➤ Do not offer products that do not meet your minimum profitability objectives (shoot castles in the air for your own amusement in your spare time).

Beyond developing an understanding of each product's cost structure and establishing the prices you should charge, there is one more pricing concept you should understand to maximize the prices you do charge: There are no standard prices per job, because each job is unique. "What's your day rate?" a client will ask before revealing any details about the assignment under consideration. "That depends on what you want me to do with my day," is the proper response. What you are really saying is that it depends on the product you are being asked to produce. Your fee for a national advertising campaign will be higher than for a local brochure.

The concept that each job is unique also works in retail photography. Your published prices are only a road map. The total price of a particular assignment depends on where the client wants to go on the map, or where you steer them.

The same goes for stock sales, if you have a super-special image or series of images. There is less room for maneuver if the images are average and the stock supply in the category selected is extensive.

This just about covers the issues you need to know about pricing for marketing purposes. Having established that there is a market with an acceptable pricing structure, the next marketing task is to actually reach specific clients and convince them to give you a chance. The most common ways to reach potential clients are direct mailing, advertising, public relations, and networking.

Direct mailing

Direct mailing has always been one of the best initial points of contact with potential clients. With the advent of personal computers it has developed from a fairly inefficient correspondence effort with relatively few potential clients into a sophisticated marketing tool. It utilizes massive, carefully developed, and regularly updated databases to launch precisely targeted and timed mass mailings, and closely scrutinizes the results. The key success factors of a direct mailing effort are

> ➤ reaching the right audience
> ➤ reaching the appropriate decision makers in the targeted organizations
> ➤ effectively differentiating your promo material from others to convey that you can provide better value for the client's money than the competition
> ➤ diligent, effective, and unceasing follow-up to keep your chances alive

The mailing list is a peculiar animal and its economics need to be understood. Returns from even the most successful mailings are typically low. A 0.5 percent response rate is often considered a good return on an initial list, so a high volume of names is a very important consideration. A 0.5 percent response rate on 5,000

Figure 4-3

Data management is a snap with good database software.

names is only 25 responses. However, one good assignment out of those 25 responses pays for the mailing, and then you are ahead. Experience shows that the subsequent additional return on additional mailings to initial responders is much higher. These responders will in fact form the core of your ongoing profitable client list.

Here's the way to approach the mailing list from the cost-benefit standpoint:

> ➢ Assess what it will cost to acquire the list and produce and mail the promo materials.

> ➢ Assess how many assignments will pay for the mailing to get an idea of the break-even point of the mailing.

> ➢ Set a goal for sales over and above your break-even point to make the mailing worthwhile in terms of profit generation versus time and effort.

Direct mailing

> Do the mailing and monitor the results. Revise your mailing strategy as required for subsequent mailings.

If properly targeted and structured, direct mailing is a steady source of repeat business. If improperly implemented, it can be a disappointingly expensive marketing fiasco, so it is very important to get it right.

Building the mailing list

There are two ways to develop a mailing list. You can buy names, or you can do your own research and compile your own list. Photographers who make serious use of mailing lists rely on both methods. They buy a set of carefully chosen names to start their initial list, and they add potential and actual clients' names as they encounter them.

Mailing lists are available from list brokers and are priced per name (or some variation, such as per 1000 names). Conscientious list brokering has developed into a fine art. Successful brokers maintain vast databases and have developed techniques for making customized lists to meet a particular list buyer's needs and maximize the chances of success. They will provide comprehensive information on their databases and the available selection criteria, and will work with you to customize your own selection criteria.

The selection criteria can be just about anything. There are no hard and fast rules. Ultimately it is up to you and your common sense, tempered by advice from a knowledgeable list broker. A good place to start is to define the ideal client and seek an initial list of names fitting this description. Here is where good market research comes in. If you've done your homework and ascertained that there is a demand for your work within a group of potential clients fitting a particular description, then it stands to reason that the more names you get that fit your description, the greater your chances of getting a response.

There are many ways to set criteria. Some typical base criteria are

> ➤ type of business

> ➤ main products of the business

> ➤ main markets of the business

> ➤ stated photography needs of the business

> ➤ dollar size of the business (annual sales, assets)

> ➤ geographic location of the business

Based on your market survey results, the next step is to define your selection criteria. Say you determined that entrepreneurial medical equipment manufacturers are good buyers of advertising photography that tend to hire photographers directly through their corporate communications department rather than work through an advertising agency. Your selection criteria might read: "all medical equipment manufacturers with sales up to $20 million in the New England states."

Figure 4-4

Company Name	Street Address	City	Zip Code	State	
3M MEDICAL DIVISION - CAMBRIDGE PLANT	23 Bay State Rd	Cambridge	02138	MA	Tony
A-B LASERS INC	4 Craig Rd	Acton	01720	MA	Al
A/D/S/	1 Progress Way	Wilmington	01887	MA	Jim
ABB ENVIRONMENTAL SERVICES INC	107 Audubon Rd Bldg III	Wakefield	01880	MA	Daniel
ABBOTT OMNI-FLOW	200 Bullfinch Dr	Andover	01810	MA	Roger
ABIOMED CORP	33 Cherry Hill Dr	Danvers	01923	MA	Robert
ABRASIVE INDUSTRIES INC BAY STATE ABRASIVES DIV	12 Union St	Westborough	01581	MA	Stephe
ACCELERATED SYSTEMS INC	130 Sylvan St Ste 4	Danvers	01923	MA	Joan
ACCUMET ENGINEERING CORP	518 Main St	Hudson	01749	MA	Raymo
ACKNOWLEDGE INC	251 W. Central St	Natick	01760	MA	Elizabe
ACOUSTIC RESEARCH	330 Turnpike	Canton	02021	MA	Mark
ACR ELECTRONICS INC	17 Joyce St	Lynn	01902	MA	Joe
ADCOLE CORP	669 Forest St	Marlborough	01752	MA	Brooks
ADCOUR INC	18 Billings St	Sharon	02067	MA	Wendy
ADVANCE REPRODUCTIONS CORP	100 Flagship Dr	N Andover	01845	MA	Stephe
ADVANCED COMPOSITES LABORATORIES INC	224 Calvary St	Waltham	02154	MA	Joseph
ADVANCED INTERACTIVE SYSTEMS INC	1377 Main St	Waltham	02154	MA	Amy
ADVANCED INTERCONNECT INC	670 Douglas Street	Uxbridge	01569	MA	Roland
ADVANCED MAGNETICS INC	61 Mooney St	Cambridge	02138	MA	Lee
ADVANCED RESEARCH DEVELOPMENT INC	359 R Main St	Athol	01331	MA	Ted
ADVANCED SURFACE TECHNOLOGY INC	9 Linnell Cir	Billerica	01821	MA	David
AERODYNE PRODUCTS CORP	76 Treble Cove Rd	N Billerica	01862	MA	Stephe
AEROSPACE SYSTEMS INC	121 Middlesex Turnpike	Burlington	01803	MA	Ken
AEROVOX INC	370 Faunce Corner Rd	N Dartmouth	02747	MA	Bernar
AFP TRANSFORMERS INC ISOREG DIVISION	234 Taylor Av POB 486	Littleton	01460	MA	Myszk.
AGFA CORP	200 Ballardvale St	Wilmington	01887	MA	Richar

A typical purchased mailing list entered on the photographer's database

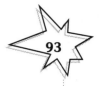

Direct mailing

It used to be that a list you bought consisted of a set of address labels you slapped on your outgoing material, and that was it. Today you should get a lot more demographic information on each name, and the list should be in database format on a disk ready to be put into your computer's database program. This allows you to use the list in many ways, customizing your mailings by whatever subcategories are appropriate, and enabling you to perform mail merge functions to customize the cover letter and other material in each package. In essence, you should be buying a database not just a list of address labels.

One of the most important considerations in buying a list is ascertaining whether it includes the names of all the buyers of photographs within the listed organizations. A list that doesn't include photo buyers is practically useless, because it is very unlikely that the recipient will take the trouble to forward your unsolicited mailing to the buyer.

There might be restrictions on how many times you are allowed to use a particular set of names. This is a reasonable practice, similar in concept to the restricted use of photographs. To control unlimited use, list brokers lace their lists with addresses that claim to be companies, but are in fact brokers, immediately alerting them to unauthorized additional use of a particular list. Some list brokers get around restrictions and the potential hassles of unauthorized use by offering reasonably priced periodic updates to initial lists.

All responses to your mailing list should be identified in your database. As you come across potential clients they should be added to your database. During slow periods you should spend some time actively identifying and adding potential clients to your database. Be sure to include the names of all photo buyers within the organizations you add.

What do you send out?

Mass mailings are unsolicited mail; therefore, the recipient's temptation to toss it in the wastebasket is great. Now's the time to let

your photographs sell themselves, to have them distinguish you from the herd. The centerpiece of all mailings should be a taste of your portfolio. The photographs should be stunning, your best work, and they should be representative of the typical needs of the recipients. Beautiful photos tend to be kept by anyone receiving them, and photo buyers will retain them and remember them even if they don't have a specific need.

The centerpiece of your package should be some striking collage of your best work. Postcard-size prints have also become very popular for main mailing packages, as well as for follow-up mailings. They are relatively inexpensive to produce and can be mailed directly as postcards in addition to being the centerpiece of a package. Most photographers have a series of cards made up in a related format for maximum flexibility. They include several cards in each package mailing, and might periodically mail individual follow-up cards between package mailing cycles.

A personalized cover letter on eye-catching stationery should briefly convey the following information:

➤ Who you are

➤ Why you are different from other photographers

➤ What you can do for the recipient

➤ How your experience (past jobs, awards, professional training, exhibits) proves that you can deliver what you promise

The more specific you are, the more chance you will have of being noticed. Highlight areas of specific expertise and accomplishments to bolster your pitch.

◉ Make it easy to respond

A key element of any mailing is arranging for the recipient to respond. This is typically accomplished by a well-designed response card. Two tricks, founded in human behavioral traits, will practically

Direct mailing

guarantee a response. Being naturally lazy, people prefer not to do things they don't have to unless it is effortlessly easy. Being naturally reluctant to spend money without a benefit to themselves, people will ignore anything that requires any payment without benefit, however small.

Design the response card to require a brief series of multiple choice responses, selected by placing an X in the appropriate box, and include return postage on the card. If the recipient can slap a few X's on a card and just toss it into the outgoing mail, you'll get a response, and more often than you might expect it will be a good one (provided that your promo photographs are good).

Figure 4-5

Martin Berinstein
Photographer

☑ Yes, I would like to see more of your work. The best day to reach me is: TUESDAY at: 10 a.m. or _____ p.m.

Name: JOE JOHNS
Title: CREATIVE DIRECTOR
Company: ABC ADVERTISING
Street: 16 SPRING ST
City: BEAVERTON State: UT Zip Code: 62918
Telephone: 941 762 2900 Fax: 941 555 555

☐ The person in charge of corporate communications is:

Name: _____
Title: _____
Company: _____
Street: _____
City: _____ State: _____ Zip Code: _____
Telephone: _____ Fax: _____

617 261-4777 Fax 617 261-4774

An easy-to-use response card is an essential element of a direct mail package.

Photographer's marketing 101

Follow-up techniques

A direct mailing effort is unlikely to be effective if it is just a single mailing. The initial mailing should be followed up by additional periodic package mailings, as well as smaller postcard "reminder" mailings in between to keep your name alive.

Responses to your mailings should be answered promptly and professionally. Upon receiving a response, you transition from marketing to selling. It is now your job to convert the contact into a sale—an assignment. Responses should also be immediately tagged on the database and subjected to periodic detailed additional mailings.

Evaluating mailing list performance

There are several things you can do to assess how well your mailing list is working. The most obvious evaluation is relating the number of responses you get to the number of names on the list. As I said before, a 0.5 percent response rate on an initial mailing is a good return. On 5000 names that is 25 opportunities to convert new contacts into assignments. Evaluate the profitability of a mailing program by seeing how much it is costing you per name to do the mailings and how much sales and profit per name is being generated. Scrutinize the respondents' demographic characteristics and adjust your name selection criteria accordingly.

Revising and expanding the database

It is important to keep your list current to ensure its ongoing effectiveness. Cull names off the list that haven't responded to an entire mailing program. Acquire new names (using revised selection criteria if necessary, based on the initial list's yield) and add them to the names you've retained as core prospects and customers.

Direct mailing

Retail photographers' mailing lists

Contrary to what some photographers might think, mailing lists are just as important for retail photographers as they are for advertising, commercial, and editorial photographers. The retail photographer's most important mailing list is a list of previous customers, which should be kept up to date and expanded religiously. It is an excellent source of repeat business, if the promotional material has attractive, specific, and time-limited special offers. Your customers already know your work, so there is no need to produce expensive four-color mailers, only tastefully designed notices of special offers.

Retail photographers can also benefit from buying lists. There is a lot of demographic information available on the communities in which retail photographers work, and lists derived from carefully tailored criteria can yield good results. For example, "all households with annual income over $75,000 and one or more children in the family under 18" might lead to a lot of portrait sittings just before Christmas. Or a mailing list of all graduating seniors can aid a "graduate portrait special" marketing program.

Advertising

There are two forms of advertising commonly used by photographers: display advertising and simple listings. Both can be arranged in a wide choice of media, but to be effective, either format has to meet certain objectives:

➤ It has to be in a medium targeted at users actively in the market for photographers, in a geographic area suitable to the photographer (this requirement narrows the field very considerably).

➤ It has to distinguish the photographer from the hundreds of other photographers trying to achieve the same goal.

➢ It has to cost an amount the photographer can afford to lose if the ad fizzles.

➢ It has to be monitored carefully for returns and modified or discarded if the cost exceeds the benefit.

Display advertising

Display advertising can be very expensive and the outcome can be far from certain, so it should be treated with great caution. Unless you can ascertain (independently of the ad marketeers' glowing claims) that a good portion of the readers of a particular publication are looking at it with an interest in hiring the services of a photographer, the returns are likely to be very disappointing in general interest publications. The trick is to find the appropriate specialty publications.

For advertising photographers, corporate photographers, and editorial photographers the best medium, promising great chances of success, are display ads in the various annual photography directories specifically aimed at photo buyers. These ads are expensive and the publishers should give you detailed information on circulation and the audience. Also check out how well regarded the directory is by its users and the advertised photographers. Call them for a reference; don't be shy.

The display ad you place in a directory should represent your best work, tailored to the audience, much in the manner of your direct mailing materials. In addition to getting a call for an assignment, it is not unusual to get a request to purchase the photographs used in your directory display ad. A photographer I know who has been using one particularly striking photograph for years, regularly sells the photograph several times a year for sums far in excess of the cost of the ad, in addition to generating a steady flow of assignments.

Retail photographers can also benefit from display advertising, but will get good results only in media that is targeted specifically at

people looking for photographers and that manages to convey a sense of specialization in the service being offered. Few people will look in the yellow pages for a wedding photographer (ad marketeers' claims notwithstanding). But many people will respond to a wedding photographer's display ad in a locally targeted and freely distributed specialty catalog of comprehensive wedding services, such as *Bride's Day.*

Carefully timed ads by retail photographers in the local paper offering special deals for a limited time might also work. That, however, is casting the net widely at an unpredictable audience and should be very closely monitored for success.

Figure 4-6

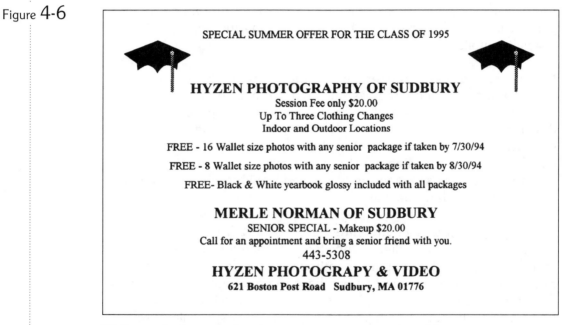

Well-timed ads in the local paper can generate a lot of business.

Listings in directories

Listings in directories are the proverbial laundry list of business names, addresses, phone and fax numbers, and perhaps areas of specialization. While not particularly effective as a main source of advertising, listings are so inexpensive that it would be foolish for a photographer to ignore them. Most professional photographers' associations publish directories of their members, and the cost of being listed is included in the annual membership fee.

There are ways to distinguish yourself even in the bland world of listings. A trade name beginning with one of the first few letters of the alphabet will get you near the top of the list (Arnold Studio). A trade name carefully chosen to indicate specialization can help (Arnold's Pet Portraits). For a small extra fee most directories will list you in bold type; an effective way to catch a roaming eye. Some directories also allow a listing of specializations that can be used cleverly.

One directory listing that is a must for retail photographers is the yellow pages. While display ads in the yellow pages don't seem to add much, a simple listing is taken out by practically all photographers, and it is worth the small expense if for no other reason than to cover all of your bases.

Public relations

Public relations is soft advertising. Its goal is to maximize an organization's positive exposure to the public by publicizing the organization's activities, accomplishments, and services to the community. Public relations conjures up expensive campaigns by professional promoters, but for the photographer willing to self-promote, public relations will amount to a healthy dose of free advertising.

The trick is to identify or deliberately create any newsworthy item in the photographer's life that can be linked to his or her photography and place it in as many publications and other media outlets as possible. The main vehicle for public relations information dissemination is the press release. It is a timely and concise announcement of a newsworthy item followed by a summary background paragraph on the photographer. It is issued on business stationery and sent or faxed to local, regional, and national newspapers and magazines. Press releases are unsolicited and are used at the recipient's discretion. More often than many photographers think, even marginally important items are used because publications are always on the lookout for interesting filler material.

Typical newsworthy events that can be used for public relations purposes include

> Opening a new photography business

> Expanding a photography business

> Relocating a photography business

> Receiving an award

> Speaking at a meeting

> Teaching a course or program

> Participating in an exhibition

> Providing community charity work

> Receiving a professional qualification

When sending press releases to publications that carry photographs, it is always a good idea to include an 8-by-10 glossy of yourself.

Other successful public relations tactics are to provide advance notice of upcoming events and convince news reporters and journalists to write news items or feature stories on them. Another good option is to convince magazines to profile you and your work. The possibilities are as endless as your imagination.

 # Networking

One of the most effective marketing tools is networking. Some people are natural gadflies and there is nothing any book can teach them that they don't already know about chatting up the right people, pumping them for information with discreet charm, and following up every lead. But most of us don't find it easy to network. We feel we are forcing ourselves upon our potential sources of information. This attitude is wrong for the simple reason that our sources of information also want information from us! It is a two-way street; a deal, fair and square.

The best results from networking are obtained if you can create the impression that you can be of some help or service in return. The exchange doesn't have to be simultaneous. It is enough for the people giving you information to know that they can call you at some point when they need something and you'll do your best to help. Information can also be bought. "Let me buy you lunch, there are a few things I'd like your opinion on," often yields results.

Similar to public relations opportunities, networking opportunities can be made use of as they present themselves during the normal course of business or can be deliberately created. Here are some favorite examples and techniques:

➢ Ask a client or potential client about other potential clients or market information. Never forget to do this during client contact.

➢ Attend photographers' seminars, talks, or other events.

➢ Attend a client's events or conventions and discreetly introduce yourself as the client's photographer (this needs the client's cooperation).

➢ Belong to the same business, social, and civic organizations to which your clients or potential clients belong.

➤ Periodically call your clients or potential clients (once you have established a rapport) explicitly to network, not to flog an assignment. You have to have something specific to start with ("Will you guys be affected by what happened at . . ."), and then you can steer the conversation onto the related items of interest to you.

➤ Benefit from the natural development of close personal friendships with other photographers, photo buyers, and editors.

➤ Periodically hold an open house in your studio for your network.

➤ Never be shy about promoting yourself. Be ready at all times with a well-rehearsed, concise story of who you are, what you do, and how you can be of help.

➤ Always, always exchange business cards with new contacts.

➤ Always, always follow up leads promptly and go to great lengths to keep them alive.

➤ Party, party, party (with the right people)!

Again, the list of techniques is limited only by your imagination. If you have a really hard time networking, make it a personal goal to place one networking call per day, and stick to it. You'll soon get the hang of it. Some photographers have the opposite problem. They get so into networking that they have practically no time left to work.

Photographers' representatives

Many photographers are strongly of the opinion that they are photographers, not marketeers, and the best solution to their marketing needs is to have someone else do the marketing. These photographers are prime candidates for the services of photographers' representatives, or agents. A most promising concept in theory, working with a photographer's rep can be highly successful or it can be a failure. Reps are expensive, typically pocketing between 25 and 30 percent of the photographer's fee (the good ones

earn every penny of it). Because of the expense, assignments have to be quite lucrative for a photographer to be able to afford a rep. For this reason most reps tend to work in photography's most lucrative field, advertising photography.

The problem with getting a good rep is that well-established, successful reps generally take on only well-established, successful photographers. These reps need to be solidly convinced that you are worthy of being their client. Selling yourself to a good rep is often harder than selling yourself to a potential client. Be prepared for portfolio presentations and an examination of your business records and practices with a magnifying glass. Reps who readily accept less experienced photographers might be quite inexperienced themselves, and the sales results might be less than satisfactory.

Under any scenario, the relationship between the rep and the photographer has to be a professional one. The rep needs to have assurance that the photographer can deliver, and the photographer needs to know that the arrangement can be terminated if sales aren't materializing at a sufficient rate. For these reasons, any relationship between rep and photographer should be covered by a contract. The terms of the contract can be anything the two parties decide upon, but there are some elements typically included:

➤ The representation is defined in great detail. Typically a rep gets exclusive rights to clearly defined products within a clearly defined territory.

➤ The rep gets a percentage of the photographer's fee, exclusive of billed expenses.

➤ The rep gets a percentage of income from any additional sales of a photograph sold by the rep.

➤ After the agreement is signed, the rep gets income on any subsequent job done by the photographer for a client initially brought in by the rep. This clause covers the scenario where the photographer receives another job as a consequence of the rep's sales efforts on a prior job.

➤ The photographer retains exclusive rights to photographs of the genre covered by the agreement that were taken prior to the agreement with the rep and will not be marketed by the rep.

➤ The rep is responsible for the expenses of marketing the photographer's work with some exceptions: the photographer is responsible for portfolio expenses, and advertising expenses might be shared by the photographer and the rep.

➤ The agreement can be terminated by the rep or the photographer unilaterally on 30 day's notice.

➤ After termination of the agreement, the rep has rights to a commission on business generated under the agreement for a specified time period.

Networking is the best way to get to know reps. Many are also listed in photography services directories, such as the *Photographer's Market.*

Photographer's marketing 101

Matters of law
and liability insurance

ANY form of business implies an exchange of obligations between two or more parties that need to be spelled out to clearly establish what is being agreed to and what the remedies are in case of any loss or dispute. In addition, during its normal course of activities a business might cause physical loss or mental harm to other parties for which it can be held liable, even if there is no agreement of any sort with the injured party. It is the job of the legal system to create and maintain a structure within which business transactions are conducted and disputes resolved. Every business has to function within this structure, especially within a segment of it that can be loosely referred to as business law. Understanding the basic legal issues confronting the photographer and making the right legal choices is crucial to establishing and running a photography business. Failure to do so might leave a photographer vulnerable not only to a significant loss of business income, but also to serious personal financial loss.

In this chapter I will cover those aspects of law that are of greatest concern to the photographer:

➤ Legal form of the business

➤ Copyrights

➤ Contracts and agreements

➤ Model and property releases

➤ Liability insurance

Legal form of the business

A big legal question for any start-up business is the form of legal existence under which it is to be established. Simply put, the choice is whether or not to incorporate. An unincorporated business, which can be a sole proprietorship or a partnership, is not a legal entity of its own, separate from the principals. The principals (the sole proprietor or the partners) are therefore *personally liable for any liabilities of the business up to the full extent of their personal as*

well as business assets. For business owners with a lot of personal assets, the unincorporated business can pose a grave financial risk.

The alternative is legally establishing the business as a corporation. A key feature of the corporation is that it is a legal entity in its own right. Liability claims against it do not reach beyond it to its owners' personal assets. The incorporated business is legally responsible for its liabilities only to the extent of its corporate assets. The incorporation of a business shields the owners' personal assets from any liability created by the corporation. The owner of an incorporated business can be sued personally (and, therefore, put personal assets at risk) only if he can be shown to have been personally negligent or fraudulent in causing the liability.

Let's take a closer look at the various forms of legal existence.

Sole proprietorship

The sole proprietorship is owned by one owner. It is not an independent legal entity and therefore cannot be taxed. Instead, all income flows through to the owner as personal income and is taxed as such. A sole proprietorship is very easy and inexpensive to form. Usually all that is required is the filing of a simple form registering your trade name ("doing business as," or d.b.a.) and payment of a modest fee at the local town hall. The drawback to the sole proprietorship is the aforementioned vulnerability of your personal assets to lawsuits.

Partnership

The partnership is the typical unincorporated form of legal existence for two or more co-owners of a business. Most photographers tend to be individualistic and prefer to work alone, but under certain circumstances (such as spouses sharing a business) it might make sense to form a partnership. The major difference between forming a partnership and a sole proprietorship is that while not a legal

requirement, any good partnership should be governed by a partnership agreement that spells out in great detail the division of ownership, responsibilities, income, and conflict resolution. A partnership without a good written agreement is asking for trouble. As is the case with the sole proprietorship, the partnership cannot be taxed; the partners' personal share of the partnership income is taxed as personal income. The partners' personal assets are also vulnerable in lawsuits against the partnership. Bear in mind that each partner is personally responsible not only for his own actions, but also for the actions of all the partners.

Corporation

The corporation is an independent legal entity. Its income is, therefore, taxed directly. The corporation's owners own shares in it, and its actions are governed by its bylaws. The corporation limits its owners' liabilities to the value of their share in the corporation, shielding the owners' personal assets from liabilities created by the business. Creation of a corporation is more complex and expensive than an unincorporated business. To form a corporation, a corporate name has to be researched (to establish that it is not already being used) and reserved, bylaws have to be written, a board of directors appointed, corporate officers designated, capital paid in, and share certificates issued. All this is formally approved at an initial board of directors meeting, at which a resolution is passed to approve the formation of the corporation (represented by the articles of incorporation and governed by the bylaws). The resolution, the articles of incorporation, and information on ownership, corporate officers, capitalization, and a host of other details have to be filed at the state level, and a hefty fee paid. The corporation has to file its own annual state and federal income tax statements. In many states a minimum annual state tax has to be paid regardless of income, as well as an annual filing fee.

The actual formation and maintenance of a corporation is less onerous than it sounds because lawyers and accountants have gotten it down to an expeditious cookie-cutter exercise. But their initial fee

Matters of law and liability insurance

can easily run to a couple of thousand dollars, and the annual filings and fees can also add up. However, for people with substantial personal assets to shield, this might be a small price to pay.

Subchapter S corporation

An alternative to the regular corporation is the subchapter S corporation, devised to aid small businesses and motivated by the difference in personal and corporate income tax rates. The subchapter S corporation provides all the benefits of a regular corporation, but allows corporate income to be taxed at the personal rate; an attractive proposition, since personal rates are lower than corporate rates. The subchapter S corporation cannot have more than 35 employees, and there are other restrictions.

The bottom line for establishing the legal structure of your business is to be aware of all the options and consult a lawyer or qualified accountant to advise you on what is best for you given your personal circumstances. Ask established photographers in your area for the names of lawyers and accountants who are used to dealing with photographers.

Copyrights

The copyright of a photograph establishes the photographer's ownership of his creation. Copyright protection is the photographer's assurance that his work will be protected from unauthorized use. Should unauthorized use occur, as it sometimes does, the copyright enables the photographer to claim compensation. Under the most recent copyright law, the Copyright Act of 1976, the photographer automatically owns the copyright to a work from the moment of creation. Since 1 March 1989 it is also no longer necessary to place a notice of copyright (©1994, Geza Szurovy) on photographs taken as of that date or since to retain the copyright. Things couldn't be simpler, could they? Well, in spite of the law's straightforward nature, it is still strongly advisable to

include a copyright notice on all photographs to allay any possible doubt about who owns it, and there is still a big advantage to registering your best work with the U.S. Copyright Office of the Library of Congress.

Copyright registration

It used to be that before you could bring legal action for a copyright infringement you had to register the copyright with the U.S. Copyright Office. This is no longer the case. However, there continues to be a tremendous benefit to registering: it is only on registered works that you are eligible to recover attorney's fees, as well as to receive up to $100,000 in statutory damages per infringement. Registration greatly strengthens your hand. Copyright infringers know that paying for an attorney out of your own pocket to prosecute them might be a prohibitive expense for you, but if they face the possibility of having to pay your attorney's fees because your work is registered, as well as hefty damages, they might think twice.

Registration is simple. It consists of filling out a registration form and sending it in with copies of the photograph and a $20 fee. But to be effective in case of an infringement, it has to be done within certain time limitations:

> ➤ An unpublished work has to be registered before the infringement occurs.

> ➤ A published work has to be registered within three months of its first publication.

There is only one wrinkle of which you should be aware: the definition of *published*. For copyright purposes, any photograph offered for publication (submitted for consideration for onward distribution) is considered published. The minute you send in a batch of photographs from which one or two will be selected to illustrate a magazine article, or the minute you mail in a set of photographs to a stock agency for consideration, they are considered published.

Some photographers might consider $20 per image another wrinkle, but fortunately simultaneous multiple registrations under one $20 fee are permitted. In the definition of multiple registration there is, again, a distinction between published and unpublished photographs. The criteria for registering published work makes it quite impractical to register large numbers of photographs simultaneously: the published photographs must have all been published as a contribution to a collective work within 12 months, and copies of the applicable collective work must also be submitted. Unpublished work, however, can be registered collectively with no restrictions. Thus, it is advisable for photographers concerned with copyright infringement to simultaneously register massive numbers of photographs prior to submission for use (that is, unpublished photographs). Individual copies, contact sheets, and even video recordings of images (one video can hold several thousand still images) are all acceptable.

With all these safeguards on copyright there is only one way for a photographer to give up the copyright to a work: by agreeing to do the work on a *work made for hire* basis, and this is to be avoided like the plague.

Avoid work made for hire

An agreement to perform work made for hire confers the copyright to the client for whom the work was done. The photographer loses all rights to the work, including secondary use, any further compensation, receiving credit—everything. It is like selling a car.

Photographers who are full-time employees of a company (with all benefits) are usually employed on a work made for hire basis, as are photographers employed by the government. But for any photographer running his own business, work made for hire is a sure way to throw away additional income. In fact, the self-employed photographer's standard contract should include a clause that explicitly states that the assignment is not work made for hire.

Note that photographers shooting for the personal use of individuals in the retail market will have much less worry about copyright infringement than photographers serving the advertising, corporate, and editorial markets.

Contracts and agreements

It is good business practice to document every deal with some form of contract, and photo assignments are no exception. A contract does not have to be complicated legal mumbo jumbo. It should be in plain English, it should be to the point, and it should cover the major issues relevant to a particular assignment. Organizations like the American Society of Media Photographers (ASMP) have sample contracts available for their members that can be used as models. The standard form can be modified as required depending on the assignment.

The word *contract* can sound intimidating, and it is rarely necessary to use the term. In many situations clients usually ask for estimates or bids (a bid is an estimate competing with other bids). This can be handled most expeditiously by providing them with a pro forma contract, which becomes final if the client accepts it by signing and returning it. Any points that the client wants to negotiate can be incorporated before the contract is finalized. Depending on the client's sophistication and internal procedures, the returned contract might or might not be accompanied by a purchase order.

Advertising, corporate, and editorial assignment contracts

While the actual terms and conditions will differ from assignment to assignment and market to market, the framework of each contract is sufficiently similar to allow for standard language and should cover the following issues:

Matters of law and liability insurance

➤ Assignment. Describe precisely what the assignment is and the amount of time it is expected to take.

➤ Fees and expenses. List in great detail all the fees and expenses to be charged for the assignment: creative fee, daily rate, optional usage fees, pre- and postshooting fees, and every conceivable expense (see the pricing section in chapter 4 for details). Total the fees and estimated expenses for the client's convenience. State that all expenses are estimates and what your procedures are in case they need to be exceeded. Include a fee schedule for additional optional uses of the photographs.

➤ Ownership of the photographs. State your standard policy on photograph ownership, which should be that you retain the copyright. This is the place to state that the assignment is not work made for hire.

➤ Reproduction rights. State very specifically what usage is authorized and for what term. Also state that no third-party usage is authorized.

➤ Assignment changes. Spell out what happens if the client changes the assignment (usually they get billed extra) or if your work does not measure up to the specified expectations (you usually reshoot for expenses only).

➤ Advance and payment terms. Specify the advance required to start the job and the payment schedule for the balance due (enclose an invoice for the advance).

➤ Rescheduling. State what happens if the job needs to be rescheduled. Usually a rescheduling penalty is specified, including any incurred expenses.

➤ Cancellations. Specify the cancellation fee. It is usually expressed as a percentage of the fee for the assignment plus all the expenses already incurred. The closer to the shoot date the cancellation is, the higher the penalty, reaching 100 percent of the fee for last minute (usually 72 hours or less prior to the start date) cancellations. You need not make up an elaborate scale: 50 percent by a certain time, reaching as

much as 100 percent for a last-minute cancellation is usually sufficient.

➤ Indemnity of the photographer. A clause should indemnify (hold harmless) the photographer from any liability created by the client's use of the photographs, since it is the client's responsibility as user to ensure that no liability is incurred.

Stock photo contracts

With the exception of the clauses covering the shoot, stock photo contracts between a photographer and the user cover the same issues as assignment contracts: fees, use, ownership, and indemnity.

The contract between a photographer and the stock agency representing the photographer addresses similar issues in somewhat different form, given the long-term relationship between the two. Typically the terms and duration of the representation are addressed, as are the setting of fees and the agency's commission, reproduction rights, ownership, compensation for damage to the submissions, and indemnity. Many stock agencies will supply their standard contract on request.

Retail contracts

Contracts are also useful to retail photographers, especially on large jobs such as weddings, christenings, bar mitzvahs, and other special events. The typical terms spelled out include

➤ Fees. This can be either a minimum hourly fee in addition to prints ordered or it can be a set fee for a chosen package. This can also include payment terms.

➤ Deposits. This is how much is required by when. Usually it is quite substantial in order to discourage cancellation. The deposit is nonrefundable if the assignment is canceled within a specified time before the event date (see Cancellation).

Matters of law and liability insurance

➤ Negatives. The photographer retains all negatives.

➤ Liability. If the shoot is canceled due to no fault of either the photographer or client, the photographer is liable to return the deposit.

➤ Exclusivity. The photographer is hired to cover an event on an exclusive basis.

➤ Late payment charge. Specify prevailing monthly late charges (a percentage of the amount due) on overdue balances.

➤ Previews. Previews are finished quality photographs and clients need to understand that they are the photographer's property on loan for the purpose of selecting prints. To encourage their safe return, the contract should state that if they are not returned within 30 days, payment for them at the standard rate is due.

➤ Cancellation. If the assignment is canceled after a specified cut-off date prior to the event, the photographer keeps the deposit.

For lesser jobs such as portrait sittings there is no need to actually sign a contract. It is sufficient to provide clients with a list of detailed and clearly stated terms and conditions and a price sheet. It is important to have these clients sign receipts for previews that state that if they are not returned in original condition within 30 days, payment is due for them.

Delivery memos

Delivery memos are an important document for advertising, corporate, and editorial photographers, providing protection against loss, damage, and the misuse of submitted original photographs. Delivery memos identify each photograph submitted and include the following clauses:

➤ The holding fee to be paid after a specified time (to encourage timely return).

➤ The terms of use. In response to stock requests photos are usually submitted only for review and the terms of use are negotiated after selection.

➤ Reimbursement for loss or damage.

➤ Indemnity of the photographer from any consequences of the client's use of the photographs.

Model and property releases

Model and property releases protect the photographer from any claims of unauthorized use of a photograph of a person or property. A frequently asked question is, "When is a release required?" It is perhaps easier to state when one is not required. If the photograph is used to inform the general public of a matter of public interest (essentially information serving "the public's right to know," however loosely that might be defined), a release is not required. If the photograph is used for any commercial, promotional purpose (including nonprofit use), a release is required. It sounds quite simple, and many cases are clear cut, but there is also tremendous room for different interpretations and potential litigation. Some examples will help.

Is a release required if a person is a bystander in a photograph of a public official visiting a museum, and the photograph is used in a people-in-the-news column? No, because the photo is clearly being used to inform the public of the public activities of an official.

Is a release required if, while waiting for the action to begin, the same photographer who shot the official in the museum snaps a few shots of clearly identifiable people admiring an exhibit, using them in a how-to book illustrating the techniques of livening up museum shots? Yes, a release is required, because the photograph is clearly used for a commercial purpose. It is being sold to individuals willing to pay for information on how to take photographs in museums.

Is a model release required if a person is photographed and clearly identifiable playing golf on a private golf course, and the photograph

Matters of law and liability insurance

is used in an editorial article in a travel magazine about golf resorts? Here is where things get murky. The travel magazine will claim that its editorial piece was serving the public's right to know about the golfing opportunities. The golfer's attorney will argue that the travel magazine is nothing more than an advertising vehicle for the travel industry, existing solely for the purpose of selling more vacations and magazines, in spite of lofty claims by its publishers of editorial freedom and public service; therefore, the golfer is entitled to be paid for playing a part in this act of commerce. The attorney might also want to know if the golf course gave the photographer permission to take photos, if it advertises in the publication, and if it paid for the photographer's lodging and transportation. To avoid potential hassles the best policy is to get a model release when any use other than straight news reporting is envisioned.

Property releases are also important, because owners of any property (cars, real estate, antiques, etc.) are entitled to fair compensation for the commercial use of images of their property. Again, if the use is commercial rather than public information, get a property release. (See Appendix A for samples.)

Model and property release forms

What should release forms contain? The objective is to get a blanket release, essentially getting the model or property owner to surrender all rights to any control over usage. Some might be reluctant to sign such a blanket release, in which case a detailed specification of usage should be included. Note that minors cannot provide releases on their own signature. The signature of a parent or guardian must be obtained to make a minor's release legally valid.

The photographer should be aware of a potential source of problems when selling the reproduction rights to a released photograph in the secondary market. Since the photographer at that point might lose control of how the photograph is used by third parties, it is advisable to specify that the sale does not include release rights. This might

make a fraction of your work less marketable, but if you have any doubts it's better to be safe than sorry. (See Appendix A.)

Compensation for a service, misuse, libel, and invasion of privacy

An issue that often causes confusion and bears some thought is the nature of claims regarding unreleased and released photographs. There are four basic types of claims regarding releases. The most common one is a claim for commercial compensation for the use of an unreleased photograph. In this case, the photographed person is saying, "You used a picture of me for commercial gain without my permission, I want my fair share of the compensation." In these cases a check at the going rate in exchange for an after-the-fact model release solves the problem.

A thornier issue is a claim of misuse of a released photograph. Say, a model poses for a lingerie catalog, signs a release, and the next thing she knows she sees her skimpily clad image advertising an adult telephone hot line. There'll be a photographer in a lot of hot water in just as long as it takes to cry MISUSE! If she was careful with the release she signed, the model will have an excellent case, and even with a vague blanket release she will be in a very strong position to claim damage to her reputation.

What is often considered the thorniest issue of all, but is actually more straightforward than it seems, is a claim of libel and invasion of privacy prompted by an unreleased, seemingly innocent photograph. The stereotypical scenario is the shot of the starry-eyed couple blissfully wandering hand in hand, when their respective spouses think they are each alone on grueling business trips. The Richter scale is triggered when the aforementioned spouses open the Sunday magazine section of the paper to the story about a charming little island hideaway. Outrageous damages might be threatened for libel and invasion of privacy, but fear not, there is no case. The couple was voluntarily in a public place in plain view, freely opening themselves up to the public to be seen. It doesn't even matter that the

photograph was used for a feature about the island and not specifically to sell anything. And had the use been publicizing the sale of something, the couple would have been entitled only to the fee due them for their unwitting commercial service of posing as "a couple in love." That they were holding hands is the truth. There is no libel.

If the couple were snapped on private property by a photographer without permission to shoot there, they would have a legitimate claim to invasion of privacy but not libel, because the fact that they were there together is, again, the truth.

Now suppose that a man and a woman were simply very close friends, as well as business associates, who hadn't seen each other for a long time, and their spouses knew exactly where they were and why (no monkey business whatsoever). A photographer snaps them greeting each other with a friendly peck on the cheek in front of a conference room, and a tabloid runs the photo under the headline "Executive Love Fest in Boardroom!" Now, that would be libel! The truth had been altered. But no tabloid is likely to be as stupid as that. After all, they pay lawyers very high fees to tell them exactly what they can get away with.

The bottom line is that a careful, responsible, professional photographer not purposefully looking for trouble might run into an occasional problem with unauthorized usage or no release. It is very unlikely that the photographer will get wrapped up in a libel or privacy suit. Nevertheless, a conservative model release policy, religiously adhered to, is best.

Liability insurance

By now it is eminently clear that the professional photographer is confronted with a variety of ways in which liability can be incurred and a claim presented through the courts, and that could be expensive. A photographer might cause personal injury to a client or third party, physical loss or damage to a client's or third-party's property or equipment, loss of business income to a client or third

party caused by a breach of contract, or even damage to a client's or third-party's reputation. If the photographer is a sole proprietor or a partner, his personal assets are at risk. To protect against liability risk all professional photographers need liability insurance. In practically all states there is a mandatory legal requirement to carry a specified amount of liability insurance to practice certain professions, and photography is one of them.

Laws and regulations differ from state to state, so check the insurance requirements with your state insurance commission (call the state house and ask for the insurance commissioner's office if you have trouble finding the commission directly). Contact an insurer who specializes in photographers and make an appointment to determine your liability needs.

Generally, the idea is to carry a level of liability insurance equal in size to the size of potential claims. The industry has these levels fairly well pegged, and will set upper as well as lower limits on the availability of liability insurance. The amount considered to be a minimum these days based on jury awards is $1,000,000. Sometimes insurers set per person per claim sublimits on the total policy limit. These policies are less expensive, but offer less protection.

Since liability risk can vary widely from job to job, and can be much higher on some jobs than on others, it is a common practice for photographers to buy additional insurance for the duration of a high-risk job (billing the expense to the client).

On an individual basis insurance for small businesses can be hideously expensive. Lower prices are possible only on economies of scale, so what you need to do is find an insurance program that pools a great number of small businesses to provide competitive rates. There are some excellent photographer's insurance programs out there. Contact the professional photographers' associations to which you belong for information on these low-rate pooled insurance programs.

Photographers also have other important insurance needs, such as health insurance, real estate insurance, and equipment insurance. These requirements are addressed in later chapters.

Matters of law and liability insurance

6

Developing the business plan

HAVING acquired the ability to understand the business in financial and marketing terms, and having clearly established, with the help of previous chapters, the type of photography you plan to do, you are now ready for one of the most important steps in establishing a business, the preparation of the business plan. In this chapter you will

➤ Learn the basic purpose of the business plan.

➤ Become familiar with all the elements of the business plan.

➤ Establish your business goals.

➤ Value your goals in financial terms.

➤ Value the costs of attaining your goals in financial terms.

➤ Develop detailed financial, marketing, and administrative plans to attain your goals.

Note that the financial figures of the start-up business will be far below the industry averages used to present financial concepts in chapter 3. In case you were worried about how you will ever get the money together to get going, you will see that the financial needs of the start-up are far more modest than the financial performance to which it can aspire.

The importance of assumptions

For any business plan to be credible, the assumptions it makes have to be credible. The old saying about computers that if you put garbage in you'll get garbage out is true for business plans. It is difficult to provide specific guidance on making assumptions because each business situation is unique. It is, however, possible to provide guidelines and guidance on technique. As you rely on the material in this chapter to develop your own business plan, put great effort into making your own assumptions, subject them to intense scrutiny from your peers as well as yourself, and don't hesitate to derive a variety of scenarios based on changed assumptions before you settle on what you think is the most likely option.

Developing the business plan

Bear in mind that any examples and financial information in the business plan discussion in this chapter are for illustrative purposes only, and do not necessarily apply to your specific situation.

Elements of the business plan

The elements of the typical business plan are quite straightforward:

➤ Mission statement

➤ Principals

➤ Legal structure and organization

➤ Product line

➤ Financial plan

➤ Marketing plan

➤ Operations plan

Let's see what they are all about.

Mission statement

Every business plan should start with a mission statement. The mission statement should be very brief and to the point, preferably one or two sentences, precisely summarizing the key objective of the business you plan to start. The purpose of the mission statement is to crystallize your thoughts, to help you focus explicitly on what you are proposing to do. It is always there to refer to and keep you on track as you go through the process of planning and even running your business. Here is a typical mission statement for a photography business:

> Provide quality advertising photography to entrepreneurial high-tech firms in the greater Boston area at competitive market prices.

Figure 6-1

The mission statement clarifies your objectives.

A great deal of background work and thought has gone into this statement. It reveals very precisely defined parameters and objectives to keep the photographer focused on a profitably manageable task. Let's see what went into deriving it.

Based on his training, talents, and interests, the photographer sees a career for himself in advertising photography. To make this statement, the photographer must have good reason to believe that he is capable of providing "quality advertising photography" and likes it sufficiently to enjoy doing it. Undoubtedly he also thought about the fact that advertising photography is the most lucrative photography market.

The photographer is targeting entrepreneurial high-tech firms. He realizes that he is not going to get the Xerox or the IBM account the first time at bat. Entrepreneurial high-tech firms, on the other hand, have a lot going for the photographer. They need advertising

photography because they are in the business of bringing new products to market. They usually work through smaller agencies or in-house advertising-communications departments and are not in a financial position to hire highly priced photographers. Being entrepreneurial, and often in the start-up phase or just beyond it themselves, they are likely to be more willing than established firms to give a chance to a competent, dynamic photographer just starting out. One of the most desirable aspects of entrepreneurial high-tech companies is that many of them are likely to grow dramatically, giving a photographer who gets in at the start an excellent chance to grow with them.

Specifying the greater Boston area as the core territory is driven by the fact that it contains one of the greatest concentration of high-tech firms in the country, increasing the photographer's chances of getting work.

The objective of offering the service at competitive market prices indicates that the photographer is not going to undercut the market and ruin it for everybody.

Quite a bit of homework to formulate a one sentence mission statement, isn't it? On reflection, you might want to suggest to this photographer a slight revision of the mission statement based on your understanding of compatible markets and the need to maximize opportunity. The targeted high-tech firms might also need corporate photography, providing additional opportunities for the photographer. Even though advertising work is more lucrative, during down times he might welcome some quick corporate assignments, or could perhaps use corporate assignments as an entree to advertising work. So a revised mission statement might read like this:

> Provide primarily quality advertising photography, and secondarily corporate photography to entrepreneurial high-tech firms in the greater Boston area at competitive market prices.

Elements of the business plan

Principals

The next step is to identify the principal or principals who will own and operate the business, including a detailed presentation of their qualifications. A *principal* is defined as a person who has an ownership interest in the business. In most cases this will be the photographer alone, or it could be several photographers in partnership, or it could be a partnership between the photographer and his or her spouse in the role of office or marketing manager.

There are two reasons to provide a detailed qualifications summary, even if the photographer is the only principal:

➤ It helps the photographer confirm to himself that he has the requisite skills.

➤ Banks and other institutions who will eventually be asked to extend the business credit will want to know.

Legal structure and organization

For purposes of business planning, as well as for the information of any outside readers of the plan, the legal structure and organization of the business has to be established. As presented in chapter 5, the choices are

➤ Sole proprietorship

➤ Partnership

➤ Corporation

➤ Subchapter S corporation

The mix of considerations that should go into making this decision include

➤ The photographer's (principal's) financial vulnerability in case of liability

Developing the business plan

➤ The financial cost of establishing and operating the various forms of legal structure

➤ The recordkeeping burdens of the various forms of legal structure

➤ The personal and corporate income tax rate in effect

To review, in sole proprietorships and partnerships the principals are personally liable to the full extent of their present and future financial worth. If the principals have significant personal assets, these can be lost in a lawsuit, in addition to the loss of the business assets and the proceeds of liability insurance. Corporations, on the other hand, are liable only to the extent of corporate assets; the principal's personal assets are protected.

The drawback to corporations is that they require more record keeping and corporate tax filings, corporate officers, a board of directors and annual meetings, and there are various fees that have to be paid to start and maintain them. However, for people with significant personal assets that is a small price to pay.

The subchapter S option is an attractive alternative if the personal income tax rate is lower than the corporate income tax rate, because it allows business income to be taxed at the personal rate while providing all the legal liability protection of regular corporations.

Review your personal circumstances, and justify in the business plan your choice of legal structure.

Products

To be successful, every business has to have a well-defined, distinct product line formulated in the context of market demand and the competition. The product line has to be at least on a par with the competition; ideally it should have certain features that distinguish it and elevate it above the competition. The business plan is the place

to define in detail each product being offered and evaluate its strengths and weaknesses as compared to the competition.

One important reason for defining each product separately is to enable you to clearly understand the cost and income structure of your business and to calculate the profitability of each product. In this way you will be able to rationally and efficiently assess where to put the most effort for the greatest return. It will also help you determine what secondary products to fall back on first if demand for your primary product slackens temporarily.

"But a photograph is a photograph," you say, "That is the product. How can you differentiate any further than that?" You can, and in great detail. A fashion photographer might offer the following products:

➤ Fashion photography, major national accounts

➤ Fashion photography, mass market retail sales advertising

➤ Editorial fashion photography

➤ Model portfolios

All four types of photography are related, but are distinctly different products. All are priced differently, and all are bought by different buyers. The first two products are a main means of livelihood, fashion photography for major national accounts being the most lucrative source of income. Editorial fashion photography is a good occasional source of income (seasonal fashion articles in monthly magazines and Sunday magazine supplements of national or regional newspapers). It is unlikely to pay as much as the advertising work, but with your ad contacts it might be available to you and worth the income if you have an opening on your schedule. Model portfolios are for really slow times. They are the least lucrative product, but a logical corollary to your other work. The point is that until you've set down on paper and priced each of these products you will not be able to tell with any great accuracy where to place your priorities.

Developing the business plan

Here is an example of a retail photographer's product mix:

➤ Wedding photography—standard, custom, and deluxe plans

➤ Children's portrait photography

➤ Family portrait photography

➤ Graduation portraits

Again, four distinctly different products, priced differently, marketed differently, and with different profit margins.

To develop your proposed product line, first make a list of the typical assignments you would like to get. From this list a pattern of different products will emerge. Isolate each product and write a concise definition of each one. When you are satisfied that you have developed a list of distinct products, develop a product sheet for each one along the following lines:

➤ Description. Write a concise product description.

➤ Market. Identify the specific markets for the product. Describe the market (potential size, location, number of buyers, etc.) and state why there is room for your product. List the types of organizations (or types of individuals in case of retail products) your product is targeted to; assemble a specific list of organizations representative of your target market. List the positions of the key buyers within the types of organizations you are targeting (art director, art buyer, communications director, advertising manager, etc.).

➤ Pricing. Develop the pricing of the product per some appropriate unit of measure. In most markets except retail, your pricing will be on a fee plus costs basis. While you should probably add a 10 to 15 percent markup to costs before passing them on, the bulk of your income will be in your daily fee (see the pricing section of chapter 4 for assistance in developing a fee schedule). Estimate all the time required to complete a typical job, including the time spent preparing and presenting the proposal, making the sale, processing, and delivery; all the time for which you are not receiving your daily

Elements of the business plan

fee. Take the income generated by the job and divide it into the typical total time (in hours) spent on the job to arrive at a measure of hourly profitability. This figure will give you a good idea of how lucrative the product is.

➤ Competition. Identify and describe the competition you have for the product. Identify similarities and differences between your product and the competition's.

➤ Strengths. Describe the strengths of your product in relation to the competition's.

➤ Weaknesses. Describe the weaknesses of your product in relation to the competition's.

When you are finished with the individual product descriptions, rank them in terms of profitability and your preferences to determine what you consider to be the ideal, prioritized product line.

Developing your product descriptions and product mix requires a lot of research, analysis, and hard work. Expect to make many passes through the product line, evaluating, modifying, adding, and discarding products until you come up with a competitive mix.

Financial plan

The financial plan can be considered the heart of the business plan. If it is accurate the photographer will prosper. If it is flawed, income will suffer and the business might even fail. The product line, marketing strategy, and administrative practices are fairly easy to revise midstream if necessary, but a serious flaw in the financial plan is difficult to correct, especially if capital has been depleted without generating the forecasted commensurate income. For the financial plan to be accurate the assumptions have to be realistic and there has to be some room to maneuver, the more the better. The financial plan has to address four major points:

➤ Sources of start-up capital

➤ Start-up costs

Developing the business plan

➤ Projected income and expenses for the first three years (income statement)

➤ Projected monthly cash budget for the first year

✳ Start-up capital and costs

Start by putting down on paper the amount of capital you have available for your venture. As you get further into the financial plan you will get a sense for how long it will take to generate enough income to start exceeding expenses. But right from the start you should assume that the income stream will not meet your monthly expenses for at least six months, and you should plan on having the resources to make up the difference. Businesses often take much longer to start generating income than would seem reasonable, so a conservative assumption in this regard is strongly advised.

Let's say you have $25,000 in savings, you own a car worth $4,000, and have $5,000 in camera equipment (assume you have already acquired the camera equipment prior to deciding to go into full-time photography). How much capital do you have? You have $25,000 + $4,000 + $5,000, which is equal to $34,000. Some of it is already spoken for (the car and equipment that you already own), but the entire amount is important to list, because all of it represents capital (equity) going into the business.

At this stage a word about additional sources of funds that you might be tempted to consider is needed. How about borrowing? No bank is likely to lend you any money unsecured, because your prospects are highly unpredictable and pose an unacceptable level of risk. How about getting a home equity loan if you own your home? You would be taking a tremendous risk, because if the venture fails and you can't make the payments on your loan, you will be jeopardizing your home.

If borrowing is not an option, then how about relying on the salary of a spouse to fund initial losses? First of all, that is not capital, because it is received monthly. Secondly, you will be deceiving yourself if you incorporate such income as a source of funds, because it is mixing a nonbusiness source with business sources, and you will

Elements of the business plan

not know accurately how your business is doing. It is perfectly legitimate to rely on such income to get your business going, but track it as a source of funds under the bottom line, as an extraordinary source above and beyond the business, available to make up any shortfalls.

Lastly, what about a home equity loan to provide start-up funding if you have a reliable outside income source to make the payments (such as a spouse's salary)? That might be a reasonable plan, but use it only if you really need it. If not, then keep the idea in mind as a contingency, a fallback to rely on only if your plans are not working out as quickly as you had estimated.

The next step is to outline all the start-up expenses you anticipate. Read through the rest of the financial plan section now, but before you estimate your start-up expenses, read the rest of this chapter to become aware of all potential expenses and how to estimate them. Estimated start-up expenses (uses) are listed in the sources and uses table along with available start-up funds (sources):

Sources and uses of start-up funds

Sources	$
Savings	25,000
Equity already owned (cameras and car)	9,000
Total sources	34,000

Uses	$
Camera equipment (already acquired)	5,000
Car (value of car already owned)	4,000
Computer equipment and software	3,000
Communications equipment and lines	500
Stationery, business cards	300
Promotional materials	2,000
Legal and accounting advice	500

Company formation fees	200
Total start-up expenses	15,500
Funds available for working capital	18,500
Total	34,000

The funds available for working capital is the money you have left over after start-up expenses to pay your ongoing business expenses until the business starts to generate monthly income in excess of monthly expenses. If spent over a six-month period, the $18,500 of working capital could pay monthly expenses of $3083. Thus, if you are giving yourself a six-month window, your business could generate monthly expenses of $3083 and no income to survive that long. From the sixth month on, though, it would have to bring in at least $3083 to keep going.

This assessment of sources and uses of start-up funds is a good beginning. You know how much money you have to start, you have an idea of what start-up expenses might be, and you know how much money is available monthly for a six-month period without the generation of income. The next step is to make as realistic an estimate as you can of the annual income and expenses you expect to realize in the first year of operations. When this analysis is done, prepare a monthly cash budget for the first year to see if you will be able to generate enough income to meet monthly expenses before you run out of initial working capital. Work through the marketing and operations sections of the business plan first; you need these results to accurately estimate potential income and expenses.

✳ Projected income and expenses

The photographer working on a fee plus costs basis gets a break when estimating income. Because all direct expenses are billed to the client (ignore the slight margin for planning purposes), income can be estimated net of the direct expenses incurred to generate it (another way to say this is "net of the cost of goods sold"). This is a significant reduction in the burdens of assumption. To estimate annual income all the photographer working on a fee basis needs to

Elements of the business plan

do is estimate how many days per year he hopes to work at what fee. This is then compared to the annual expenses of running the business (also called indirect expenses or overhead plus salary) to see what the profit potential is.

Photographers serving the retail market, whose costs are built into their product, face a slightly greater challenge in estimating annual income. They need to estimate the profitability of each job type and multiply this amount by the number of anticipated jobs to derive annual income.

In either case, a good way to start projecting income and expenses is to take a stab at expenses first. Following are the typical expense categories and the first-year estimates for the example:

Expenses	$
Occupancy expense (in this case, office rent)	5,400
Utilities (electricity, heat)	1,200
Telephone	1,800
Postage/freight	500
Advertising	2,000
Insurance	2,500
Accounting	500
Vehicle	1,700
Professional dues, fees, conferences	350
Office supplies	300
Total overhead	16,250
Depreciation (camera and computer equipment, car)	2,000
Salary	24,000
Total annual expenses	42,250

The photographer faces expenses of $42,250 for the first year of operation over and above start-up costs. Now you can start estimating income and how to achieve it. You know that to break

Developing the business plan

even in the first year, $42,250 in income is required. How much work does that mean? Let's say the average going rate in daily fees for your chosen field is $1,000 per day. You would therefore have to spend 42.25 days shooting to meet all expenses for the first year. Bear in mind that expenses include your salary, thus while you are making money personally, the business is only breaking even. Assuming that all the jobs are one-day jobs, you would have to get 3.5 jobs per month, or a little less than 1 per week, to break even. You know that some jobs will take more than one day, so you probably need to get fewer than 42.25 jobs to have 42.25 days of work billable at $1,000. Let's say that about half the income is generated by two-day assignments. Ten two-day assignments would yield $20,000, leaving 22.25 one-day assignments for the rest, for a total of 32.25 assignments, or only 2.57 assignments per month.

You also begin to get an idea of how long the $18,500 in available working capital can support the business without any income being generated. On an average monthly basis expenses are $3,520. At that rate, $18,500 would last for a little over five months, which is less than the six-month target set at the beginning of this particular planning process. You can accept this, or you can make adjustments. Let the result stand for now, with the contingency plan that performance will be monitored closely from month to month, and if necessary, a minor reduction in salary will be made to stretch the working capital to six months.

You could look for more outside sources of initial working capital, or you could reduce slightly the salary you are planning to give yourself for the first six months. Here is where a source of outside income, such as the salary of a spouse, can help. Your salary can be drastically reduced temporarily if need be, and you can live off your spouse's salary until your business takes off. This is a good fallback, but it is a bad idea to count on it because you might get used to it, and then you wouldn't really be making it financially as a photographer.

You now know what income is needed to break even, but the idea for every business is to make money, so let's build a profit into the plan. It would take $2,500 to make a 6 percent net margin, which is about

Elements of the business plan

the industry average. That is only 2.5 additional one-day jobs, or one 2.5-day job. A 10 percent net margin would mean four additional one-day jobs, or two additional two-day jobs. There is also the matter of differently priced products to consider. Clearly the most desirable assignments are the most highly priced ones, but not all opportunities are going to be highly priced. To build in a profit and make the income statement reflect a likely mix of assignments yet keep the photographer focused on the jobs that pay best, the income projection should be finalized along these lines:

➤ Five days of high-end advertising assignments billed at $1,500 per day. To hope to capture five days of highly priced assignments in an entire year might be a reasonable expectation; this might represent only two jobs.

➤ Forty days of average advertising assignments billed at $1,000 per day. This is the main focus of the business. The work required is well within the abilities of the photographer. It generates sufficiently high income to pay the expenses if enough assignments are received. It might represent thirty jobs or less depending on days per job. This is where the main marketing effort should be placed.

➤ Ten days of miscellaneous assignments billed at $500 per day. Lower paying assignments should be considered for slow periods, but should not be heavily marketed because too much time spent chasing and doing low-fee assignments will result in insufficient income to meet expenses.

With these income assumptions, let's complete the projected income statement:

Projected Income Statement	$
Gross income	
Advertising, high income (5 days @ $1500)	7,500
Advertising, average income (40 days @ $1000)	40,000
Miscellaneous (10 days @ $500)	5,000
Total gross income	52,500

Developing the business plan

Operating expenses

Occupancy expense (in this case, office rent)	5,400
Utilities (electricity, heat)	1,200
Telephone	1,800
Postage/freight	500
Advertising	2,000
Insurance	2,500
Accounting	500
Vehicle	1,700
Professional dues, fees, conferences	350
Office supplies	300
Total overhead	16,250
Depreciation (camera and computer equipment, car)	2,000
Salary	24,000
Total annual operating expenses	42,250
Operating income	10,250
Income tax expenses	3,000
Net income	7,250

You now have the projection most likely to be achieved during the first year, but two more important tasks remain. You have to develop worst-case and best-case analyses (this is called sensitivity analysis), and you have to do projections for years two and three to have a longer-term plan.

Sensitivity analysis We've already done the work for the worst-case scenario of the sensitivity analysis. It is essentially the break-even scenario. While a start-up business might suffer losses through its first year of operations (and even beyond), a small business with limited capital resources should strive to at least break even by the end of year one. The best-case scenario assumes higher than

Elements of the business plan

expected income. We will assume that each income category exceeded the most likely case by 10 percent. Sensitivity analysis is useful to you for monitoring trends as the business gets under way, and provides an early warning of underperformance. Let's add to the projected income statement the worst-case and best-case scenarios:

Projected Income Statement ($)	Worst case	Likely case	Best case
Gross income			
Advertising, high income (@ $1500/day)	0	7,500	8,250
Advertising, average income (@ $1000/day)	42,250	40,000	44,000
Miscellaneous (@ $500/day)	0	5,000	5,500
Total gross income	42,250	52,500	57,750
Operating expenses			
Occupancy expense (in this case, office rent)	5,400	5,400	5,400
Utilities (electricity, heat)	1,200	1,200	1,200
Telephone	1,800	1,800	1,800
Postage/freight	500	500	500
Advertising	2,000	2,000	2,000
Insurance	2,500	2,500	2,500
Accounting	500	500	500
Vehicle	1,700	1,700	1,700
Professional dues, fees, conferences	350	350	350
Office supplies	300	300	300
Total overhead	16,250	16,250	16,250
Depreciation (camera and computer equipment, car)	2,000	2,000	2,000
Salary	24,000	24,000	24,000
Total annual operating expenses	42,250	42,250	42,250

Developing the business plan

Operating income	0	10,250	15,500
Income tax expenses	0	3,000	4,650
Net income	0	7,250	10,850

Bear in mind that these scenarios are based on the best information you have for your particular situation and your interpretation of them. The expense projections were conservative, but larger than anticipated expenses can be as much a cause of underperformance as income shortfalls. You should take a close look at expenses and do not hesitate to change them if you see any chance of variance.

Three-year projections Three-year projections are an important tool for setting long-term goals, to give you something to aim for. While it is difficult to specifically forecast business growth before your business gets under way, there are some reasonable assumptions you can make. You should also closely track actual performance versus planned performance, and revise early and often. Take a look at the following three-year projection:

Projected Income Statement ($)	Year 1	Year 2	Year 3
Gross income			
Advertising, high income (5 days @ $1500)	7,500	8,250	9,075
Advertising, average income (40 days @ $1000)	40,000	44,000	48,400
Miscellaneous (10 days @ $500)	5,000	5,500	6,050
Total gross income	52,500	57,750	63,525
Operating expenses			
Occupancy expense (in this case, office rent)	5,400	5,400	5,670
Utilities (electricity, heat)	1,200	1,200	1,200
Telephone	1,800	2,000	2,200
Postage/freight	500	550	600

Elements of the business plan

	Year 1	Year 2	Year 3
Advertising	2,000	3,000	4,000
Insurance	2,500	2,750	3,000
Accounting	500	550	600
Vehicle	1,700	1,700	1,700
Professional dues, fees, conferences	350	400	450
Office supplies	300	400	500
Total overhead	16,250	17,950	19,920
Depreciation (camera and computer equipment, car)	2,000	2,000	2,000
Salary	24,000	25,000	26,000
Total annual operating expenses	42,250	44,950	47,920
Operating income	10,250	12,800	15,605
Income tax expenses	3,000	3,840	4,682
Net income	7,250	8,960	10,923

It is not unreasonable to expect an annual growth of 10 percent in income for a growing business in a well-chosen market, especially if initial income levels are modest. Expenses are also quite predictable. Some, like occupancy and vehicle, are relatively stable, or grow only modestly from year to year. Expenses directly associated with business volume, such as advertising, telephone, and office supplies, might grow more rapidly. Advertising should be projected to grow aggressively, the volume of business being very closely linked to the level of advertising. And remember, the ability to retain income is the key to having the additional capital available to expand. Consider the cumulative effect of annual profits. By the end of year three, the business should have $27,133 in retained earnings, more than the savings with which the business was started. This income-generating ability begins to create a capacity to borrow to grow (you now have extra income to make loan payments). It might also be time to think about a bigger studio, more equipment, or perhaps even buying your own studio.

Developing the business plan

❋ Projected monthly cash budget

The annual financial plan tells you what to expect for the year, but you also need to know if sufficient income is expected to flow into the business at a pace that keeps up with ongoing expenses. This is the information you will develop in the monthly cash budget. The cash budget is simply a record of cash flowing into the business and out of the business. It is done on a monthly basis because that is sufficient detail for the typical small business. I chose to show income from operations minus expenses to derive a monthly excess/deficit cash position because this tells you how much money the business is generating on a net operating basis. Below the net operating cash position is the initial working capital amount used to make up the deficit and the initial working capital remaining. This enables you to forecast if the initial working capital is sufficient to fund projected losses. See the Year 1 cash budget on page 144.

The cash budget is easy to calculate. Monthly expenses are known and can be filled in. Monthly income is derived from the rate at which you expect to realize your annual income projections. After a slow beginning, typical for start-ups, the marketing effort begins to pay off and the days spent shooting steadily increase in the second half of the year. Note that the figures tie into the projected annual income statement, and depreciation does not appear in the cash budget because it is not a cash expense.

The cash budget completes the financial plan. You can try to project a balance sheet too, but that would not be productive, because you expect to have few receivables and payables initially, and will have no debt. Your accounting software or accountant will prepare the balance sheet periodically as your business progresses, and reference to it will become important as its elements begin to play an active role.

◎ Marketing plan

A business will be doomed to fail before it even gets started if you don't do a good job of marketing, and to do that you need a detailed marketing plan. Now is the time to devise a specific plan of action

Elements of the business plan

Annual Cash Budget	Jan	Feb	March	April	May	June	July	Aug	Sept	Oct	Nov	Dec	YEAR
Gross Income													
Advertising, high income								2,500		2,500	2,500		**7,500**
Advertising, average income			1,000	1,000	2,000	3,000	3,000	6,000	6,000	6,000	6,000	6,000	**40,000**
Miscellaneous						1,250		1,250		1,250		1,250	**5,000**
Total Gross Income			1,000	1,000	2,000	4,250	3,000	9,750	6,000	9,750	8,500	7,250	**52,500**
Operating Expenses													
Occupancy expense	450	450	450	450	450	450	450	450	450	450	450	450	**5,400**
Utilities	100	100	100	100	100	100	100	100	100	100	100	100	**1,200**
Telephone	150	150	150	150	150	150	150	150	150	150	150	150	**1,800**
Postage/freight	40	40	40	40	40	40	40	40	40	40	40	60	**500**
Advertising			500			500			500			500	**2,000**
Insurance			625			625			625			625	**2,500**
Accounting						250						250	**500**
Vehicle	140	140	140	140	140	140	160	140	140	140	140	140	**1,700**
Professional dues, fees, conferences						175						175	**350**
Office supplies				100				100			100		**300**
Total Overhead	880	880	2,005	980	880	2,430	900	980	2,005	880	980	2,450	**16,250**
Salary	2,000	2,000	2,000	2,000	2,000	2,000	2,000	2,000	2,000	2,000	2,000	2,000	**24,000**
Total Expenses	2,880	2,880	4,005	2,980	2,880	4,430	2,900	2,980	4,005	2,880	2,980	4,450	**40,250**
Operating Cash Income/Loss	(2,880)	(2,880)	(2,005)	(980)	(880)	(180)	100	6,770	1,995	6,870	5,520	2,800	
Income tax expense												3,000	**3,000**
Surplus/Deficit	(2,880)	(2,880)	(2,005)	(980)	(880)	(180)	100	6,770	1,995	6,870	5,520	(200)	
Beginning Working Capital	18,500	15,620	12,740	10,735	9,755	8,875	8,695	8,795	15,565	17,560	24,430	29,950	
Ending Working Capital	15,620	12,740	10,735	9,755	8,875	8,695	8,795	15,565	17,560	24,430	29,950	29,750	**29,750**

Developing the business plan

tailored to your business objectives, incorporating the concepts covered in chapter 4. Now is the time to conduct the research necessary to identify and confirm the existence of your target market. Based on the results, you then have to work out a comprehensive plan to capture your share of the market.

✳ Market research

Start by describing the market as you see it (or markets, if there are several). Utilize the resources covered in chapter 4 to establish the existence of the market you think is out there. Analyze the size of the market and the competition you face. Answer such questions as

> ➤ For each product you plan to offer, how many firms and advertising agencies are out there with what size advertising budgets?

> ➤ How are their photographic needs being met?

> ➤ Are the businesses that are potential users of your products growing, implying room for the growth of photographic businesses serving them?

> ➤ Establish sources for lists of target companies or, if practical at this early stage, establish a specific list of the companies at which you will aim your marketing campaign (see chapter 4 for details).

> ➤ If you are targeting the retail market, how big is it, and how many photographers are serving the community? Is the number of residents per photographer large enough to support another business? Is your target community growing, stable, or shrinking? What is the median income in your target community? How does it compare to other, neighboring communities?

Examine this information in the context of the market share you need to capture to realize the financial objectives you established in the financial plan. You will quickly get a sense for how promising your target market is. Revise as necessary.

✳ Marketing strategy

Describe in this section the strategy you will rely on to capture your share of the market. What roles will direct mailing, advertising, public relations, and networking play? Go back to chapter 4 and apply the presented strategies to your specific business proposal.

✳ Direct mailing

How appropriate is direct mail for you? Where will the initial mailing list come from? What needs to be done to ensure that the list is the right one? How will you make sure that decision makers receive the mailings? What will the direct mailing material be? How, by whom, and by when will it be developed? What will the mailing schedules be? How will responses be tracked? What follow-up will there be?

✳ Advertising

What role will advertising play? Where will you advertise and how often? What free sources of advertising are available and how will you take advantage of them? Who will formulate your ads, and by when? How will you monitor your advertising results? Establish an advertising schedule.

✳ Public relations

What steps will you take to secure free publicity for your business? What organizations (professional and civic) should you join? What roles can you play in these organizations to get free publicity? What community service can you perform that is not too time-consuming, yet gets you free publicity? What press releases and other material will you attempt to place in what media and by when? Establish a timetable for public relations action items.

✳ Networking

What conscious effort will you make to network? What organizations will you join for the purpose of networking? Make a list of individuals whom you will periodically contact to network, and assess realistically their value as contacts and sources of information. Set specific goals to accomplish per networking session (these last two items are important in order to avoid frivolous gabbing). Set as a specific

Developing the business plan

ongoing task the maintenance and expansion of your networking list. Set a weekly or even daily networking goal (say, five contacts per week, or one per day).

✳ Marketing projections

Project the results you expect from implementing each component of the marketing plan on a quarterly and annual basis in number and dollar volume of jobs booked. Outline a system and a schedule to monitor and evaluate your results. Make a commitment to timely revisions of your marketing plan as necessary based on plan versus marketing results. Use these projections as the basis for projecting income.

✳ The marketing budget

What will all this marketing cost? Go back to each marketing plan item and estimate the costs of implementing it. Revise judiciously if necessary to stay within available resource limits yet get the necessary impact from the marketing plan.

⦿ Operations plan

The last major component of the business plan is the operations plan. Its purpose is two-fold: to set out a schedule of key events that will get the business established, and to establish a set of key operations procedures to run the business. Read this section now, but before you actually devise the operations plan, also read chapter 9, "Starting and running the business."

✳ Schedule

Lay out in the schedule all the events that have to take place and tasks that have to be done to get the business established. A typical schedule will look something like this:

January 15 Acquire computer
Have telephone and fax lines available
Join all appropriate professional and civic organizations
Commence business plan
Start developing promotional material and stationery

February 25 Complete market research and product development sections of business plan

Elements of the business plan

Finalize arrangement for business premises

Choose company name

Complete company formation (verify trade name availability, do all filings, pay fees, get tax ID number, etc.)

Transfer telephone and fax numbers to company name, or add company lines

Open and fund business bank account

Set up and start using company accounting system

Get business cards, stationery

March 15 Complete financial plan section

Complete promotional material design and production

Line up direct mailing list, complete setup marketing database

Place advertising

March 31 Complete entire business plan

Complete any last-minute photographic equipment acquisition requirements

Establish initial calling schedule

Complete the development and production of all standard contracts, model releases, and other forms

Send invitations for opening reception

April 15 Hold official opening reception

Complete initial assignments lined up from clients known from prior experience

Complete initial direct mailing

Commence regular marketing calls

�֎ Operations

This section of the operating plan should address the day-to-day operations of your business from the financial, marketing, legal, insurance, and tax perspectives. In other words, all those aspects of everyday business management that are essential but not necessarily fun.

Developing the business plan

The operations section should outline in detail the kind of financial and marketing recordkeeping systems you will have for the ongoing operation of your business, how they will be maintained (daily, weekly, monthly tasks), and what periodic summary financial and marketing reports you will use to track business performance. It should cover the legal contracts, model release forms, and any other legal forms you need, and should contain samples of the forms you plan to use. It should address all insurance needs, and how they will be met. It should also cover your tax recordkeeping and reporting obligations, how they will be handled, who will prepare your annual income tax filings, and what arrangements, if any, you will have with accountants or bookkeepers.

❋ Equipment and inventory

In this section list all the equipment, supplies, and materials you will need in your business. The reason for this is to have an idea of the associated expense and to avoid any nasty financial surprises when you realize you forgot something expensive. Typical items to be included are

- ➤ Photographic equipment (cameras, lighting equipment, darkroom equipment, etc.)
- ➤ Photographic supplies
- ➤ Computer equipment (CPU, monitor, printer, notebook computer, etc.)
- ➤ Communications equipment (telephones, fax, etc.)
- ➤ Opening inventory of business cards, stationery, forms, and promotional material

Business plan software

It is a daunting task to assemble from scratch a thorough business plan loaded with realistic assumptions. But business planning has been made relatively easy by a number of software packages designed specifically to help you develop a business plan. They are available at various levels of sophistication and a variety of prices.

For a small business, avoid expensive, complex planning software. Use a simple, inexpensive program with basic financial capabilities.

The typical package is essentially a business planning template, laid out in much the same fashion as the business plan structure presented in this chapter. In each section you are prompted to answer a series of questions, and are given fairly detailed guidelines on how to formulate each answer. You simply skip the questions that are not relevant to your particular business. When you have completed all the relevant questions, you click on Print, and a complete business plan magically emerges from the printer. The financial planning sections of most programs contain financial templates into which you enter the applicable numbers to generate the desired financial projections. No matter how you prepare your business plan, take it seriously and invest a great deal of effort into it. Without good planning it is highly unlikely that your business venture will be a success.

Figure 6-2

Business planning software's question-and-answer format is a good way to develop the first draft of the plan.

Developing the business plan

7

Affordable knock 'em dead promotional material

PROMOTIONAL material is a key marketing tool for the professional photographer. By promotional material I mean more than just a portfolio. It also includes any other material that projects the photographer's image to the market: the trade name, business cards, stationery, marketing literature, and photo handouts. Your portfolio is reinforced by the rest of your promotional package in demonstrating to prospective clients that you have the ability to perform the required quality of work.

To convey the most professional image, your promotional material should be an integral package with a consistent, common motif. In form and substance it should be of a quality expected by the market at which it is aimed. It should also have elements sufficiently exceptional to make a lasting impression on potential clients and differentiate it from the competition.

The trouble with high-quality promotional material is that it can get very expensive. Business cards, stationery, and envelopes can quickly rise in price depending on materials and style, and there is always the pitfall of getting stuck with a vast unusable supply if you have to move. Postcard and miniposter photo handouts have to be aimed at such a diversified audience that making these materials to be all things to all recipients can be quite a challenge.

The creation of promotional material also requires skills many photographers don't possess. Chief among these are design and writing. Frugal reliance on professional help shouldn't be ignored, and a capable computer and laser printer will prove invaluable. In the end, to control cost and maximize benefits, the development of promotional material has to be handled as just one more professional business decision. Let's take a look at ways to achieve the most with the least.

Choosing a trade name

Because a photograph is worth a thousand words, and ultimately photographers are judged by the quality of their photographs, they

Affordable knock 'em dead promotional material

have some advantage when selecting a trade name. While many other businesses have to pack a lot of meaning into their trade name to differentiate them from the competition, for the photographer the name matters less because the promotional photographs fulfill this function.

Like fashion designers, most famous photographers are known by name. Photography is a highly personal skill, an art, and viewers of photographs instinctively associate an image with the person (the artist) who took it, not some company. As your work becomes well known and your services come into greater demand, your name will begin to carry a certain prestige; a different company name might just confuse things. You should seriously consider using your own name followed by the word Photographer for the name of your business. Many names are sufficiently unusual to be far more distinctive than some contrived company name. And potential clients will want to see your photographs to decide whether or not to talk to you, whatever your business name is.

What if you have a very common name like John Smith? To make the name stand out, a good solution is to choose a more unusual first name for business purposes. Eugene Smith became a pretty well-known name in photographic circles (his original name, but it illustrates the point). Or you can follow the acting profession's practice of using stage names, changing your name entirely for professional purposes. You might wish to consider this if your last name is especially long or made up entirely of consonants. If it has the right ring to it, some photographers use only their last name or first name for a trade name. In any case, the idea is to identify the business with a person.

Another reason to choose a personal name is because then there is no doubt that you are a photographer. Eugene Smith, Photographer tells the world exactly who the person is and what his business is. Studio 64, on the other hand, can cause confusion. Is it a one-hour photo store? An art gallery? A disco?

Choosing a trade name

A further advantage to using your own name for the business is that it can easily go with you. If you name your studio after the town you are in, it might become meaningless when you move to another town. Or you might find that the clever name you devised and carefully checked for availability in the state where you started your business has been claimed by a kindred soul in the state to which you move.

Some photographers prefer to appear up front in alphabetical listings, and a name starting with W will foil the plan. If you share this concern, choose your business name accordingly.

Business cards and stationery

Your business card and stationery leave a lasting impression and provide considerable scope to make a memorable impact. The idea is to keep the impression consistent and reinforce it constantly. To that end, the style of the card and *every* piece of stationery should be compatible. The central motif is the photographer's business name written in such a distinct style that it becomes the business's logo. This motif should appear on the card and all items of stationery, including envelopes and mailing labels.

In some instances it might be appropriate to have an emblem logo incorporated into a composition with the business name, but don't spend too much time, effort, and money dwelling on one. An emblem is most useful for making an impression on a retail audience that is unlikely to have anything beyond your card to remind them that you are a photographer (four-color photo handouts for a retail audience would be prohibitively expensive for the return you would get).

For the design of your business card and stationery you should collect samples from competing photographers to get a sense for the design standards and paper quality expected in your chosen market. While many photographers have a good artistic sense and enjoy design work, you should consider consulting a designer to give you some advice. Keep the consultation to a minimum and the fee modest, but you will find an hour or two spent with a designer affordable and invaluable.

Affordable knock 'em dead promotional material

Stationery costs can really get away from you if you order a wide selection of different items for specific purposes or opt for exotic paper. You can also get stuck with a lot of useless stationery if each piece contains your address and/or phone number and there are changes. A computer with a laser printer and a serious attempt to minimize the variety of custom stationery you get will save you a lot of money.

Here are the custom stationery items you really need:

➤ Business cards

➤ 8½-by-11 writing paper with letterhead

➤ Size 10 envelopes

➤ Mailing labels

➤ Client response cards

One size of customized paper should suffice for all correspondence needs, and any good-quality copy machine can be used to generate print quality forms on customized paper from generic master forms. Customized size 10 envelopes are suitable for mailing all routine correspondence (proposals, payments, invoices, etc.), and customized mailing labels can be slapped on any generic envelope larger than size 10.

Your savings on stationery will really increase if you have a computer and a laser printer. Then you can leave your address and telephone and fax numbers off of all items except the business card. You need only have your logo or trade name printed, letting the computer do the rest. The printer can also be used to print forms on your "one type serves all uses" customized paper. Not only that, but you can (and should) have all your design layout work on a computer file so that you can provide the printer with camera-ready layout when it is time to reorder.

There is such a variety of writing paper on the market these days that you can easily select a distinguished looking quality paper that does not have to be special ordered. Only the first page of any

correspondence need be on custom stationery. Matching blank paper is satisfactory for the rest.

There has been a proliferation of custom stationery kits lately, relying on the computer's power to customize. While suitable for many small businesses, as a photographer you might want to avoid this option. In spite of the wide selection, the styles are easily spotted as "canned" stationery, an impression to be avoided in a profession dealing in individualized visual images.

Photo handouts

Here is your opportunity to let a photograph speak instead of a thousand words. Typically produced in high-quality, four-color print, photo handouts are the items that will catch the eye of carefully targeted prospective clients in the advertising, corporate, and editorial markets. They are the mainstay of your direct mail program, and are also the examples of your work left behind when you leave with your portfolio or it is returned after a review. I covered their purpose and application in chapter 4. The question now is how to produce them to get the most out of them for the money invested.

A crucial element is versatile design. As discussed in chapter 4, the best option is to have one large piece (but not so large as to render it unsuitable for filing) and a good selection of supplemental postcards. Have an attractive layout of several of your best photographs on the large piece. Have individual photographs on the postcards, each making a strong statement for a particular market. This way you can mix and match, tailoring any package to your potential or actual clients' needs.

The miniposter and the postcards should have a common layout style and should all carry the same logo you use on your stationery, as well as your address and telephone and fax numbers. Many photographers print the address and phone/fax numbers on the back where a label with new information can mask them in case of changes. Other information on the handouts can include a list of your specialties, recognizable client names, and awards.

Affordable knock 'em dead promotional material

Figure 7-1

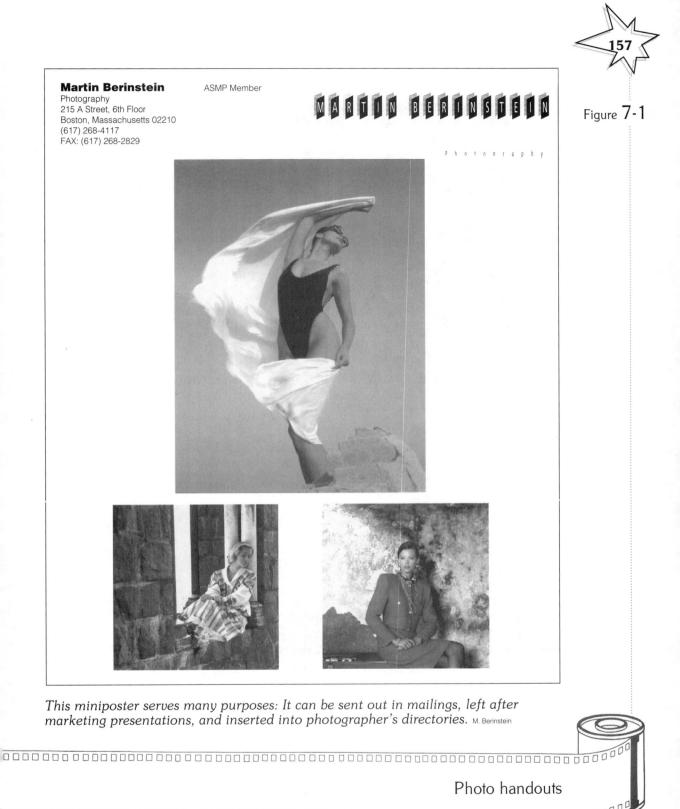

This miniposter serves many purposes: It can be sent out in mailings, left after marketing presentations, and inserted into photographer's directories. M. Berinstein

Photo handouts

Figure 7-2

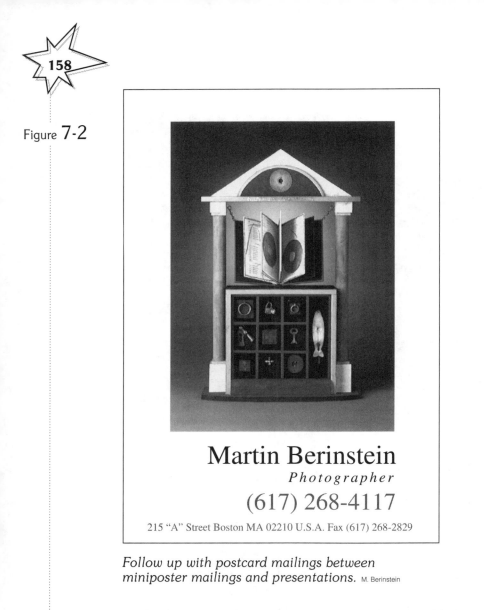

Martin Berinstein
Photographer
(617) 268-4117

215 "A" Street Boston MA 02210 U.S.A. Fax (617) 268-2829

*Follow up with postcard mailings between
miniposter mailings and presentations.* M. Berinstein

To further control costs, an economically priced but quality printing source is a must. Fortunately there are numerous printing cooperatives that provide excellent and affordable service. Seek information on these from your professional organizations. Get samples before committing to any orders.

Affordable knock 'em dead promotional material

 # Marketing literature

When it comes to marketing literature, photographers are, again, in the position to let their photographs speak for themselves. They are thus spared the need for the flamboyant gushing verbiage typically spewed forth by the parade of ads and brochures illustrated by many of their photographs. There is some need, however, for a minimal amount of to-the-point, informative text, usually in an accompanying letter, letting recipients know what it is the photographer can do for them and that he understands their needs.

When writing a marketing letter, remember these pointers of business writing:

> ➢ Write to your audience.

> ➢ Outline your main points.

> ➢ Put your points in a logical sequence.

> ➢ Use the active voice instead of the passive voice.

> ➢ Open the letter with your pitch. This should be designed to catch the reader's attention and prompt him to read on.

> ➢ Start each paragraph with a lead-in sentence that summarizes the point of the paragraph.

> ➢ Have a coherent set of related thoughts logically sequenced in each paragraph.

> ➢ Review the first draft and rewrite it to improve it.

> ➢ Avoid using complicated words when you can use simple ones.

> ➢ Get rid of *every* word you can do without.

> ➢ Keep the tone informal, but avoid jargon.

> ➢ Rewrite the rewrite.

> ➢ When you are done, ask yourself once again what you are trying to say, to whom are you trying to say it, and did you succeed in saying it.

> ➢ Keep it short and let your pictures do the talking.

If you feel you have trouble writing, it might be a good idea to take a business writing course. Make sure it is taught by people who have experience writing in the business world.

A very effective piece of marketing literature is a list of your major professional accomplishments and awards. Let the facts speak for themselves. Keep the list to one page to hold the reader's attention.

 # Your portfolio

In a book on the business of photography rather than photographic techniques, there are only a few things to say about your portfolio. Use your photographic skills and talent to develop a portfolio technically competitive with those of your peers. The main objective from a business point of view is to present a portfolio commensurate with the style of work expected by each prospective client. Otherwise you might find that while clients (or their representatives) genuinely think that you have an excellent portfolio, it doesn't quite fit with their needs. Here are some other business tips to make your portfolio more effective:

➤ Closely study the published products (ads, editorial spreads, annual reports, and so on) of the markets you are targeting. Note styles, themes, and technical quality by specific end users.

➤ Within the appropriate subject matter, edit your portfolio carefully. Present quality, not quantity. A few powerful images are more effective than many technically competent but visually weaker ones.

➤ Develop a theme within groups of presented images to make your point. Tell a story if the assignments you seek tell stories. Demonstrate that you can also see the "big picture."

➤ Include examples of any published assignments you already have under your belt.

Produce your portfolio in the format expected by prospective clients. As ways of doing business change, so do portfolio presentation styles. Network within the profession to keep current.

Affordable knock 'em dead promotional material

The indispensable computer

IF you are serious about running a photography business, you really should have a personal computer. Computers save so much time, are so reasonably priced, and are now so user-friendly that computer illiteracy is no longer an excuse to avoid using them. And not having one will make you seriously uncompetitive. Rapid advances in computerized digital imaging technology are having a monumental effect on how images are stored, manipulated, marketed and reproduced. This technology is flooding down to the personal computer level, and there is no end in sight. The photographer who doesn't take the trouble to understand and embrace the new ways is rapidly being left behind.

Photographers will find a personal computer indispensable for several tasks:

➤ Word processing—the alternative is typing on a typewriter, a form of communication that became extinct at the end of the Jurassic era

➤ Bookkeeping—the alternative is manual bookkeeping, manageable for the small business, but immensely time-consuming and rigid in relation to user-friendly computer-based alternatives

➤ Marketing database and mass mailing management—no effective manual alternative

➤ Digital image storage and manipulation—more applicable in some fields of photography than others

You can't just buy any old computer though. There are hundreds of brands, thousands of configurations, and price lists that look like the listings of the New York Stock Exchange. It is a computer shopper's jungle out there (but an excellent business opportunity for the advertising photographers who take all those pictures for the flood of glossy ads). You have to know what you need and what you are being offered before you sign on the dotted line.

The indispensable computer

In this chapter I will start with the basics and then move on to how to assess your computer needs and select a system appropriate for those needs.

Computer basics

It is customary to draw a distinction between computer hardware and software. *Hardware* is the physical machinery that runs and displays the computer programs. Hardware includes the processing unit of the computer, fax-modems, the keyboard, and the monitor.

Software is the collective word for the computer programs run by the hardware. Software is stored in the form of electronic code on floppy or CD-ROM disks (which are inserted into the disk drives on the computer) or on a permanent storage disk built into the computer known as a hard disk.

Hardware

The hardware components of the basic computer system are the

> ➤ central processing unit (CPU)
> ➤ keyboard
> ➤ mouse or other pointing device
> ➤ monitor
> ➤ printer
> ➤ fax/modem (optional)

There are currently two main hardware systems in use:

> ➤ IBM and compatible. This is by far the larger of the two choices, centered around technology developed by IBM and "cloned" by hundreds of other manufacturers (makers of IBM compatible computers).

➤ Apple Computer. Apple Computer developed its own technology and offers it in its Macintosh line of computers. The products of Apple Computer have not been cloned to date.

IBM and IBM-compatible hardware is generally not compatible with hardware made by Apple Computer. Software is also incompatible. Software has to be purchased separately for IBM and compatibles and for Apple computers. However, each of the two makes is increasingly able to read files created on the other, as long as each has its own version of the software. These beginnings of compatibility are likely to become more seamless over time.

While both groups deliver essentially the same capability, both have their ardent bands of loyalists. IBM and compatibles are more numerous (because IBM has been more successful in its marketing to the business community) and the selection of software titles is wider for them. The Apple Macintosh is favored by the educational community (Apple's original main market) and has exceptionally good graphics capability. Regardless of how they get the job done, the function of each of the hardware components is similar. Let's take a closer look.

✳ Central processing unit

As the name implies, the central processing unit (CPU) is the device that physically processes the computer programs, the software. For our purposes it is important to understand only a few key components of the CPU.

Microprocessor The microprocessor is the heart of the CPU. Also referred to as the "computer chip," it is the piece of wizardry inside the box that actually churns through the software and makes it do what you command it to do. The key question for users is how fast is the microprocessor at doing the processing? The more complex the software program, the greater the processing speed required from the microprocessor to run the program efficiently.

IBM and compatibles are identified by the type of chip they contain, which tells you how fast it is. It all started with the 8086 chip,

The indispensable computer

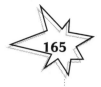

followed by the 80286 chip, the 80386 chip, the 80486 chip, and the 80586 chip (also known as the Pentium chip). The 586 chip is many times faster than the 386 chip. Today anything less than a 486 chip is rapidly heading for obsolescence.

You should also be aware of the "clock speed" of a particular chip, measured in megahertz (MHz). The higher the clock speed, the higher the speed of the chip. A 66-MHz 486 chip is faster than a 33-MHz 486 chip. Speed is important because new software is constantly being written (including new editions of existing software) that requires ever more speed to run. Macintosh computers have their own system of speed classification for the chips they use. Check with a knowledgeable computer salesperson.

Hard disk A hard disk is a storage medium for software. Most commonly it is built into the CPU. It is the place where the software programs and the files you create are kept. It can be thought of as a file cabinet in which the work you generate is kept.

Hard disks also come as a freestanding box connected to a CPU via a cable (a solution some people opt for when their built-in hard disk is full). Increasingly, hard disks are also available in plug-in models, which are the size of a pager and plug into the PCMCIA slots (see PCMCIA section) of computers so equipped. Plug-in hard disks are also a convenient way of increasing storage capacity.

The storage capacity of a hard disk (or, for that matter, any disk) is spoken of in terms of memory. Without getting into technicalities, the units of measure of memory in ascending order of magnitude are bytes, kilobytes, megabytes, and gigabytes. It is most common to talk in terms of megabytes of memory. The amount of memory a hard disk has is often referred to as the hard disk size; for example, a "240-megabyte hard disk." The important thing for the nontechnical user to do is to compare the amount of memory required by the various software programs to be used with the amount of memory available on the hard disk. Software programs have a large appetite for memory, and this appetite is ever-increasing. If the hard disk

Computer basics

space just meets your current needs, you can be sure that in the near future, you will be woefully short on hard disk space.

Random access memory Random access memory (RAM) is simply a memory area into which the computer can place those sections of the software that it needs to do the work it is currently being commanded to do. If the hard disk is the file cabinet, think of RAM as a desktop onto which items from the file cabinet are placed to be worked on. The more desk space you have, the more you can pile on it, thus the less time you have to spend going back and forth to the file cabinet. The main advantage of more RAM is greater speed in getting the work done. All software programs require some minimum amount of RAM (desk space) to work, and will work faster with more RAM. Graphics programs, such as photo retouching, are especially covetous of RAM.

Floppy disk drives/floppy disks Floppy disk drives are disk drives into which floppy disks can be inserted to permit use of the software files stored on the disks. Floppy disks are thin, square-shaped, portable storage mediums. The disadvantage of floppy disks is that their storage capacity is limited in comparison to hard disks. The highest capacity floppy disks at present are 1.44 megabytes. (Software is available that can "zip up" files for storage, expanding the de facto capacity of floppy disks.) Floppy disks come in 3½-inch and 5¼-inch sizes, though the latter is quickly disappearing from use. Some computers may come with both 3½- and 5¼-inch disk drives, though it is increasingly common to find computers with only 3½-inch floppy disk drives.

CD-ROM disk drive/CD-ROM disks A CD-ROM disk drive allows the computer to use CD-ROM disks, which are rapidly becoming a popular storage medium. CD-ROM disks are just like the music CDs you play on your stereo, and can store up to 600 megabytes per disk. An entire encyclopedia easily fits on one CD-ROM disk. They provide enough memory to present text, audio, and video information. It is therefore often referred to as a *multimedia* device. Still photographs, film and video clips, speech and music, and motion graphics (such as a cutaway depiction of a functioning jet

The indispensable computer

engine) are all typical contents of CD-ROM disks. The CD-ROM disk's drawback is that you can't change (add to or delete) information stored on it; ROM stands for read-only memory. Thus CD-ROM is most useful as a medium to present "canned" educational information, such as encyclopedias, user's manuals, instructional courses, and the like. It is also a popular medium for games. Also note that to get sound out of CD-ROM, you need a sound card and speakers in addition to the CD-ROM drive.

PCMCIA slot/PCMCIA cards Originally developed for notebook computers, PCMCIA cards are coming into increasingly widespread use on PCs as well. A PCMCIA card looks like a thick credit card, has no moving parts, and is inserted into the computer's PCMCIA slot to perform a variety of amazing tasks. The most popular PCMCIA card is the fax/modem card, which does everything a traditional fax/modem does. Advanced PCMCIA slots can also accept credit-card-like hard drive cards, which give your computer an instant extra hard drive. PCMCIA cards can be switched from computer to computer; an advantage when you have more than one computer (say, a PC for the office and a notebook for the road). The drawback of PCMCIAs is that they are quite a bit more expensive than the bulkier non-PCMCIA solutions for similar tasks.

✳ Keyboard

The keyboard is a straightforward hardware component, used to give typed commands to the computer and as a typewriter within any application where text is required. A useful keyboard feature is a separate numeric keypad section, presenting the numbers as they appear on calculators and making the entry of large volumes of numbers much easier.

✳ Mouse or other pointing device

The mouse is what makes computer use a no-brainer for people who were considered computer illiterate before they came into widespread use. The mantra is *point and click*. The mouse is a pointing device used to move an arrow around on the computer screen. Simply put, here is how it works: a variety of choices appear on your screen, you point at the selection you want, click a button

on the mouse, and the task is done. Other variations on the pointing device are the trackball and the pressure-sensitive button. Try them all. The choice is a matter of personal preference.

✳ Monitor

The monitor is a far more important piece of hardware than most computer users realize. If the screen's resolution is poor it can do a real number on your eyes. Ask a knowledgeable computer salesperson to explain the various resolution options, and (literally) see the choices for yourself. Color monitors are the standard now.

✳ Printer

Printers come in two basic varieties: dot matrix and laser (or laser quality; which for the user means the same thing). On a dot matrix printer a set of pins pounds through an inked ribbon to create the printed text or image (as a photographer you know that all recorded images are really just a bunch of dots). The more pins a dot matrix printer has, the better the resolution.

Laser and laser-quality printers offer much higher resolution than the typical dot matrix printer. Resolution of 300 dpi (dots per inch) is the standard in the less expensive models, and is wholly adequate for any printing needs except photographs. The 300-dpi laser printer has become so affordable that for any business seeking to project a professional image, it has replaced the high-end dot matrix printer as the standard. Resolution of 400 and 600 dpi is becoming more affordable, and resolution of 1200 dpi is also widely available.

Printers have their own random access memory (RAM), which they require to process the software files sent from the computer for printing. For simple tasks, such as printing word processing documents, the minimum RAM with which the printer is equipped is usually sufficient. However, to process and print complex graphics, your printer will probably need additional RAM.

✳ Fax/modem

A fax/modem is an optional but practically indispensable feature. It enables your computer to send faxes directly to other fax machines as

The indispensable computer

well as other computers. It also enables your computer to receive faxes; but that requires having the computer on 24 hours a day, not necessarily a convenient proposition. The modem portion of the fax/modem connects the user to other computers and to one of the most rapidly growing phenomena of our time, the on-line computer bulletin board. If you don't yet see a use for a fax/modem, you should get one anyway (many package deals include them), because sooner or later you will have a need. The key performance indicator for a modem is the speed at which it transfers data. Again, talk to a knowledgeable computer salesperson to review your options.

✳ A word on notebook computers

Notebook computers have become increasingly popular as their capabilities have increased to match the performance and memory offered by popular PC options. The convenience of a notebook computer is in its compact size and easy portability. The computer needs of most small businesses can be easily met by a capable notebook computer, especially if the primary need is for word processing, bookkeeping, and spreadsheets. A drawback of notebooks is their rather high price relative to the equivalent PC option. All that miniaturization comes at a price.

Software

Software is the collective name for the programs run by your computer. Software programs are essentially stored electronic signals triggered by computer commands to perform certain tasks. There are two types of software: operating system software and application software.

Operating system software is essentially an intermediary, a translator between the computer hardware and the application software. DOS and Windows are typical operating systems (for IBM and compatibles). You need not worry too much about operating systems. Your PC usually comes with whatever operating system is required. Once installed it runs automatically whenever you turn on the computer.

Application software programs are the computer programs used to perform the specific tasks you need to do, such as word processing and financial analysis.

Some diehard computer veterans still like to use software that requires keystrokes for everything instead of a mouse. Do yourself a favor and always use software that operates with a mouse.

For the photographer, the most common tasks performed by software programs are word processing, bookkeeping, marketing database management, and photo storage and retouching. Let's take a closer look at each of these.

✳ **Word processing**

Practically all small businesses need word processing capabilities, and the photography business is no exception. Proposals have to be written, estimates have to be given, price lists have to be prepared and customized, product descriptions have to be generated, contracts have to be drawn up, correspondence might be required, and countless other writing needs might arise. A good word processing program is indispensable.

✳ **Bookkeeping**

Bookkeeping software takes all the aggravating work out of keeping your financial records. All you have to do once you set up your chart of accounts is enter income and expenses as they arise. The program automatically keeps your books. Up-to-the-minute income statements, balance sheets, cash flows, overdue receivables reports, and budgeted versus actual performance is available at the push of a button. The good programs also print invoices and checks, including the addresses; all you have to do is stuff the windowed envelopes and slap on the stamps.

You will be better off spending the extra few dollars to get a program specifically for small business finances, rather than a personal financial management program. The personal programs lack many capabilities important to business, such as invoice printing and receivables accounting.

The indispensable computer

✲ Marketing database management

The computer also comes into its own in the role of marketing assistance. Any serious photographer has to mount a credible direct mailing effort to generate business, must track all existing and past customers, and must have solid information about the characteristics of those customers (who they are, what their needs were, how much they spent, how often, and so on). A database, which is basically a list of customers (past, present, potential), is the only way to keep track of marketing efforts in any meaningful sense. Database software programs do this for you elegantly and effortlessly, by presenting you with a variety of easy to use pop-up entry boxes, and giving you the ability to sort your data by a wide variety of criteria. These programs truly do in seconds the type of work that would take you days if done manually. They also print mailing labels.

✲ Photo storage and retouching

This application of computer technology is the most exciting development in the field of photography. At the commercial level, electronic retouching, alteration, and composite imagery has been possible for quite some time. Concerns about who owns what part of a composite image notwithstanding, electronic image manipulation promises an explosion of fresh and exciting artistic possibilities. The trend may well lead to a renaissance of the photograph as a work of art.

Photo manipulation software is now becoming available for the PC at affordable prices. Though not yet capable of cost-effectively producing the highest quality of print-ready altered or retouched images, the results are good enough for lesser applications. They are especially useful as training tools. A 486 computer with a couple hundred megabytes of memory and 16 megabytes of RAM does a fairly good job running the presently available image manipulation software.

Electronic image storage also has a promising future. It is eliminating the danger of long-term film deterioration and is making storage compact and efficient. It is also making portfolio assembly, editing, transmission, and presentation a lot more simple and flexible. Most

Computer basics

Figure 8-1

Digital image manipulation is here to stay.

stock houses are already offering their catalogs on CD-ROM, and many are going on-line.

The big hurdle for filmless electronic photography and PC-based image manipulation and storage is memory and processing speed. Storage of a single slide at its original resolution can be done on a PC, but requires a whopping 42 megabytes of memory. There are external memory cartridges available at reasonable prices that are capable of storing three photographs at their original resolution. Another solution is storing images on CD-ROM, which have about 600 megabytes of memory. But for the moment, that option continues to require expensive equipment (costing tens of thousands of dollars) found mostly at service bureaus.

✳ Other specialized software for photographers

There are many software programs on the market developed especially to make the photographer's life easy. Some are accounting packages tailored to photography businesses. Others are photography database programs. Both tend to be somewhat more expensive than the very capable and flexible generic accounting and database programs that are on the market, though some might find the customized features worth the extra expense. Among the most useful software programs specifically written for photographers are image labeling and tracking programs to manage stock files. A good source of information on currently available titles are the various photographers' associations. Also look for reviews in photography magazines.

The indispensable computer

 # Assessing computer needs and shopping wisely

Computer technology changes so rapidly that even the most advanced system you buy today is sure to become second-rate in a year or two. First, you will be annoyed to see that, after a few months, the system you bought is available at a much lower price. Then you will notice that faster computers with much more memory are being introduced, relegating your system to second-rate status. And if you choose not to upgrade for several years, you will find that your computer can no longer run the latest software.

First-time buyers of a computer system are best off financially if they purchase a system offered as a package. The typical package includes the CPU, monitor, keyboard, and optional CPU components such as CD-ROM and fax/modem. The operating system software is also included (and preinstalled), and additional software might be part of the package. Printers are usually not included in most packages.

To get the most out of your computer system for the longest time, follow these guidelines to the extent your budget permits:

➤ Get the fastest system you can afford.

➤ Get the most memory you can afford.

➤ Always get at least twice as much memory as your present needs require.

➤ For the best prices, opt for a complete system package deal.

Present needs

Take a good look at what you expect to do on your computer (word processing, bookkeeping, marketing database management, etc.), and assess what software will best accomplish these tasks for you. When selecting software, choose programs that are the most easy to

use, and opt for extra features if the price differential is not too outrageous. It is annoying to find yourself saying in a few months, "If only this program could do . . .!" Then evaluate your computer (CPU) needs along the following lines.

✳ Processing speed

Find out what the processing speeds are of the computers currently in production. This will help you avoid the bargain computer deals being offered to unload slow computers no longer being produced. Check the price differential between the fastest units and what appear to be the most widely sold units. The faster the computer you buy, the longer you will be able to go without an upgrade. The down side is that you always have to pay a premium for the fastest, state-of-the-art machines. Buy the most speed you can afford.

✳ Hard disk memory

Assess your software needs and add up the memory requirements (hard disk space). You will probably want to add software programs later, and you will probably have a need for additional space to upgrade the software you have. You also have to leave room to work with and store the files you create. Given the memory configurations available these days, it will seem that hard disks are being offered with several times the capacity of your immediate needs. You will be surprised how quickly your space gets used up. A good rule of thumb is to get a hard disk whose size exceeds your current needs by a factor of two, and then double that.

✳ Random access memory

Software programs are becoming just as greedy for RAM as they are for hard disk space. Programs will run with a minimum amount of RAM, but they will run much better with extra RAM. As a general rule, check what the minimum RAM requirements are for the software you are planning to use and exceed that requirement by as much as you can afford. If you settle for minimum RAM you will most likely have to buy additional RAM later on.

The indispensable computer

Room for expansion

An important consideration when buying a computer system is the ability to expand its capabilities. Expansion is cost effective up to a point, but you have to be careful not to go overboard. Eventually it makes more sense to get a new system. Computer systems are expandable in several respects. The microprocessor chip for many of the more recent IBM and compatible computers is upgradable to a new, faster processor. If the upgrade can be accomplished by simply unplugging the old chip and plugging in the new one, this can be a cost-effective option to keep ahead of obsolescence for an extra few years.

Another way to expand is to add more RAM. This is an easy operation, requiring you only to open the computer case (a few screws) and plug in the additional RAM chips. Find out how much room the system you choose has for additional RAM. Also check the RAM expansion room on the printer you select, especially if you plan to print a lot of graphics.

Hard disk expansion is more tricky. On IBMs and compatibles you can almost double the space on your hard disk with disk compression software. Anything beyond that requires the replacement of the hard disk or the installation of an additional hard disk (if your computer has any unused disk drive bays; also referred to as expansion slots). Another option is to buy an external hard disk linked to the computer by a cable. An increasingly popular but expensive option is to get a computer with a PCMCIA III slot (or higher), into which you can plug credit-card-size hard drives.

The addition of a CD-ROM drive is possible if the computer has the requisite slots, or you can opt for an external CD-ROM drive. Don't forget that to get sound on CD-ROM you need a sound card and speakers. A fax/modem (external or internal) can also be added later. Check before you buy to be sure.

Once you know what you want, the next big question is where to buy. Your two options are computer stores (including the computer departments of major merchandisers) and mail order.

✳ Computer stores

The big advantages of buying at a computer store are seeing what you get and being able to try it before you buy. The disadvantage is that you pay a premium compared to mail order. Some brand names are available both at computer stores and through mail order, so you can check them out and then buy from the lowest cost source.

✳ Mail order

Mail order is a good source for computer buyers. The chief attraction is price. By avoiding costly retail overhead, mail-order suppliers will usually beat computer store prices. There are mail-order traders who stock a variety of brands, as well as computer manufacturers who sell direct through the mail. Some of the best name-brand computers are available only by mail order, direct from the factory. Cutting out the middleman allows the factory to have higher profit margins while at the same time offering competitive prices to consumers.

There are several potential drawbacks to mail order. The obvious problem is not being able to see beforehand what you are getting. Another inconvenience is the delay in receiving your order. This is especially true if you buy a system directly from the manufacturer. Most manufacturers who sell through the mail assemble your computer system only after receiving your order. It can be several weeks from the time you place your order and pay for it to the time your system arrives. On occasion you might get burned if a financially struggling company goes under after it receives your payment but before it ships your order.

You can take a variety of steps to get the most out of mail order. Carefully read and compare all the evaluations in the computer magazines. Get personal referrals from computer users who have gone the mail-order route and take a look at their systems. Find out how long the companies making the systems you are considering have been around. If in doubt, stick with the big, well-established manufacturers.

The indispensable computer

9

Starting and
running the business

IT is often said that to do something well, the greatest effort has to go into laying the groundwork to do it. The culmination of the groundwork required to start and run a business is the business plan. It is the road map to guide you in getting underway, and if it is a detailed and accurate map, setting out on the trip will be a predictable and exciting affair. It will be backbreaking work, but you will always know exactly what to do next, and will soon settle into the routine of running the business day to day.

In this chapter you will see how to put your business plan into action, and how to cope with the demands of running a business. This chapter will cover how to make sure that all tasks (marketing, assignments, financial, and administrative) are done, how to identify critical, time-sensitive tasks, how to prioritize your activities, and how to motivate yourself to do the tasks not entirely to your liking. It will also address how to conduct yourself with clients, how to sell, and how to deliver.

Getting started

Once the business plan is completed and a start-up schedule set, the main objective is to establish the business in the shortest time possible. The sooner you start doing business, the sooner you will generate income. Your business plan tells you the time frame you have for use of your limited start-up resources, and when the clock starts ticking you will experience firsthand that old business adage that time is money. The sequence for completing the various tasks is important in order to be as efficient as possible. Following is an outline of the tasks that need to be accomplished and the order in which it is advisable to do them. There is a certain amount of overlap in the timing of the various tasks, and depending on individual circumstances some flexibility might have to be employed in following these recommendations. But in general, make an effort to adhere to the sequence of events.

Establish your business identity and place of business

For business as well as psychological reasons it is important to formally establish your business identity and your physical place of business up front. Formally existing as a business and having a physical place of business will give you a degree of credibility in your dealings with the business world. It puts everyone on notice that you exist as a business and function as one. You have to have a formal business identity in order to open a business bank account, establish phone and fax lines, and get your promotional material done. It is also an important boost to your morale. "I legally exist as a business, I have a place of business, therefore I must be in business," you'll say to yourself. Before you know it you'll be acting as if you have been a businessperson for years.

There are two stages to this first step. First, establish your legal business identity. This is very easy if you are going to be a sole proprietorship. In most places you need only file a "doing business as" (d.b.a.) form at the town hall and pay a small fee. A partnership requires the preparation of a partnership agreement, and if you choose to incorporate there is the more complicated process of filing for incorporation. Whatever your choice of legal existence, check the specific requirements in your location by contacting the Secretary of State, as well as your local town hall. Your accountant or lawyer will also be able to help. For the establishment of anything but the simplest sole proprietorship you should get professional help. The point is, get it done.

Second, establish your place of business. When you prepared the business plan you researched the cost and general location of your business. If you have chosen to work out of your home, then you have the easiest time. You have only to isolate your office area from your living area so that you have a space where you can work effectively. If it is impractical to work out of your home, you have to acquire the kind of commercial business space you scouted out while preparing your business plan. It might take some time to find suitable

space, so locate a commercial real estate agent with a long list of likely properties and start your search early. Besides providing a business address, an established business space allows you to start working in earnest.

Figure 9-1

Many options are available for gaining access to a studio: You can buy one, rent one, rent one part time, or even share one.

Open a checking account for the business

The minute you start functioning as a business, you'll have payments to make, and you'll have to keep the capital of the business somewhere. Also you will have to start keeping track of the business's financial affairs from the first financial transaction. Before

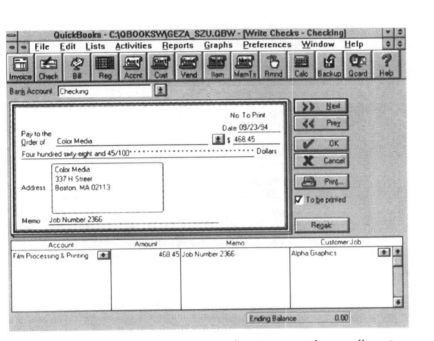

Figure 9-2

Establish your business account up front to avoid recordkeeping confusion.

you existed as a business and had a place of business you couldn't establish a business checking account, but now you can and should.

Choose a bank that is easily accessible, and compare business account terms at the various banks. All banks have a variety of business account packages designed for different levels of banking activity at different prices. Have an account officer take you through all the options and, in general, choose the simplest, least expensive checking account to start with. You can always upgrade to a different level of service later. Deposit the capital going into the business as the opening deposit, and as soon as the account is established use it to pay all the business expenses by check. The easily maintained business checkbook thus becomes the business's core financial record. This information is then entered into the accounting system.

Figure 9-3

Spell out in detail how the accounts will flow.

If you have a large amount of capital going into the business that will be used over a long period of time, you should consider putting most of it into an investment account that earns interest. Make periodic transfers into the checking account as required by cash needs. Ask the banks about such investment options.

Get computer and communications equipment

You should already have gotten your computer before you prepared the business plan, but if you used someone else's, then now is the time to get one along with word processing, accounting, and database software. You need to start writing letters, keeping accounts, developing client databases, and more. You can't afford to be without a computer. See chapter 8 for further details.

Starting and running the business

You should also establish telephone and fax lines and get the associated equipment. Clients and business associates will get suspicious if you claim to be a business but don't have a phone number. There are several options to consider when establishing communications lines. You can get two separate lines, one for the telephone and one for the fax. This is expensive and is not necessary if you don't expect heavy fax traffic. The best solution is to put the phone and fax on the same line to start. But how to distinguish between the two lines? The answer is shared line service. This allows you to assign more than one telephone number to the same line. Pick one to be the fax number and one to be your business number.

Another service you should get is call waiting. This allows you to handle two calls at once instead of giving a busy signal to callers when you are on the line.

As far as equipment is concerned, telephones are now fairly inexpensive, so whatever style suits you should be fine. There is no need to get the fanciest, most expensive, plain paper fax machine. An inexpensive one will do an excellent job as long as it has ten-sheet document feeding and a paper cutter.

You also need an answering machine to answer those important calls while you are on location. Perhaps the most efficient solution is to get a fax machine with a built-in answering machine, because then you can use it on the shared line as your telephone as well as your fax. A cordless telephone might also be a practical investment, especially if you have a large studio.

Should you get a cellular phone? The service is expensive, especially if you use it a lot, but on the road it can be very useful. If you are going to spend a lot of time on the road, a basic service with a certain number of free calls per month can be an economical proposition, though you are probably better off with a beeper that displays the number calling you.

Getting started

Get business cards and stationery

You should get that all-important proof of your business existence, the business card, as soon as you know your business name, address, and phone/fax numbers. You will also need to communicate in writing as soon as your business is formed, so you should get stationery at the same time. Most high-volume commercial printing/copying services can efficiently and economically meet the business card and stationery needs of the typical small business. They have a large selection of paper, and many of them also provide design services or can recommend graphic designers.

Prepare standard forms and contracts

Now that you have your computer, prepare the standard forms and contracts that you will need: estimate, bid, and quote forms, model releases, property releases, delivery memos, and so on. You will need them as soon as you get your first assignment, and you should be ready to roll.

Use as a guide the sample forms provided by such professional associations as ASMP. Set up each form as a separate file. You can then open the file whenever you need a particular form, save it as a separate job file, and fill in the blanks as required. Be sure to back up the master form files to a storage medium independent of the hard disk.

Set up the accounting and recordkeeping system

Now that you have your computer and you have expenses (if not yet any income), you should set up your accounting system to keep track of everything. You should also establish a workflow and filing system to meet all the recordkeeping needs of your business.

I strongly recommend that you purchase one of the small business accounting software packages sold in all the popular software outlets. It will enable you to track your financials on an accrual basis (maintaining a balance sheet in addition to an income statement and automatically presenting you with information on upcoming payments to be made and income to be received) without requiring you to post present and future cash inflows and outflows to the balance sheet. You have to perform three tasks:

➤ Maintain the electronic checkbook, which will write and print checks for you and prompt you to enter deposits, just like your paper checkbook.

➤ Generate invoices on the system to be sent to clients. The invoice appears on the screen, you fill in the blanks and print it out.

➤ Enter invoices sent to you.

The program automatically makes all the entries on the financial statements, so you always have a full set of up-to-the-minute statements at your fingertips.

When setting up the program, you will be prompted to name the income statement and balance sheet accounts according to your needs. Refer to the chapter on finance for the appropriate accounts, and review chapter 11 to make sure you set up the accounts to conform with income tax recordkeeping needs. Remember, keep things simple.

Another option if you have an aversion to financial recordkeeping is to maintain records on a cash basis. This, too, you can do with accounting software on your computer. All you need to do is use the electronic checkbook: write checks to make payments and enter deposits of payments received.

To organize the flow of related paper (there is always some paper), keep one box for all bills to be paid, and another box for invoices that you have sent out, but for which you have not yet received payment. Stack the bills and invoices in the boxes in chronological

Figure 9-4

Small business accounting software takes the labor out of invoicing.

order. You will also need a filing cabinet to store your paperwork. The paperwork flow will then be

> ➤ Incoming bills.
> - You receive a bill. Place it in the box for bills to be paid. Enter it into the accounting system if you keep records on an accrual basis. There is no need to enter anything on a cash basis.
> - When you pay the bill, write the check on the electronic checkbook, send it out, and file the bill under Expenses in your filing cabinet. File all expenses chronologically using the expense categories you use to file your business taxes (telephone, utilities, office rent, etc.). The accounting software will automatically make all additional entries as necessary.

Figure 9-5

Design your system of accounts carefully to meet your recordkeeping requirements.

> ➤ Payments to be received.
> • Fill out the invoice on your computer and print two copies. Send one out and place one in the "Invoices sent out" box. This way you can see at a glance what payments you are expecting (as you become accustomed to your software you might rely entirely on the "Invoices due" list it provides and do away with the box).
> • When payment is received, deposit the payment in your checking account, make the appropriate deposit entry in the electronic checkbook, and file the related invoice chronologically in a single "Income" file.

I reiterate that if you want to be a competitive photographer you will need a computer, and maintaining your accounts on it will save you

considerable time. However, if you insist on being computer illiterate and wish to track your financials manually, you will find it most easy to do on a cash basis, keeping a manual checkbook and using the box system described previously. You will have less financial information available to you during the fiscal year and will face more work at the end of the year by having to manually compile your financial statements.

The other recordkeeping task you have is to devise a system to keep track of each job done for each client and store all related material including film. Most photographers favor the technique used by many small businesses working on an assignment basis: give each job a number and maintain a set of informational records attached to that number. Maintain a job log, in which job numbers are assigned chronologically as jobs are received, and reference the job number on all materials and correspondence sent to clients. Maintain a job file by job number and keep all records related to that job in it: estimates, contracts, releases, expense records, miscellaneous correspondence, everything. This is your working file, as well as your reference file once the job is completed.

To minimize risk of damage, store all retained film, contact sheets, and related photographic material in a separate file by job number. Make sure that each strip of negatives, negatives removed individually, and slides are identified by job number. Otherwise the tracking system will quickly become a disaster.

Set up the job log as a matrix, with job numbers running down the page and related information running across. The informational records in the job log should include

- ➤ Client name
- ➤ Subject matter
- ➤ Location
- ➤ Date
- ➤ Film type

Starting and running the business

➤ Product line (take the categories from the business plan and log for the purpose of marketing analysis)

The job log is best set up on your computer as a database, because you can then search by any of the information categories. If you want all jobs done for the ABC Company, search the database's client category for "ABC Company." If you want every photograph you've taken of race cars, search by subject for "race cars." It pays to be specific on the subject category, using several subject categories per job to permit greater selectivity.

If you don't want to fool with a database, a spreadsheet program is another option, but it is just as much work and doesn't give you nonnumeric search ability. Also, as a spreadsheet gets very big, the software tends to slow down in comparison to database software, which is specifically designed to manipulate immense amounts of information.

Lastly, there is the manual log option. This requires just as much work to maintain as a database, requires more time to search, but can work quite well for the typical small business.

Whatever you do, don't use the Table function of a word processor to maintain job logs. Big tables dramatically slow down word processing software, and if they get large enough, they will eventually blow up. If you use your computer to maintain a job log, stick to a database or spreadsheet program.

Join professional associations

One of the first things you should do when you begin the process of starting your photography business is join all relevant professional associations. In fact, you should have joined the professional photographers' associations well before you started doing the research for your business plan. If you expect to benefit from the local chamber of commerce, now is the time to join.

Set up insurance

There are basically four insurance policies you will need:

➤ Liability insurance

➤ Health insurance

➤ Disability insurance

➤ Equipment insurance (camera equipment, car, etc.)

A single insurance agent might be able to handle all these needs for you, but you should find one who has experience dealing with photographers. Get recommendations from peers and the professional associations to which you belong. Take advantage of less costly group plans whenever you can. If you have employees you are liable for additional types of insurance. Check with your insurance carrier.

Get photo handout production underway

As soon as you complete the establishment of your business identity and are ready to begin marketing, you will need photo handouts. You can start designing them any time after you complete the marketing plan and know who your potential clients are. You should make production arrangements as soon as you know your business name, address, and phone/fax numbers. There is some lead time involved, so time the production carefully to make sure you have the handouts when you are ready to start marketing. Don't forget to design and order the customer response cards to be used in direct mailings along with the handouts.

◉ Begin developing a client list and direct mailing list

Another marketing tool on which you should get an early start is the client list and the direct mailing list. As soon as your database program is up and running, start building your database. Identify sources of direct mailing lists. Find out how effectively the lists can be customized to your specifications. Establish specifications based on your marketing plan, and check out what is involved in adding the list to your database.

The actual purchase of any list has to be timed carefully. You want it to be as current as possible, so you don't want to get it too early. On the other hand, you don't want to hold up the mailing because you got the list too late and are having trouble transferring it to your database.

◉ Finalize photo equipment and supply arrangements

I have assumed that you are already a trained photographer and have acquired most of the core equipment you need to get started. If not, now is the time to do so, or to make any additions. Have high-quality core equipment and sufficient backup to complete any job without embarrassment in case of equipment failure. Don't be extravagant, buying expensive, rarely used equipment. For those needs there is always the rental market; identify reliable rental sources. Also line up dependable discount supply sources. Establish an account with them if you qualify (they might want some experience with you first).

Getting started

Select a reliable and accessible photo lab

The photo lab you use can make or break a job. After you've shot your first assignment is not the time to go searching for one. There is great variation among photo labs in the quality of work, the ability to meet promised deadlines, and the ability to get a complex order correct. Identify the major photo labs in your area (ask established photographers) and give them all a try. Meet the manager and ask for a tour (most will be happy to oblige, and as a commercial client you will probably be assigned to a customer representative). Try recommended out-of-town labs if the ones in town don't measure up. Compare price as well as quality. Select a primary lab, but also line up at least one backup lab. Establish an account if you qualify.

Finalize your portfolio

As soon as your marketing plan is complete and you have clearly identified the target market, it is time to finalize your portfolio. Probably you already have a body of work upon which you will be relying for the bulk of your portfolio, but the marketing plan might have identified the need for additional images. Now is the time to shoot them and get everything ready to launch your marketing program.

Issue a press release

When everything is in place and you are about ready to launch your marketing program, it is time to announce your venture to the world. Compose a press release and send it on your brand new stationery. Send it to local, city, and regional papers (include an 8-by-10 glossy of yourself), and perhaps even to a select list of potential clients (include a postcard teaser instead of a portrait of yourself).

Hold a grand opening reception

Celebrate your new venture with a grand opening reception. This is an especially attractive proposition if you have a studio, but if you don't you can rent one for the purpose. Display your work, have promotional packages available, and scatter your business cards about liberally. Invite any personal contacts and acquaintances you have in the business as well as your friends. You might even want to invite some potential clients.

If you are opening a retail studio, by all means hold an open house for the community. Advertise the open house in the local paper, offer introductory promotional deals, and have a lottery for a photo session.

Running the business

The reception is over, it is Monday morning and your first official day on the job in your own business. It is make or break time.

Launching the marketing plan

The first order of business is to launch your marketing plan. You will spend most of your initial time drumming up assignments. Depending on your target market, you'll be splitting your time between your direct mailing effort and calling on an already assembled short list of likely customers. As the direct mailing begins to get results and the client response cards start coming in, your calling activities will increase further.

If you are doing a mass mailing, write your marketing letter, get busy with your database and mail merge files, assemble the mailing, and ship it out. But how to send it? Expensive first-class mail, third class, or bulk? First class does make the best impression because it is more urgent and personal, but it is expensive. On a mailing of 4000

pieces the difference can be several hundred dollars compared to third-class or bulk mail. Bulk is the least expensive, but it requires a permit from the post office, a minimum number of pieces must be sent, and the mailing has to be sorted a certain way. Ask your local post office for a bulk mailing information kit. For the first round you might want to use first-class mail. You can experiment with other options on subsequent mass mailings.

Along with the mass mailing, send out packages to your preassembled "most likely" list, and start calling on them. Send a small number of packages at a time to give you a manageable calling schedule.

◉ The transaction cycle

Whatever it is that gets your foot in the door, before you get an assignment you have to make the sale. Then comes the fun part, the photography, and then comes more running around to labs, delivering the finished product, and getting final payment. While the transaction cycle presented here is primarily descriptive of advertising, corporate, and editorial photography, many of the concepts also apply to retail photography. Readers going into retail photography should concentrate on the underlying general concepts and ignore inapplicable detail.

✳ Selling

Selling is a distinct, final stage of marketing. It is the face-to-face chance to convince the potential client to work with you. Marketing research gets you to the right clients and marketing packages pique their interest. Selling starts the minute you make the first personal contact and begin the job of convincing them to give you a hearing.

Some people are born to sell. They feel completely at ease with potential clients, make just the right amount of small talk at the right time, instinctively spin out convincing arguments of why they have more to offer than the competition without bad-mouthing the competition, and get a real high from closing the deal. For others selling is the most dreaded part of the job. But the fact is that selling

techniques can be learned by anyone, and with practice, selling becomes much more natural for *everyone.*

Most Sales 101 courses will tell you that there are four distinct stages to selling: initial contact, the sales presentation, closing the deal, and the follow-up.

Initial contact The initial contact is a telephone call, following up on the marketing package you had just sent. The package is the excuse for the call. Just calling out of the blue and saying that you are Benny the photographer and you want to show pictures will rarely get you anywhere. In your promo piece your pictures have already done the talking. If they are up to snuff, most recipients will feel both obligated to talk to you and comfortable talking to you.

Keep the conversation brief and to the point. "Hello, I'm Benny the photographer. I just sent you an information package on my work, and I would really appreciate an opportunity to show you my portfolio and discuss with you how I can help you meet your photo needs." Or something along those lines. Sound enthusiastic, but don't be pushy. Aggressive sales tactics are more often than not counterproductive. If there is any merit to your promotional material, you should get a sympathetic hearing.

If you are told to come on down, great. Grab your portfolio and get going. If you are told that there are no immediate needs and no point in meeting, you might ask for a strictly informational meeting. Say that you are just starting out, and if it wouldn't be too much of an imposition you would really appreciate a half-hour to get the benefit of the person's vast experience in the field. Flattery can work wonders. If it is really a "no go," ask for the names of anyone else that person thinks might be interested in your type of work.

One more point about telephone contacts: how to deal with protective secretaries and assistants. Often these people are charged with screening calls, so you should be ready with a good reason for your call. "He has some material from me that I would like to discuss," or "I was told to call him by so and so, his good friend," or

any other valid reason. It's better than saying you want to make a sales call. If you are told that the person is not in, leave a message; ask when the person will be back and call again.

The sales presentation If you make it to the presentation stage you are doing your job, and now is the chance to do it even better. Any presentation has to have a clear sense of purpose. Determine in your own mind what the primary objective is and what additional objectives you would like to accomplish. Write them down and devise a presentation plan.

People inexperienced in sales always worry about what they are going to say. The small talk up front is always useful to create an easy atmosphere, but don't worry too much about it, and especially don't overdo it because it starts to smack of wasting time. Your prospective clients are probably used to meetings and will make their own effort to put you at ease, so things will work out fine.

When it comes time to get down to business, be ready with a practiced pitch. Use the soft-sell approach. View the presentation as a two-way street. You are there just as much to learn about the prospective client as you are to present yourself. Briefly explain who you are, what your area of specialization is, and get right into presenting the portfolio. Then you can transition into asking for the prospective client's reaction to your work and questions about how the organization's photo needs are handled. Listen as much as you talk. Feel free to take notes. This is your opportunity to get firsthand information on your market, which will be very useful in selling to other prospects. Make good use of your chance. Demonstrate by your responses that you understand what is being said, and gently explore not just immediate possibilities, but also long-term opportunities.

Closing Sales calls run their course quite naturally, and even the novice can sense when it is time to bring the session to a close. The important thing about closing is that it should clarify and firm up whatever opportunity might have come out of the meeting. If an assignment is not the end result, and most often it will not be at the

end of an initial call, then it is crucially important to secure the right to call again. If the prospective client keeps a list of preferred photographers, it might be appropriate to ask if you could be included, or what do you need to do to be included.

What if you are asked to leave your portfolio? By all means, leave it, but not for too long, implying that you have places to go and people to see. Set a firm date for retrieving it (in person), which gives you an excellent follow-up opportunity.

Before you leave ask for the names of anyone else in the industry who, in the opinion of your prospective client, might want to see you. Often this will lead to several contacts, and you have an automatic in by being able to say that "So and so thought you should see my portfolio."

Follow-up It is vitally important to follow up a sales presentation, because neglect can derail all the accomplishments of the meeting. If an assignment is in the offing, keep after it to nail it down. If a longer-term relationship is suggested, or if your work was liked, plan the next call. A brief personal thank you on a postcard not previously seen by the prospective client is an excellent idea.

At first there will be some rough edges, but soon you will find that sales calls settle down into a pleasant, or at least tolerable, routine. You will without a doubt encounter an occasional jerk who goes out of his way to make you feel miserable, and then it is very important to maintain your self-confidence. Recognize that the problem is not you and quickly move on without missing a beat. As you begin to develop personal relationships with some of your clients, you'll look forward to seeing them, and you'll become part of a network that will probably generate more work than all the cold calling you did to get there.

Performing the assignment

This is what you do best, this is what being in your own business is all about. Here are some points to live by:

➤ Be very careful to understand exactly what the assignment is, what the client wants, what the finished product is to be, and what the deadline is.

➤ Take great care to plan the sequence of the job and the amount of time required to complete each phase. This is the only way to ensure that the deadline expectations are realistic. Write out a detailed plan for each job the first few times, and always do one for complex, lengthy assignments.

➤ Take great care to think of every expense; estimate every expense as accurately as you can. Decide what happens if additional expenses are necessary.

➤ Clearly establish what documentation the client requires of expenses (this might be very detailed for both financial control and tax reasons).

➤ When it comes time to shoot the assignment make sure you have all the equipment and film you need, including contingencies for equipment failure. Use an assignment checklist to assemble everything before leaving for the location.

➤ Leave ample time to obtain special equipment rentals and models.

➤ Don't run out of steam after you've had your fun shooting and reviewing the results. Deliver the final product on time and on budget.

➤ Always use a major courier or bonded messenger service to deliver the finished product (charge it to the client).

Getting paid

Be firm on payment terms. No money, no pictures! It is as simple as that. Get the agreed advance before you start a job, and invoice promptly for the balance. Use the advance to cover all of the expenses of doing the job so that you will not be out of pocket if you run into problems with the balance. If the expenses on a particular job are so high that they exceed the customary advance, get an additional advance to cover them.

As a rule, collect any balance due from smaller clients when you deliver the finished product (cash on delivery). Bigger companies (large agencies and corporations) expect to be billed for the final balance due, which is essentially extending unsecured credit for 30 days (the usual terms of invoices).

Don't be reluctant to ask for credit references. It is a common practice in the business world. Check them out, and if you want more comfort you can also get a Dunn and Bradstreet report (a credit monitoring agency). If you are in any doubt, deal on a cash on delivery basis.

As I have said before, retail photographers should deal exclusively on a cash on delivery basis. Giving terms, even net 30 days, to the general public is just asking for headaches.

Don't be understanding about delays in payment. Call requesting payment, send past due notices promptly every 30 days, and charge an overdue penalty charge. If a bill becomes 90 days past due, send a demand letter, politely stating that if payment is not received within 15 days you will have no choice but to seek legal remedies. A legal demand often flushes out a payment. If it doesn't produce results, turn the case over to a collection agency. They charge a percentage of the amount they collect, payable upon collection.

Running the business

Evaluating performance

You should regularly monitor how your business is doing. It is a pleasure to see that you are doing better than expected. On the other hand you need to know sooner rather than later if things aren't going as well as they should. Performance measurement is also important to see if the nature of the business (types of assignments, rates per assignment, and so on) is as you expected. You will gain a better understanding of the business and will be able to make more reliable assumptions for subsequent annual business plans if you do periodic performance assessments.

The most common monitoring technique is to measure financial performance. Periodically it is worthwhile to evaluate how well your marketing effort is going by putting together a marketing report. Neither task is as onerous as it might sound, especially if you use a computer.

✳ Financial reports

There are no special reports to generate to measure financial performance. All you really have to do is look at your cash budget, income statement, and balance sheet at the end of each month.

By comparing the actual monthly cash budget to the planned monthly cash budget, you will instantly have a pulse for the business. The income statement and balance sheet will tell you at a glance if you are accumulating capital or depleting it. As the year progresses, comparisons to the previous months' results will give you an interesting insight into trends.

If you are keeping your accounts on a cash basis only, most accounting software will still provide the cash budget and income statement. If you rely on the manual checkbook basis of Stone Age accounting, you should have a bookkeeper or accountant compile at least an income statement at the end of each quarter.

The computer can also spit out the financial ratios presented in chapter 3. Take a look at these and think about what they mean. Get

behind the numbers. If there are deviations, find out the causes and decide if any changes are necessary in how you run the business.

✳ Marketing report

The marketing report is simply a record of the actual jobs booked during a given period. It is essentially the job log for the period. Are you getting assignments at the rate anticipated and are they the kind of assignments you planned to get? How profitable is each assignment in comparison to your plan? You need not review marketing results more often than at the end of each quarter.

If you are keeping the job log on a database, it is easy to create a marketing report by printing out the relevant section. If you are keeping a manual log, just review the relevant section, don't bother with a separate report. In either case, compare your marketing results to the marketing plan.

◎ Keeping up with administration

If you've set up the business properly, its administration will not be an onerous task. It is important, however, to make a conscious effort to keep up with administration, especially for photographers who are naturally inclined to ignore it. Make a list of all the administrative tasks you have to do, estimate the amount of time they require, and set time aside in your schedule to do them. A typical list of tasks might look like this:

- ➢ Bill paying (weekly)
- ➢ Invoice preparation and mailing (weekly)
- ➢ Mailing list database maintenance (biweekly)
- ➢ Job log database maintenance (weekly)
- ➢ Financial statement review (once a month)
- ➢ Marketing results review (once a quarter)
- ➢ Direct mail preparation

On such a schedule you should probably set aside one afternoon a week or two half-afternoons a week to do all the administrative tasks, except the direct mail preparation, and see how it goes. Direct mailings are a major, time-consuming effort. To handle them, set aside a specific time when the mailings need to be done. The trick to effective administration is not to fall behind.

Some people also have trouble keeping receipts, bills, deposit slips, and the like until they need to be handled. Make it easy on yourself. Toss everything in one pile as you come and go during the day, then sort it all out during your scheduled administrative time. If you put off administration, the pile will become overwhelming. Admit it if you are a totally hopeless administrator and avail yourself of a bookkeeper's services once a month before it is too late.

Don't let up on marketing

When success comes it is tempting to ease off marketing and spend all your time on the assignments that your initial efforts brought in. This is a common reaction and a big mistake. The pipeline of assignments can quickly dwindle, and even dry up, if you do not continue to spend a considerable amount of your time drumming up additional business. The marketing program must be ongoing and systematic. Targets for numbers and types of assignments must be maintained, and every attempt should be made to increase the volume of business as well as the fees per assignment. Any fall off in business volume should be recognized early, the reasons identified, and corrective action taken before the business suffers.

Over time the photographer will reach a saturation point in the number of assignments that can be performed per year as a one-person show. At that point a choice has to be made. The business can be expanded by hiring a promising photographer to work with you on bigger jobs and take the overflow under your close guidance, or you can choose to concentrate your efforts entirely on increasing your fees per assignment. In either case your systematic marketing effort must continue.

As your business matures, your marketing strategy will change in that you will begin to develop a core clientele from whom you will get

steady repeat business. You will have to split your marketing time between cultivating these existing clients and searching for new clients.

Along these lines you should also refine your database by flagging core customers (add a separate Core category). While the initial mailing and cold calling will most likely yield a percentage return in the very low single digits, repeat business from core customers is likely to run considerably higher. To maintain the relationships, you might want to make periodic special mailings to core customers only.

Your existing client base will form a valuable information and referral network, making the search for new clients easier. But you must continue to keep a clear marketing focus, track marketing results, and invest a lot of time in marketing.

Time management, the great juggling act

So how to juggle all these tasks? Be persistent, and have patience. Here are a few tips:

Make a daily "to do" list. Assess everything you need to get done each day, make a list, and work your way through the list.

Prioritize the "to do" list. Mark as "critical" every item on the list that absolutely has to be done by day's end and do them. Transfer any uncompleted item to the following day's list (eventually each item will move up to "critical" and will get done).

Tackle and complete one task at a time. A sure way to let things get out of hand is to dive into a number of tasks at the same time without finishing any of them. If you start something, make sure you have enough time for it and finish it. There will be times when you will have to do several things more or less at the same time, but focus on finishing one task after the other in order of priority. You'll be much more productive than if you keep scurrying back and forth between them.

Avoid makework and unnecessary telephone calls. Some people have a tendency to focus on mindless, low-priority tasks, and then they wonder why they are falling behind when they are working so hard. If you run out to the photo store three times a day, make two trips to the post office, and spend the rest of the time on the phone telling a friend how hard you are working, you won't get much done by day's end. Combine errands and cut them to a minimum.

Unproductive telephone calls can be both a temptation and a real nuisance. Some people are happy to talk forever, and you might be too, but you must keep moving. Good ploys are, "I have someone in the studio," or "I have to go out on an assignment," and so on.

Observe the daily patterns of your energy levels and tackle tasks accordingly. We all have the best times and slow times of the day. Note when you are at your best and try to schedule demanding, creative work for those periods. Schedule dull but necessary tasks like administration for your lethargic, low-energy periods.

Work habits, professional demeanor

A photographer's professionalism has a lot to do with being chosen by a client. There is both form and substance to a professional demeanor. Form is important, because rightly or wrongly many clients are greatly influenced by that all-important first impression created by the photographer's dress and general appearance. Photographers should appreciate that because they are the sellers and the clients are the buyers, the more they meet their client's expectations, the better their chances of getting an assignment.

It is best to tailor your general appearance to what is expected by a particular client. The dress code of a progressive ad agency is quite different from the dress code of a conservative corporation. A traditional wedding party would be very disappointed if you showed up to shoot the reception in a Hawaiian shirt and baggy shorts. Research the general expectations of your various potential clients and dress appropriately.

More important in the long run than form is substantive professional conduct. Again, bear in mind that you are the seller, so you have to conform to the clients' expectations. The more professionally accommodating you are, the more enduring your relationship with your client is likely to be. Many of the following suggestions are self-evident, but you would be surprised how often businesspeople, including photographers, have trouble remembering them:

➢ Always deliver what you promise.

➢ Don't exaggerate your abilities.

➢ Meet deadlines religiously.

➢ Keep professional hours.

➢ Always be on time for appointments.

➢ Be reachable at a professional location.

➢ Return all phone calls and return them promptly.

➢ Respond to client response cards and unsolicited expressions of interest immediately.

➢ Always be constructive, positive, even tempered, and fair, even when things aren't going your way.

Choosing accountants and lawyers and dealing with them

Accountants and lawyers are an invaluable source of specialized professional services, and managed properly they can save the photographer a lot of money and grief. How do you know if you are filing the proper tax forms, maintaining the proper financial records, making the right legal choices, protecting yourself sufficiently from liability, and operating your business within the bounds of business and other laws? Just as most accountants and lawyers turn to photographers when they want a professional portrait, so should you turn to them when you need their professional services.

Be aware that many accountants also act as general business consultants and are able to handle routine legal tasks such as company formation. Also bear in mind that laws and regulations vary from state to state, so hire a lawyer licensed to practice in your state.

There are two perceived problems with accountants and lawyers commonly raised by photographers wary of them: their charges can escalate dramatically beyond an affordable level, and it is difficult to tell if you are getting the services of one familiar with and experienced in serving the needs of photographers. Both issues can be easily handled if you follow a few simple guidelines:

➤ Be in control. You control the relationship. You have to let the accountant and lawyer know exactly what you want and what budget you have in mind. You should expect to be presented with options, and you should be the one making the ultimate decisions. Just as you never cease to market yourself to your clients, so too will accountants and lawyers try to convince you to use more of their services. For that they can't be blamed, and it is up to you to say no.

➤ Get referrals. Choose an accountant or lawyer only on the recommendation of other photographers who have used them with good results.

➤ Check them out with the authorities. Before signing on an accountant or lawyer, check with government and professional organizations to see if there have been any complaints against them. The Secretary of State, consumer affairs departments, better business bureaus, and state bar associations are all sources of information on complaints and other professional problems.

➤ Conduct an interview (for which there should be no charge). Just as you are interviewed before being given an assignment, so should you discuss with prospective accountants and lawyers your needs and how they can meet them. If they want to charge you for this initial consultation, walk out.

➤ Ask for a price estimate of each specific service. Ask up front what a particular service will cost. Some services are provided on flat rates, but accountants and lawyers frequently charge by the hour. Ask how many hours a task will take, and make it clear that any additional hours have to be approved by you.

Starting and running the business

10

Growth, employees, health insurance, and retirement planning

THIS chapter looks at the issues facing the successful photography business as it matures, and addresses the important but often neglected topics of health insurance and retirement planning.

Growth

The payoff of running your own business well is seeing it prosper. Real prosperity for small businesses that are started with limited capital resources comes from growth. But growth also brings its own peculiar problems that can seriously hinder prosperity if not properly managed.

Financing growth

Any increase in business activity puts additional demands on the photographer's resources. There might be a need for more equipment, additional space, or greater demands on the photographer's time, all of which cost money. If the photographer is actively seeking additional growth through increased marketing efforts, that too costs money. The additional financial resources required can come from two sources: additional equity (retained earnings) and bank borrowing.

The classic financial problem caused by growth is a cash flow squeeze. It occurs when, because of a very rapid increase in business volume, the expense-income cycle is distorted: expenses escalate because of additional business, but the income generated by this increase in business doesn't flow in fast enough to meet expenses. If expenses can't be paid, suppliers are quick to cut off the business. The business then finds itself in the position of not being able to get the necessary material to complete its jobs, and it won't get paid by its clients unless the jobs are completed. Photographers working on a fee plus expenses basis with hefty up-front advances (the advances are key) are less threatened by a cash flow squeeze than say, a rapidly expanding manufacturing firm that needs to purchase large volumes of inventory.

Growth, employees, insurance, and retirement

Photographers are not, however, immune to cash squeezes, so the phenomenon needs to be understood. Suppose that you have three clients that owe you $1,000 each in a given month. That is $3,000 coming to you that you might need to pay your expenses. This is not a large sum, and you are likely to be able to handle it from the cash in your business account. Now suppose that you have been wildly successful and you now have ten clients owing you $2,000 each. If you need that money to support increased expenses, you now have to dig up $20,000 from internal resources until you get paid. That might be a lot harder to come up with than $3,000.

It is in such situations that borrowing can play an important role. For the short period of time between billing your client and receiving payment you can take out a loan to meet immediate cash needs that cannot be met from internal sources. When payment is received from your clients you repay the loan.

Another financial problem related to growth occurs when the photographer spends so much on additional equipment and premises that the additional income generated is insufficient to meet these increased expenses. This can also be a payment timing problem. In this case borrowing might, again, be appropriate. You can take out a loan for the purchase of the equipment or premises, payable over the time the equipment or premises are expected to generate income. Such loans are referred to as *long-term loans* because their maturity is longer than one year. Customarily the bank claims a security interest in the financed equipment or real estate. Equipment loans generally have maturities of from three to five years, and mortgages for commercial property can be as long as fifteen to twenty years. The idea is to have a monthly loan payment that the business is able to pay from the additional income generated by the associated growth.

A more serious problem arises when a business overestimates anticipated growth (by overestimating income growth or underestimating increases in expenses or both), and realizes the misjudgment too late, after significant additional expenses have been incurred.

Growth

Handling the workload

A common nonfinancial problem caused by growth is committing to a higher workload than you can effectively manage, causing the quality of the products and services provided by the business to suffer. Delivery deadlines start to slip, start dates are missed, and the quality of the photography begins to show the haste with which it was done. When this happens, customers can vanish quickly. And no potential customer is more difficult to win over than an ex-customer.

The importance of planning for growth

The problems of growth demand business planning that is done with just as much care as the start-up business plan. As you embark on a marketing campaign to realize growth in your business or as it comes to you unsolicited, analyze the options and plan your moves carefully. Utilize the planning skills you acquired preparing your initial business plan. Here are some of the more important questions you should ask yourself before you commit to major increases in business volume:

➤ Do I have the physical resources to meet the demands of the additional business? Do I have the equipment, the space, and the time?

➤ What does growth in the business actually mean: is it an increase in the number of jobs or an increase in profitability per job? If the business's average profitability rate per job is going to decrease because the additional jobs have low profit margins per job, why is it worthwhile considering the additional jobs?

➤ Will I need to reduce the time spent on each job to take on additional business? Will the quality of my work suffer? Why not?

➤ If I don't have enough time, how can I free up time? Should I consider hiring an assistant? Should I consider hiring someone to do the administration? How much will that add to costs?

➤ How much will annual net income increase?

> ➤ What will the business's cash cycle be with the additional jobs? What are the maximum internal cash needs likely to be and for how long?

> ➤ Should I get a short-term loan? What will it cost (in interest)?

> ➤ If I need additional equipment or larger premises, what will it cost? What kind of financing can I get if I don't have the internal capital? How much will the financing cost (interest)? Can I support the monthly payments?

> ➤ How much less can additional growth be than anticipated and still allow me to meet my increased financial obligations?

 # Borrowing

The start-up small business rarely qualifies for borrowing. As it develops a track record indicative of a reliable source of loan repayments, the banks will become more interested. Again, there are two basic types of commercial loans available to small businesses.

✳ Short-term working capital loans

These loans are used to finance brief periods of cash flow shortages during the transaction cycle. The bank assesses what the borrower's peak working capital borrowing needs are likely to be and provides a line of credit for that amount, if the company is creditworthy. The line can be drawn on partially or entirely as required. Each individual borrowing has to be repaid within a certain amount of time (anywhere from 30 days to 180 days, depending on the bank's assessment of the length of the business cycle). Upon repayment, the repaid amount becomes available again. The line is reviewed by the bank, and if the borrower continues to be creditworthy, it is renewed each year.

Many banks are willing to extend short-term credit to small businesses only against some form of security, such as real estate. Generally they also require the owner's personal guarantee, which

Growth

permits them to reach beyond even the incorporated company to the owner's personal assets in case of default.

Use a short-term line properly. Borrow only in amounts equivalent to future payments already in the transaction pipeline. Don't draw down the line if income isn't coming in, hoping that you will get an assignment before repayment is due. Under many lines you can do that (especially if they are secured and guaranteed), because the bank will take the security and come after you under the guarantee.

❋ Long-term loans

Long-term loans have maturities beyond one year, and are intended to finance the acquisition of a specific piece of equipment (camera, lighting system, computer equipment, and so on) or real estate used by the business (in the photographer's case, a studio). As a rule the lender takes a security interest in the asset financed and does not finance 100 percent of the acquisition cost.

Let's look at how to get a loan and what a lender looks for when evaluating your application.

❋ Where to apply

Most banks have divisions specializing in community lending and small business lending. Ask at your local branch, and comparison shop among banks. You will be given an application to fill out and will be required to submit income tax statements for the last three years, the business's financial statements, and any business plans and projections you have.

❋ Loan purpose

The bank will want to know the specific purpose of the loan, and will want it to be used for that purpose explicitly. The bank takes a very dim view of using a loan for an unspecified purpose.

❋ Credit evaluation

The bank's main objective when making a loan is getting repaid. To this end it will want to evaluate your creditworthiness—your ability to

Growth, employees, insurance, and retirement

make the payments on the requested loan. The focus is mainly on the following:

> The business's cash generating ability (especially excess cash flow available for debt service)

> The business's equity position (how much equity is available in case of trouble, and what is available be taken as security)

> The liquidation value of the assets (in case the bank has to foreclose and sell the assets quickly)

> Your personal financial position

> The business's reputation (credit checks will be made)

> Your personal financial record (a personal credit check will be made)

✳ Security

The bank will have to make a decision on what type of security they require to provide them with a fallback position in case of a default. Generally all long-term loans are secured by the asset financed. For small businesses, which are considered high risk, the bank will also want some security for short-term working capital loans.

✳ Personal guarantee

Most lenders require a personal guarantee from the small business owner, in addition to the security provided by the business, figuring (correctly) that the business is only as good as the owner. Being personally on the hook concentrates the owner's mind on running the business responsibly.

✳ The Small Business Administration

If you don't think you can get a loan, given the banks' onerous requirements, don't give up hope just yet. The Small Business Administration (SBA) might be able to help. The SBA is a government agency charged with financing small businesses that find it difficult to qualify for loans from commercial banks. Through a network of local offices nationwide, the SBA has a variety of

Growth

programs, including direct loans and SBA guarantees of commercial bank loans.

Be conservative in borrowing. Used the right way, borrowing is one of the greatest aids to business. But misused or abused, it can quickly overextend a business to the point of failure.

Also keep in mind that borrowing is expensive. If you borrow $10,000 for five years at 10 percent, the interest you'll pay during the life of the loan is a whopping $6,453—more than half the principal you borrowed.

Employees

One potential result of growth is the need to consider hiring employees. One problem for small businesses on tight budgets is that employees tend to be very expensive. Another problem is the government's substantial legal and administrative requirements regarding employees. There is an alternative to full-time employees, and it is an alternative particularly suited to photographers—the independent contractor.

The independent contractor is available for hire by others, and controls his own schedule, work, insurance, and taxes. All you do is pay the agreed fee and report it to the IRS on a Form 1099. Photographer's assistants and occasional administrative help can be hired on an independent contractor basis. When independent contracting became a popular option to avoid the burdens of keeping full-time employees, many independent contractors worked for only one employer year-round. To close this loophole, authorities put time limits on working continuously for any one employer as an independent contractor. Check with your state employment office for current regulations.

Following are some of the things you have to do if you hire employees, even on a part-time basis:

➤ Pay social security tax

➤ Pay unemployment tax

➤ Pay workers' compensation insurance

➤ Calculate and administer withholding from paychecks

➤ File quarterly federal and state payroll reports

➤ Prepare end of year tax reports (Form W-2)

It is much easier to hire an independent contractor, pay a fair fee to compensate them for the lack of benefits, and be free of the paperwork. Of course, if you really hit it big, you won't be able to avoid hiring an employee or even employees full time. When that time comes farm out the administrative work, unless you enjoy it and can do it without it eating into the time required for marketing or performing assignments.

For some tasks (mostly administrative) a good option is hiring help from a temporary agency. The agency is responsible for all paperwork, withholding, and tax payments. You just write the agency a check.

Whenever you hire help in any form, have specific objectives in mind for what they will do. You might even want to write a task description to clarify your thinking. Be sure to clearly communicate responsibilities and expectations. Network with your peers for sources of independent contractors and employees. Try to stick with people who have come highly recommended not by the references they give you, but by your own sources.

Health insurance

A lot of people give health insurance low priority because it is very expensive. Yet few things can clean you out as quickly as uninsured

medical bills. You owe it to yourself and your family to have some form of basic health insurance. Optimistically, by the time you read this there might be some minimum universal health insurance coverage. But being individualistic and self-employed, you probably know better than to rely on the government to provide something as important as health insurance.

The best way to get lower cost health insurance is to participate in a small business health insurance pool. They pool the insurance needs of many small businesses to get lower insurance rates similar to the rates available to corporations employing thousands of people. At the time I wrote this a policy that cost $5,000 on an individual basis was available for $3,000 from a small business health insurance pool. These organizations generally represent several HMOs (health maintenance organizations) and many different programs. Your state insurance commissioner can give you information on these providers, as can professional photographers' organizations. Whatever you do, don't do it without health insurance.

Note that health insurance is not included in the business expenses of the business plan and financial sections of this book. It is considered a personal expense that comes out of the salary you pay yourself.

And what happens if you are injured on the job and can't work for a long time? For that there is disability insurance. Ask your insurance provider for information on plans and premiums.

Retirement planning

Investment advisors often say that you can't start saving for retirement soon enough, and they are right. Just as borrowing is expensive, investing capital can be lucrative. The longer the retirement funds are invested before they are used, the greater the funds available. Fairly modest amounts can yield surprising returns. If you put aside $2,000 per year for thirty years at 10 percent, you'll have about $380,000 in the bank. The trick is to save consistently and never raid your savings.

There are various retirement savings options available, mostly differentiated by their tax benefits and annual contributions. You could just stash away after-tax income, but then you'd have to pay tax on the income earned by your invested savings. An Individual Retirement Account (IRA) allows you to set aside $2,000 per year. Although the tax breaks on IRA contributions have been largely taken away, interest earned on IRA savings is still tax deferrable. To encourage savings, there is a penalty on IRA accounts for withdrawals made before age 59½.

The most popular savings plans offered by businesses are 401(k) plans, which allow you to set aside pretax income. This is taxed only when you make withdrawals upon retirement, presumably when you are in a lower tax bracket. There are penalties for early withdrawal. The problem with 401(k) plans for small businesses is that they are very administration intensive. To make such plans more attractive to small businesses, the Simplified Employee Pension (SEP) plan was devised. These have most of the benefits of a 401(k) plan but with minimal paperwork. Another option is the Keogh plan, which allows you to put aside a higher amount than an SEP.

Most big mutual fund and investment companies offer these plans. Collect all the information you can on them and decide which alternative suits you best. Be very careful with how you choose to invest your savings. It is beyond the scope of this book to give investment advice, so do your homework thoroughly, be wary of professional investment advisors who might be pushing investments on which they earn high commissions, and shop around. Make up your own mind, be conservative, and follow your investments closely.

Retirement planning

11

Taxes

AN entire book could be written on the highly specialized subject of taxes. In this chapter the aim is to alert you to tax issues that you should be aware of and point you in the right direction to meet your tax obligations with minimum fuss. You should seek the services of an accountant to at least review your annual income tax return, even if you prepare it yourself. There are so many regulations on the treatment of business income and expenses that an annual professional review is well worth the expense. Accountants' fees for tax work depend on the complexity of the individual's tax situation and the amount of work required. If the accountant has to assemble your books from a pile of receipts tossed into an old shoe box, it'll cost you an arm and a leg. If you keep good records designed to flow into your tax statement, and compilation requires few adjustments, then it becomes much more affordable (as little as $200 per return at the time of this writing).

Taxes are a source of revenue for federal, state, and local governments. The most serious offense is a failure to report all income. The expenses and deductions that you claim when calculating net taxable income can always be argued about in good faith (unless there is outright fraud) and adjustments made. But if it turns out that you didn't report income you should have, you will be faced with fines and possibly even more severe penalties.

There are actually several types of taxes for which your business is liable, all based on levels of income. If you have no employees you will have to report and pay

➤ Federal income tax

➤ State income tax

➤ Social security tax

➤ State and local sales tax (where applicable)

➤ Other local taxes

Taxes

If you have employees you will also have to report and pay

➤ Federal income taxes withheld from your employees' pay (and sent by you to the IRS)

➤ State income taxes withheld from your employees' pay (and sent by you to the state tax authority)

➤ Employee social security taxes (FICA; withheld and sent to the Social Security Administration along with the business's contributions to the employee's social security benefits)

➤ Other employee related local taxes

The basic financial record that forms the basis for tax reporting on your employees is the individual payroll record. You can see once again why hiring independent contractors might be the better way to go.

Note that the tax authorities require that tax payments be made during the year in proportion to the income earned during the year, not just in one lump sum at year end. For employees, the employer takes care of making tax payments during the year based on the level of withholding they request. But as a self-employed person no one withholds taxes for you. Instead, you have to estimate your personal federal income tax liability quarterly and send in the quarterly estimate (Form 1040ES) along with a check for any payment due. If you have employees you must also send in an Employer's Quarterly Income Tax Return.

Annually you need to file the business's tax statement. There are different federal filing forms for sole proprietorships (Form 1040 Schedule C), partnerships (Form 1065), corporations (Form 1120), and S corporations (Form 1120S). You also have to file a personal income statement (Form 1040).

Various state and local income tax and sales tax filings need to be made periodically. However, requirements vary so much from state to state that it precludes any useful comment here. For both federal and state tax requirements, visit your federal and state tax offices and ask for the many detailed information packages available on specific tax recording, reporting, and payment requirements applicable to your form of business.

The typical income tax return (personal or corporate) is essentially an income statement. All income is recorded, all expenses and deductions are subtracted from income, and the annual income tax is calculated on this net taxable amount.

Income is easy to track and record. Expenses are not particularly mysterious either. There are, however, certain peculiarities regarding the federal tax treatment and documentation of particular expenses that are worth being aware of in order to apply the rules to your greatest financial advantage.

Depreciation

Depreciation is the deduction allowed on equipment, vehicles, and business property by the IRS to account for annual wear and tear. The idea is that the untaxed annual depreciation expense be set aside into a reserve (accumulated depreciation) to be used to replace the depreciated item when its useful business life is exhausted.

For example, if you depreciate a $5,000 camera over five years, you deduct in annual depreciation expense an amount determined by the depreciation tables until the total depreciation expense that you've taken over five years is equal to $5,000. Presumably by then the camera has been so heavily used that you will need to replace it. If the depreciation expense had been physically put in a separate account, the accumulated amount would be available to buy a new camera. In practice businesses take the depreciation expense, but don't bother to put the money in the bank in a separate reserve account.

The depreciation that can be taken is determined entirely by the IRS's massive lists of depreciation schedules. It is difficult, and in many cases impossible, for the IRS to determine how much value an item loses per year, but an attempt is made to link the depreciation schedules to useful life. Thus most computer equipment is depreciable over five years, because there is such rapid obsolescence in the industry. Most commercial buildings are depreciable over 31.5 years, because their useful life is much longer than that of computer equipment. In addition, some items can be depreciated straight-line

Depreciation

over their depreciable life (equal amounts every year), while others are depreciated by the double declining method, which allows greater depreciation in the early years (such as cameras).

It is also important to know that individuals (sole proprietors) can expense equipment, up to a total value of $10,000 each year in the first year of purchase, rather than depreciate it bit by bit. So if you choose to, you can expense the entire $5,000 you spend on a camera in the year you buy it rather than fuss with depreciation recordkeeping.

Capital gains tax

Once you know about depreciation you should also know about capital gains. You know that a $5,000 camera will have some market value at the end of five years, even though it can be depreciated on the books to zero value by then. If you sell the camera for, say, $1,000 after year five, you will have realized a capital gain of $1,000. Capital gain is important because it is taxable. You need not wait until year five to realize a capital gain. In principle, there is a capital gain every time you sell an asset for more than the value at which it is carried on your books. If the camera is depreciated to a value of $2,000 in year three, and at that point you sell it for $2,500, the capital gain is $500 and tax is due on it. Even if assets (above a certain value) are sold at a loss, the IRS wants to know, so a report has to be filed.

Personal automobile expense

This is always a big tax question because of the potential for abuse by charging personal use as business use. To qualify for expensing the use of your personal car for business, usage must meet a certain definition and you must keep a trip log to document the deduction.

Business use is using the car to get to and from business commitments other than going to and from your home to your place of work. The latter is commuting miles and not deductible. Keep a log of each business drive, recording the beginning and ending odometer readings and the purpose of the trip. At the end of the year

add up the business miles driven. This is the amount of use for which you can claim expenses.

Auto expenses can be claimed under a standard mileage deduction allowed by the IRS. Ten thousand business miles driven in a year at the IRS mandated 26¢ per mile yields $2,600 in auto expenses. The rate keeps increasing, so check the going rate for mileage deductions.

You can also deduct actual expenses instead of applying the standard mileage deduction. This is a messy affair, because you have to keep records of all auto expenses, including gas, oil, and maintenance, calculate the business use as a percentage of total use, and prorate business use and depreciation to arrive at the expense. The standard deduction is usually generous enough to exceed actual expenses.

Travel, meals, and entertainment

Travel, meals, and entertainment all have to be meticulously documented with receipts and conducted for legitimate business purposes to be deductible. Essentially you have to spend most of the days on a trip doing business, and spend most of each day doing business. Keep receipts for transportation, lodging, meals, and incidentals. Meals are only 80 percent deductible.

If a trip is a combined business and pleasure trip, only the business days are deductible, and the cost of transportation to and from the destination is deductible only if 75 percent or more of the time was spent on business. A prorating has to be applied to transportation if the time spent on business is between 50 and 75 percent and it is not deductible under 50 percent.

For many photographers, travel expenses should not be a major expense category because most of their trips will be on assignment, billed to the client. However, to get the tax benefits, the client will usually insist that you keep records to meet the tax deduction requirements.

Entertainment expenses can also be a big sore point with the IRS. Where does business stop and the fun begin? The definition of

business entertainment eligible for deductions has been sharply curtailed in recent years. But some entertainment, primarily business meals with business associates, continues to be 80 percent deductible. To qualify, you have to record who was present representing whom, where the meal was, how long it lasted, and what business was discussed.

Home office deduction

Many people running small businesses, including photographers, claim as an expense the use of a home office. This can be done only if the home office is the *primary* place of business (you conduct most of your business from it) and it is used *only* for business. You can't claim a deduction for your kitchen because you make a lot of business phone calls from it.

If you qualify, you need to record and document all the expenses associated with your home, such as the mortgage, gas, heat, and electricity. You can deduct a percentage of these expenses as a business expense based on the home office's percentage of the total home, as defined by IRS rules. A legitimate home office deduction can be very beneficial, but it also invites extra attention from the IRS, and possibly even an audit.

There are plenty of other tax considerations. These are merely some of the highlights. Get as much information as you can from the federal and state tax offices, and consider the services of an accountant. Don't be alarmed if you are audited. Often an audit is only a mail inquiry or a question to be discussed in person regarding one small aspect of your return. If you are audited, don't panic. Discuss the matter with your accountant, collect documentary proof of your case, have your accountant attend the audit, never volunteer more information than you are asked for, and be cooperative and courteous. Most of all, keep good records!

An increasingly popular way to prepare tax returns is tax return software. Fairly modestly priced, these programs prepare your taxes

Taxes

by asking you a series of questions on screen, similar in format to the tax organizer questionnaires sent out by tax accountants. You answer the questions and the computer spits out your tax return. You should have an accountant review the results, but the software might reduce the time the accountant has to spend on your taxes. It is crucially important to use the most updated version of the tax software. Tax laws change constantly, and software makers offer updated programs to keep their tax software in compliance with current regulations.

Home office deduction

12

The part-time photographer

FOR many budding photographers without the resources or time to start a full-time business, part-time photography provides an excellent way to launch a professional career. Many full-time professional photographers, as well as some photographers' organizations, bristle at the mention of part-time photography. They consider it an irritating, amateurish intrusion onto their playing field. While it is true that there are some part-time photographers whose conduct is quite unprofessional (mostly because they simply don't know any better), it is harsh and unjust to knock part-time photography as a whole. For many photographers, part time is the way to go.

The importance of being professional

The most difficult challenge for the part-time photographer is projecting a professional image. Many obstacles stand in the way. The part-time photographer is most likely holding down another job. This places heavy demands on the photographer's time and can be distracting. Besides being short on time, the part-time photographer often faces scheduling problems. It is awkward when your response to scheduling an assignment is, "How about 8:30, Friday night?"

Another common problem is not having the proper work environment. As a part-timer you are unlikely to have the resources to rent or buy a studio or office. Even if you can afford one, you will have difficulty justifying it economically, given its part-time use.

If you are busy during the day with things other than photography, clients might have a hard time contacting you during their own regular business hours. In time they will become annoyed at speaking to your answering machine and waiting for their calls to be returned.

Many clients are reluctant to work with part-timers, often being under the impression that somehow part-timers are not as good as

full-time photographers. They also wonder about the commitment of the part-timer.

The first step in dealing with these problems is to realize that the part-time photographer should be every bit as professional as the full-time photographer. The difference between part-time and full-time photography is not quality of work, but quantity of time spent doing photography. Once you recognize that "part time" is not a professional distinction, it follows that your task is to get this across to your market with a professional image.

Succeeding as a part-time professional

Time constraints, inconvenient schedules, and the other problems facing the part-time photographer pose a big challenge, but they can be overcome with careful planning and organization.

Define a narrow, manageable niche. Don't take on more than you can handle part time. Choose a field or set of related fields that is sufficiently narrow to allow you to give top-notch service within the limited time you have available.

Put as much effort into planning the business as you would for full time. Part time or full time, business is business, and good planning is the key to success. Prepare a comprehensive business plan for a part-time business just as you would for a full-time business (see chapter 6).

Pick a niche that allows for a flexible schedule. Give a lot of thought to the schedules of your clients, and choose a niche in which their time requirements tend to be compatible with your schedule. Working people, for example, prefer having their portraits taken outside regular working hours or on weekends. Weddings usually take place on weekends. Product catalogs can be shot any time of the day or night once you get hold of the products.

Figure 12-1

Life on the road can provide good opportunities for part-time stock photography (Heron Island, Australia).

Pick a niche that doesn't require you to have your own studio. The easiest way to solve the lack of a studio is to do work on location. Location candid portraits and pet portrait photography at weekend pet shows are good examples.

If you need a studio consider sharing with another photographer. You can also rent a studio as you need one. Many photographers like to supplement their income by renting out their studios by the hour when they are not using them.

Have promotional materials and stationery on a par with full-time photographers. Just because you are part time, it doesn't mean that your promotional materials and stationery should be of a lower standard than those of a full-time photographer. Put the same effort into these important marketing tools to get the same results. The more professional the image you project, the less likely it is that potential clients will think you are a part-timer.

Be easy to reach. Organizing communications so that you are easily reachable is one of the biggest challenges for a part-time

photographer. Remember, clients demand professional service and part of that service is responding promptly to their requests. Set up a reliable answering machine or service with 24-hour access, and check your messages frequently. If you have enough volume, a beeper might be an attractive option. If you have difficulty returning calls from where you are during the day (your employer takes a dim view of personal calls), get a telephone charge card and return calls from a public phone booth.

Charge as much as full-time photographers for comparable work. Equal quality of work is worth equal pay! Don't try to compete on price with full-time photographers; that only depresses the market for everyone. Get what you deserve. It'll be enough of a challenge to make money part time without shaving your prices.

You also have to administer a part-time business the same way you do a full-time business. You'll have to maintain a business account, keep business records, and file taxes. It is a lot of work, but it is a good way to find out if full-time professional photography is for you without taking a lot of risk.

The part-time photographer

A
Sample forms
and documents

232

Please note that all material in this appendix, including but not limited to all forms, contracts, agreements, releases, and price schedules, is provided solely for the purposes of illustration. Obtain appropriate legal advice specific to your situation before entering into any legal commitments.

Appendix A

Martin Berinstein
Photographer

September 26, 1994

Proposal

Assignment

For AlfaZulu, Inc.'s advertising campaign for its TLC brand soap Martin Berinstein will guarantee five images of "Teddy Bears in a Vermont field on a sunny, spring day", of which AlfaZulu Inc. will choose a single image to run for six months from date of first insertion in national consumer magazines.

Fees and expenses

AlfaZulu, Inc. will be billed for each day of travel, prep, and shooting as specified below. All job related expenses will be billed at cost. Any unusual expenses will be cleared with AlfaZulu, Inc. Fees and expenses for this assignment are estimated, based on 1 day of prep, 2 days of travel,, and 1 day of shooting.

	$
Fees:	
◆ Creative fee	1,000.00
◆ Day rate (one day @ $2,500)	2,500.00
◆ Usage fee (1Xday rate)	2,500.00
Estimated Expenses:	
◆ Assistant fee (four days @ $200 per day)	800.00
◆ Scouting fee (two days @ $500 per day)	1,000.00
◆ Stylist fee (one day at $550.00)	550.00
◆ Prop rental	450.00
◆ Travel	560.00
◆ Local car rental	175.00
◆ Gasoline, tolls and parking	50.00
◆ Three night's lodging	255.00
◆ Meals	200.00
◆ Telephone, fax, courier and incidentals)	350.00
Total	**$10,390.00**

Weather days are charged at half the day rate.

This estimate is exclusive of applicable sales taxes.

249 "A" Street Studio # 31 Boston, MA 02210-1615 Tel: 617-555-4777 Fax: 617-555-4774

Sample assignment contract

Sample forms and documents

Figure A-1

Ownership of photographs

All photographs are copyrighted Martin Berinstein, and will remain Martin Berinstein's property. All photographs must be returned to Martin Berinstein in the same condition in which they were delivered, 120 days after the last insertion of the advertisement.

This is not a work made for hire.

Reproduction rights

The rights of reproduction granted AlfaZulu, Inc. by this agreement apply exclusively for print advertising, to run in national consumer magazines for a period of six months from the date of first insertion. Any rights of further reproduction are reserved and must be negotiated separately with Martin Berinstein. While Martin Berinstein retains the right to sell the images in the secondary market, he agrees not to resell any images until 12 months after the date of last insertion.

Assignment changes

If the assignment is changed while in progress through no fault of Martin Berinstein, all additional work will be considered an additional assignment and additional fees and expenses will be agreed to prior to the commencement of additional work. If the assignment has to be reshot because of Martin Berinstein's fault, it will be reshot for expenses only.

Advance and payment terms

Please pay an advance of $5,195.00 per the enclosed invoice, which amounts to 50% of total costs. The advance has to be received prior to the commencement of any work.

Rescheduling

If the assignment is rescheduled to a mutually convenient date that is within 30 days of the proposed start date, a rescheduling fee of 25% of total costs will be paid by AlfaZulu, Inc. Any rescheduling to a date beyond 30 days from the proposed start date will be considered a cancellation.

Continued

Appendix A

Cancellations

AlfaZulu, Inc. will pay a cancellation fee equivalent to 50% of the total fees and expenses agreed to herein if the assignment is canceled between 14 to 3 days prior to the start date of the assignment specified above, and 75% if the assignment is canceled in under 3 days prior to the start date.

Indemnity

AlfaZulu, Inc. and Martin Berinstein each agree to indemnify and hold the other party harmless from and against all claims which may arise as a result of a breach of the party granting the indemnity, of any representation, warranty or undertaking performed by the party granting the indemnity.

Sincerely yours,

Signed and accepted: _____

Date: _____

Continued

Sample forms and documents

Figure A-2

HYZEN PHOTOGRAPHY & VIDEO
621 BOSTON POST
SUDBURY, MA
(508) 443-5308 FAX (508) 443-5519

WEDDING CANDIDS--TERMS AND AGREEMENTS

Minimum amount of photography is $ per hour of coverage. May be made up of prints, albums, or both; but not the previews.

There is a Photography Charge of $ per hour, which is added to the order.

A complimentary engagement session, with 1-5x7 glossy, is included when you use our services for your wedding. There is also a 10% discount off of the Portrait Price List for these photographs

There is a 20% discount on invitations.

There is a complimentary 5x7 newspaper glossy on your wedding day

No order or part of will be delivered until balance is paid in full.

Contracted prices will remain in effect for 30 days after receipt of previews and final payment is made; otherwise current prices will take effect.

Table photographs are taken by request only. If taken, you agree to purchase at least one 4x5 print of each table over and above the minimum order. If a 4x5 print is not purchased, there will be a fee of $ per table added to the order. YES_____ NO_____

If the order exceeds $ you are entitled to a 16x20 mounted print.
If the order exceeds $ you are entitled to a 20x24 mounted print.

Dinners are to be provided for photographer and assistant.

Payment Schedule: Photography Retainer - $ (non-refundable)
 Additional deposit of $ is due one week before function.
 Balance due upon placement of final order.

DO NOT SIGN UNTIL YOU HAVE READ THE BACK OF THIS AGREEMENT!

I agree to the above terms_____Date:_____

Studio Representative_____Date:_____

Bride's Name:_____ Groom's Name: _____

Address _____

City_____ ST_____ Zip_____

Home #_____Work#_____

Date of Function_____

Sample retail assignment contract (wedding)

Appendix A

Figure A-2

1. PREVIEWS - The prints on loan to you are FINISHED
PHOTOGRAPHS. They are the property of
Hyzen Photography. If any become lost or
damaged they will be charged at the current
rate. If they are not purchased as a set,
they are priced as finished 5x5 prints, and
will be used to make up the order. If they
are not returned within 30 days they will be
considered the property of the client and
payment will become due immediately.

2. DEPOSITS - Client shall make a deposit to retain studio to perform
the requested photographic services. Client's deposit shall be
applied to the total cost of this order.
If Client cancels Studio's Service on the indicated
date, Studio shall charge Client a cancellation fee
of that deposit.

3. NEGATIVES - Studio has the sole and exclusive right to hold all negatives and
make additional reproductions therefrom for Client. Studio has the
sole and exclusive right to apply for copyright protection for any part
of this order.

4. LIABILITY - In the event that this order cannot be completed
due to an Act of God; strikes; severe weather
conditions; riots; action by any local, state or
Federal agency; any event considered a "force
majjeure"; or any other event or act outside the
control of the Studio, Studio's liability to Client
shall be limited only to refund of deposits.
In the event that this order cannot be completed due
to any cause not described above, Studios liability
shall be limited to the Client's order as set forth herein.

5. MISC. ---1) Studio is retained as the exclusive photographer,
and no other photographs
may be taken without permission.
2) This order is binding upon the parties,
their successors and assigns, and may only
be altered in writing.
3) A 1 1/2% service charge per month will be added
to any unpaid balance if not paid within 30 days
of completion of order.
4) All parking expenses will be paid by the Client.
5) A reorder charge of $3.50 will be added to all subsequent orders.

Continued

Sample forms and documents

Figure A-3

Martin Berinstein
Photographer

Adult Release

In consideration of my engagement as a model on the terms stated herein, I hereby grant to _____ (Photographer), his or her heirs legal representatives and assigns, those for whom Photographer is acting and those acting with his or her authority or permission:

(a) the irrevocable and unrestricted right and permission to copyright and use, reuse, publish, and republish portraits or pictures of me or in which I may appear in whole or in part, composite or distorted in character or form without restrictions as to changes or alterations in conjunction with my own or a fictitious name, or reproductions thereof, in color or otherwise, made through any and all media now and hereafter known for illustration, art, promotion, advertising, trade, editorial, or any other purpose whatsoever.

(b) the use of any printed material in conjunction therewith.

I hereby relinquish any right to examine or approve the completed product or products or the advertising copy or printed matter that may be used in conjunction therewith, or the use to which it may be applied.

I hereby release, discharge and agree to save harmless Photographer, his or her heirs, legal representatives, or assigns, all persons functioning under his authority, or those for whom he is functioning, from any liability by virtue of any blurring, distortion, alteration, optical illusion, or use in composite form whether intentional or otherwise, that may occur or be produced in the taking of said picture or in any subsequent processing thereof, as well as any publication thereof, including any claims for libel or invasion of privacy.

I hereby affirm that I am of full age and have the right to contract in my own name. I have read the above authorization, release, and agreement prior to its execution, and I fully understand the contents thereof. This agreement shall be binding upon me and my heirs, legal representatives and assigns.

Date:_____ Signed:_____

 Address:_____

Witness:_____

249 "A" Street Studio # 31 Boston, MA 02210-1615 Tel: 617-555-4777 Fax: 617-555-4774

Model release

Appendix A

Figure A-4

Martin Berinstein
Photographer

Adult Release

For valuable consideration received, I hereby grant to _____ (Photographer), the unrestricted and irrevocable right and permission with respect to the photographs Photographer has taken of me or in which I may be included with others to:

(a) copyright the same in his or her own name or any other name he or she may select.

(b) use, reuse, publish, and republish the same, whole or in part, separately or in conjunction with other photographs in any and all media now and hereafter known for illustration, art, promotion, advertising, trade, editorial, or any other purpose whatsoever, without restriction as to alteration.

(c) use my name in conjunction therewith if he or she so decides.

I hereby release and discharge Photographer from any and all claims and demands arising out of or in connection with the use of the photographs, including any and all claims for libel or invasion of privacy.

This authorization and release shall also inure to the benefit of the heirs, legal representatives, licensees, and assigns of Photographer, as well as the person(s) for whom he or she took the photographs.

I hereby affirm that I am of full age and have the right to contract in my own name. I have read the foregoing prior to its execution, and I fully understand the contents hereof. This agreement shall be binding upon me and my heirs, legal representatives and assigns.

Date:_____ Signed:_____

 Address:_____

Witness:_____

249 "A" Street Studio # 31 Boston, MA 02210-1615 Tel: 617-555-4777 Fax: 617-555-4774

Simplified model release

Sample forms and documents

Figure A-5

Martin Berinstein
Photographer

Minor Release

For valuable consideration received, I hereby grant to _____ (Photographer), the unrestricted and irrevocable right and permission with respect to the photographs Photographer has taken of me or in which I may be included with others to:

(a) copyright the same in his or her own name or any other name he or she may select.

(b) use, reuse, publish, and republish the same, whole or in part, separately or in conjunction with other photographs in any and all media now and hereafter known for illustration, art, promotion, advertising, trade, editorial, or any other purpose whatsoever, without restriction as to alteration.

(c) use my name in conjunction therewith if he or she so decides.

I hereby release and discharge Photographer from any and all claims and demands arising out of or in connection with the use of the photographs, including any and all claims for libel or invasion of privacy.

This authorization and release shall also inure to the benefit of the heirs, legal representatives, licensees, and assigns of Photographer, as well as the person(s) for whom he or she took the photographs.

I have read the foregoing prior to its execution, and I fully understand the contents hereof. I hereby affirm that I am of full age. I represent that I am the parent/guardian of the minor model named herein and have every right to contract for the minor model in the above regard. For value received I hereby consent to the foregoing on his/her behalf. This agreement shall be binding upon me and my heirs, legal representatives and assigns.

Date:_____

Minor's name:_____ Parent or guardian:_____

 Address:_____

Witness:_____

249 "A" Street Studio # 31 Boston, MA 02210-1615 Tel: 617-555-4777 Fax: 617-555-4774

Minor release

Appendix A

Figure A-6

Martin Berinstein
Photographer

Property Release

For valuable consideration received, and being the legal owner of or having the right to permit the taking and use of photographs of certain property designated as:

_____,

I grant to _____(Photographer) his agents or assigns, the full rights to use such photographs and copyright same, in advertising, trade, or for any other purpose. I also permit the use of any printed material in connection therewith.

I hereby relinquish any right to examine or approve the completed product or products or the advertising copy or printed matter that may be used in conjunction therewith, or the use to which it may be applied.

I hereby release, discharge and agree to save harmless Photographer, his or her heirs, legal representatives, or assigns, all persons functioning under his authority, or those for whom he is functioning, from any liability by virtue of any blurring, distortion, alteration, optical illusion, or use in composite form whether intentional or otherwise, that may occur or be produced in the taking of said photograph(s) or in any subsequent processing thereof, as well as any publication thereof, including any claims for libel or invasion of privacy.

I hereby affirm that I am of full age and have the right to contract in my own name in the above regard. I further affirm that if I am acting as an agent or employee of a firm or corporation, I have the authority to do so. I have read the foregoing prior to its execution, and I fully understand the contents hereof. This agreement shall be binding upon me and my heirs, legal representatives and assigns.

Date:_____ Signed:_____

 Address:_____

Witness:_____

249 "A" Street Studio # 31 Boston, MA 02210-1615 Tel: 617-555-4777 Fax: 617-555-4774

Property release

Sample forms and documents

Figure A-7

HYZEN
Photography & Video Inc.
Bob Hyzen

621 Boston Post Road
Sudbury, Massachusetts 01776
(508) 443-5308 / 800-287-5308 / FAX (508) 443-5519

Martin Berinstein
Photographer

249 "A" St. #31 Boston, MA 02210 617 261-4777 Fax 617 261-4774

Business cards. The card with more information and shutter logo is intended for a retail clientele.

Appendix A

NO POSTAGE
NECESSARY
IF MAILED
IN THE
UNITED STATES

BUSINESS REPLY MAIL
FIRST CLASS MAIL PERMIT NO. 05327 BOSTON, MA

POSTAGE WILL BE PAID BY ADDRESSEE

Martin Berinstein
Photographer

249 A St. Studio # 31
Boston, MA 02210-9959

Martin Berinstein
Photographer

☐ Yes, I would like to see more of your work. The best day to reach
me is:_____ at:_____a.m. or _____p.m.

Name:_____
Title:_____
Company:_____
Street:_____
City:_____State:_____ Zip Code:_____
Telephone:_____Fax:_____

☐ The person in charge of corporate communications is:

Name:_____
Title:_____
Company:_____
Street:_____
City:_____State:_____ Zip Code:_____
Telephone:_____Fax:_____

617 261- 4777 Fax 617 261- 4774

*Customer response card for advertising, corporate,
and editorial mailing*

Sample forms and documents

Figure A-9

Martin Berinstein
Photographer
249 A St. #31 Boston, MA U.S.A. 02210-1615

Envelope design. The return address need not be printed when the envelope supply is ordered. It can be printed subsequently with a laser printer to ensure continued suitability of stationery in case of address changes.

Figure A-10

▼	▼
FROM **MARTIN BERINSTEIN PHOTOGRAPHY** 249 "A" ST., STUDIO # 31 BOSTON, MA 02210	**FROM** **MARTIN BERINSTEIN PHOTOGRAPHY** 249 "A" ST., STUDIO # 31 BOSTON, MA 02210
► TO:	► TO:

Mailing labels

Appendix A

Figure A-11

MARTIN BERINSTEIN PHOTOGRAPHY
249 "A" ST., STUDIO #31
BOSTON, MA 02210
PH. 617-261-4777

MARTIN BERINSTEIN PHOTOGRAPHY
249 "A" ST., STUDIO #31
BOSTON, MA 02210
PH. 617-261-4777

MARTIN BERINSTEIN PHOTOGRAPHY
249 "A" ST., STUDIO #31
BOSTON, MA 02210
PH. 617-261-4777

MARTIN BERINSTEIN PHOTOGRAPHY
249 "A" ST., STUDIO #31
BOSTON, MA 02210
PH. 617-261-4777

Inexpensive self-adhesive labels identify ownership of submitted photos.

Sample forms and documents

May 17, 1994

«SAL» «PARENT» «LAST»
«ADDRESS»
«CITY», «ST» «ZIP»

Dear «SAL» «LAST»,

Congratulations on the upcoming «Type»-Mitzvah of your «SEX» «CHILD». If you are in need of a photographer or a videographer, Hyzen Photography would be pleased to serve you.

We have been photographing such events for the past twenty-two years and offer state of the art still and video photography.

At Hyzen Photography no job is too large or too small. If you need a photographer for a few formal photographs in the morning on the bima, or to cover the whole day from the formal photographs in the morning to the end of the reception in the afternoon or evening, we can provide that for you.

I would pleased to show you my work and to provide you with references of satisfied customers. Please call to set up an appointment. Bookings for 1994, 1995 and 1996 are going fast. Don't be disappointed!

Sincerely,

Robert Hyzen

Retail marketing form letter prior to merging with mailing list database and printing on business stationery

Figure A-13

HYZEN PHOTOGRAPHY & VIDEO
621 BOSTON POST
SUDBURY, MA 01776
(508) 443-5308 FAX (508) 443-5519

PORTRAIT PRICE LIST

Session Charge
Single...........................$ Families, Groups & Brides........$
Couple...........................$ Publicity-Black & White............$
 (includes 6-5x7 B&W glossies)

Engagement Special.......... 3-5x7 prints in Aristohyde Folio - $

Environmental - The session is done in your home or at a location of your
 choice - $ additional

SIZE	Custom First Print	Custom Adtnl Prints	Master Canvas Board	Renaissance Canvas Stretcher
4x5			--	--
5x7			--	
8x10				
11x14				
16x20				
20x24			--	
24x30			--	
30x40			--	
40x60			--	

***Additional prints are from same size and pose only**

If a Renaissance print is ordered, than all of the additional Custom Prints
are from the adttnl print's column.

Wallets - Minimum of four per pose
 Color: Eight for $ Each additional pair $
 B&W: Four for $ Each additional pair $
 Plastic Laminating: Four for $

 Black & White Glossies

 adtnl
 First 5x7 or smaller.......................$ / $
 First 8x10 glossy............................$ / $

 Previews: Individually.................................$
 Folio of 8.................................$
Reorders: Orders placed after the initial order........$
Retouching charge for additional poses.................$

Portrait price list

Sample forms and documents

Figure A-14

HYZEN PHOTOGRAPHY & VIDEO
621 BOSTON POST
SUDBURY, MA
(508) 443-5308 FAX (508) 443-5519

CANDID PRICE LIST

10x10	1-49	50-99	100 + up
Master			
Elite			

8x10 or 8x8
Master
Elite

5x7
Master
Elite

5x5 or 4x5
Master
Elite

The Master Print includes minor retouching and a protective lacquer glaze, while the Elite Print has only the protective lacquer.

Wallets : Elite $ each - minimum of 4 per pose
Custom $ each - minimum of 4 per pose
Plastic Laminating $ each - minimum of 4

Wall Portraits	30x40	24x30	20x24	16x20	11x14
Master					
Elite	--	--			

Previews only-(if order is less than $) $

Previews -If total order is:	Complete set only at:
Up to $1000	$ each
1001 to 1500	each
1501 to 2000	each
2001 or over	each

Art Leather Folios (photographs additional): Panorama Prints:
Large...................................$ 10x20........$
Medium............................$ 8x16.........$
Small..................................$

PRICES SUBJECT TO CHANGE

Candid price list (candids shot at weddings and other functions)

Appendix A

Figure A-15

HYZEN PHOTOGRAPHY & VIDEO
621 BOSTON POST ROAD
SUDBURY, MA 01776
508-443-5308 FAX 508-443-5519

SUGGESTIONS FOR A BETTER PORTRAIT SITTING

Our 15 years of experience in the portrait business has enabled us to develop guidelines and criteria for our type of portraiture. When followed, we feel confident the result will be a finished portrait that both you and our studio will be proud to display. We would like to share these criteria with you.

PLEASE make sure all family members are well rested. If young children are involved, your appointment should be at a time best suited for their schedule. Be sure you know how to get to the studio and how much travel time is required so that you will not have to rush or be late for your appointment. If there is doubt about the time required or the route, please call the studio for further assistance.

CLOTHING should be SIMPLE and normally subdued so that the attention in the final portraits will be focused on the subjects. AVOID bold pattern such as plaids, stripes, polka-dots, flowers, etc., and brilliant colors such as red. Normally, low key colors (medium to darker tones) will photograph best. It is important in a group portrait that colors and styles of clothing be compatible so they do not clash.

WOMEN will usually photograph better in full length sleeves. Children seem to be most natural and relaxed in informal clothing. Please bring a change of clothing to the studio the day of your appointment and we will assist you in your final selection. You may also wish to change clothing during your sitting to add a change of pace.

BE SURE to select and assemble your clothing and props before the day of your sitting. Please be certain that nothing is missing, clothing is free of wrinkles and nothing is in need of repair.

EXCITEMENT and ANTICIPATION are key ingredients in every successful portrait. Please look forward to your sitting because WE ARE!

Portrait sitting suggestions given to clients

Sample forms and documents

Figure A-16

HYZEN PHOTOGRAPHY & VID
621 BOSTON POST ROAD
SUDBURY, MA 01776
(508) 443-5308 FAX (508) 44

Previews for_____Envelope#_____Cus#_____

I acknowledge receiving _____ color Previews on ___/___/94. It is understood that they are the property of Hyzen Photography & Video. If they are not returned within thirty days they will be considered Client's property and payment will become due.

 The value of these previews is $_____.

Hyzen Photography & Video has the right to use the negatives for displaying of studio's work, entry in contests and general display for the studio.

A 1 1/2 % interest charge per month will be added to all orders not picked up within 30 days.

 Signed_____

Your appointment is on _____ / / 94 at _____

_____ $ Preview Release Deposit Received

Retail delivery memo

Appendix A

Figure A-17

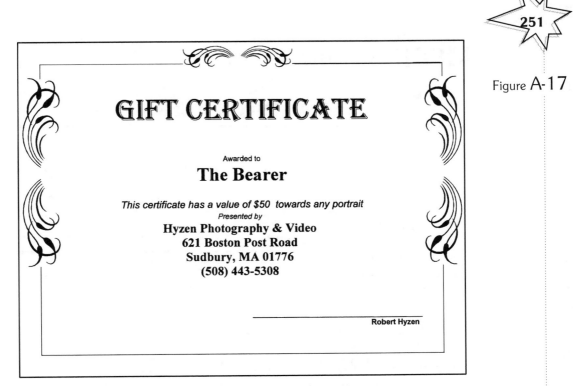

Retail photographer's gift certificate

Sample forms and documents

⊘Filling Out Application Form VA

Detach and read these instructions before completing this form.
Make sure all applicable spaces have been filled in before you return this form.

——BASIC INFORMATION——

When to Use This Form: Use Form VA for copyright registration of published or unpublished works of the visual arts. This category consists of "pictorial, graphic, or sculptural works," including two-dimensional and three-dimensional works of fine, graphic, and applied art, photographs, prints and art reproductions, maps, globes, charts, technical drawings, diagrams, and models.

What Does Copyright Protect? Copyright in a work of the visual arts protects those pictorial, graphic, or sculptural elements that, either alone or in combination, represent an "original work of authorship." The statute declares: "In no case does copyright protection for an original work of authorship extend to any idea, procedure, process, system, method of operation, concept, principle, or discovery, regardless of the form in which it is described, explained, illustrated, or embodied in such work."

Works of Artistic Craftsmanship and Designs: "Works of artistic craftsmanship" are registrable on Form VA, but the statute makes clear that protection extends to "their form" and not to "their mechanical or utilitarian aspects." The "design of a useful article" is considered copyrightable "only if, and only to the extent that, such design incorporates pictorial, graphic, or sculptural features that can be identified separately from, and are capable of existing independently of, the utilitarian aspects of the article."

Labels and Advertisements: Works prepared for use in connection with the sale or advertisement of goods and services are registrable if they contain "original work of authorship." Use Form VA if the copyrightable material in the work you are registering is mainly pictorial or graphic; use Form TX if it consists mainly of text. **NOTE:** Words and short phrases such as names, titles, and slogans cannot be protected by copyright, and the same is true of standard symbols, emblems, and other commonly used graphic designs that are in the public domain. When used commercially, material of that sort can sometimes be protected under state laws of unfair competition or under the Federal trademark laws. For information about trademark registration, write to the Commissioner of Patents and Trademarks, Washington, D.C. 20231.

Architectural Works: Copyright protection extends to the design of buildings created for the use of human beings. Architectural works created on or after December 1, 1990, or that on December 1, 1990, were unconstructed and embodied only in unpublished plans or drawings are eligible. Request Circular 41 for more information.

Deposit to Accompany Application: An application for copyright registration must be accompanied by a deposit consisting of copies representing the entire work for which registration is to be made.

Unpublished Work: Deposit one complete copy.

Published Work: Deposit two complete copies of the best edition.

Work First Published Outside the United States: Deposit one complete copy of the first foreign edition.

Contribution to a Collective Work: Deposit one complete copy of the best edition of the collective work.

The Copyright Notice: For works first published on or after March 1, 1989, the law provides that a copyright notice in a specified form "may be placed on all publicly distributed copies from which the work can be visually perceived. "Use of the copyright notice is the responsibility of the copyright owner and does not require advance permission from the Copyright Office. The required form of the notice for copies generally consists of three elements: (1) the symbol "©", or the word "Copyright," or the abbreviation "Copr."; (2) the year of first publication; and (3) the name of the owner of copyright. For example: "© 1991 Jane Cole." The notice is to be affixed to the copies "in such manner and location as to give reasonable notice of the claim of copyright." Works first published prior to March 1, 1989, **must** carry the notice or risk loss of copyright protection.

For information about notice requirements for works published before March 1, 1989, or other copyright information, write: Information Section, LM-401, Copyright Office, Library of Congress, Washington, D.C. 20559.

——LINE-BY-LINE INSTRUCTIONS——

Please type or print using dark ink.

1 SPACE 1: Title

Title of This Work: Every work submitted for copyright registration must be given a title to identify that particular work. If the copies of the work bear a title (or an identifying phrase that could serve as a title), transcribe that wording *completely* and *exactly* on the application. Indexing of the registration and future identification of the work will depend on the information you give here. For an architectural work that has been constructed, add the date of construction after the title; if unconstructed at this time, add "not yet constructed."

Previous or Alternative Titles: Complete this space if there are any additional titles for the work under which someone searching for the registration might be likely to look, or under which a document pertaining to the work might be recorded.

Publication as a Contribution: If the work being registered is a contribution to a periodical, serial, or collection, give the title of the contribution in the "Title of This Work" space. Then, in the line headed "Publication as a Contribution," give information about the collective work in which the contribution appeared.

Nature of This Work: Briefly describe the general nature or character of the pictorial, graphic, or sculptural work being registered for copyright. Examples: "Oil Painting"; "Charcoal Drawing"; "Etching"; "Sculpture"; "Map"; "Photograph"; "Scale Model"; "Lithographic Print"; "Jewelry Design"; "Fabric Design."

2 SPACE 2: Author(s)

General Instruction: After reading these instructions, decide who are the "authors" of this work for copyright purposes. Then, unless the work is a "collective work," give the requested information about every "author" who contributed any appreciable amount of copyrightable matter to this version of the work. If you need further space, request Continuation Sheets. In the case of a collective work, such as a catalog of paintings or collection of cartoons by various authors, give information about the author of the collective work as a whole.

Name of Author: The fullest form of the author's name should be given. Unless the work was "made for hire," the individual who actually created the work is its "author." In the case of a work made for hire, the statute provides that "the employer or other person for whom the work was prepared is considered the author."

What is a "Work Made for Hire"? A "work made for hire" is defined as: (1) "a work prepared by an employee within the scope of his or her employment"; or (2) "a work specially ordered or commissioned for use as a contribution to a collective work, as a part of a motion picture or other audiovisual work, as a translation, as a supplementary work, as a compilation, as an instructional text, as a test, as answer material for a test, or as an atlas, if the parties expressly agree in a written instrument signed by them that the work shall be considered a work made for hire." If you have checked "Yes" to indicate that the work was "made for hire," you must give the full legal name of the employer (or other person for whom the work was prepared). You may also include the name of the employee along with the name of the employer (for example: "Elster Publishing Co., employer for hire of John Ferguson").

"Anonymous" or "Pseudonymous" Work: An author's contribution to a work is "anonymous" if that author is not identified on the copies or phonorecords of the work. An author's contribution to a work is "pseudonymous" if that author is identified on the copies or phonorecords under a fictitious name. If the work is "anonymous" you may: (1) leave the line blank; or (2) state "anonymous" on the line; or (3) reveal the author's identity. If the work is "pseudonymous" you may: (1) leave the line blank; or (2) give the pseudonym and identify it as such (for example: "Huntley Haverstock, pseudonym"); or (3) reveal the author's name, making clear which is the real name and which is the pseudonym (for example: "Henry Leek, whose pseudonym is Priam Farrel"). However, the citizenship or domicile of the author **must** be given in all cases.

Dates of Birth and Death: If the author is dead, the statute requires that the year of death be included in the application unless the work is anonymous or pseudonymous. The author's birth date is optional, but is useful as a form of identification. Leave this space blank if the author's contribution was a "work made for hire."

Author's Nationality or Domicile: Give the country of which the author is a citizen or the country in which the author is domiciled. Nationality or domicile **must** be given in all cases.

Copyright registration form

Appendix A

Nature of Authorship: Categories of pictorial, graphic and sculptural authorship are listed below. Check the box(es) that best describe(s) each author's contribution to the work.

3-Dimensional sculptures: fine art sculptures, toys, dolls, scale models, and sculptural designs applied to useful articles.

2-Dimensional artwork: watercolor and oil paintings; pen and ink drawings; logo illustrations; greeting cards; collages; stencils; patterns; computer graphics; graphics appearing in screen displays; artwork appearing on posters, calendars, games, commercial prints and labels and packaging, as well as 2-dimensional artwork applied to useful articles.

Reproductions of works of art: reproductions of preexisting artwork made by, for example, lithography, photoengraving, or etching.

Maps: cartographic representations of an area such as state and county maps, atlases, marine charts, relief maps and globes.

Photographs: pictorial photographic prints and slides and holograms.

Jewelry designs: 3-dimensional designs applied to rings, pendants, earrings, necklaces and the like.

Designs on sheetlike materials: designs reproduced on textiles, lace and other fabrics; wallpaper; carpeting; floor tile; wrapping paper and clothing.

Technical drawings: diagrams illustrating scientific or technical information in linear form such as architectural blueprints or mechanical drawings.

Text: textual material that accompanies pictorial, graphic or sculptural works such as comic strips, greeting cards, games rules, commercial prints or labels, and maps.

Architectural works: designs of buildings, including the overall form as well as the arrangement and composition of spaces and elements of the design. NOTE: Any registration for the underlying architectural plans must be applied for on a separate Form VA, checking the box "Technical drawing."

3 SPACE 3: Creation and Publication

General Instructions: Do not confuse "creation" with "publication." Every application for copyright registration must state "the year in which creation of the work was completed." Give the date and nation of first publication only if the work has been published.

Creation: Under the statute, a work is "created" when it is fixed in a copy or phonorecord for the first time. Where a work has been prepared over a period of time, the part of the work existing in fixed form on a particular date constitutes the created work on that date. The date you give here should be the year in which the author completed the particular version for which registration is now being sought, even if other versions exist or if further changes or additions are planned.

Publication: The statute defines "publication" as "the distribution of copies or phonorecords of a work to the public by sale or other transfer of ownership, or by rental, lease, or lending"; a work is also "published" if there has been an "offering to distribute copies or phonorecords to a group of persons for purposes of further distribution, public performance, or public display." Give the full date (month, day, year) when, and the country where, publication first occurred. If first publication took place simultaneously in the United States and other countries, it is sufficient to state "U.S.A."

4 SPACE 4: Claimant(s)

Names(s) and Address(es) of Copyright Claimant(s): Give the name(s) and address(es) of the copyright claimant(s) in this work even if the claimant is the same as the author. Copyright in a work belongs initially to the author of the work (including, in the case of a work made for hire, the employer or other person for whom the work was prepared). The copyright claimant is either the author of the work or a person or organization to whom the copyright initially belonging to the author has been transferred.

Transfer: The statute provides that, if the copyright claimant is not the author, the application for registration must contain "a brief statement of how the claimant obtained ownership of the copyright." If any copyright claimant named in space 4 is not an author named in space 2, give a brief statement explaining how the claimant(s) obtained ownership of the copyright. Examples: "By written contract"; "Transfer of all rights by author"; "Assignment"; "By will." Do not attach transfer documents or other attachments or riders.

5 SPACE 5: Previous Registration

General Instructions: The questions in space 5 are intended to find out whether an earlier registration has been made for this work and, if so, whether

Continued

there is any basis for a new registration. As a rule, only one basic copyright registration can be made for the same version of a particular work.

Same Version: If this version is substantially the same as the work covered by a previous registration, a second registration is not generally possible unless: (1) the work has been registered in unpublished form and a second registration is now being sought to cover this first published edition; or (2) someone other than the author is identified as a copyright claimant in the earlier registration, and the author is now seeking registration in his or her own name. If either of these two exceptions apply, check the appropriate box and give the earlier registration number and date. Otherwise, do not submit Form VA; instead, write the Copyright Office for information about supplementary registration or recordation of transfers of copyright ownership.

Changed Version: If the work has been changed, and you are now seeking registration to cover the additions or revisions, check the last box in space 5, give the earlier registration number and date, and complete both parts of space 6 in accordance with the instruction below.

Previous Registration Number and Date: If more than one previous registration has been made for the work, give the number and date of the latest registration.

6 SPACE 6: Derivative Work or Compilation

General Instructions: Complete space 6 if this work is a "changed version," "compilation," or "derivative work," and if it incorporates one or more earlier works that have already been published or registered for copyright, or that have fallen into the public domain. A "compilation" is defined as "a work formed by the collection and assembling of preexisting materials or of data that are selected, coordinated, or arranged in such a way that the resulting work as a whole constitutes an original work of authorship." A "derivative work" is "a work based on one or more preexisting works." Examples of derivative works include reproductions of works of art, sculptures based on drawings, lithographs based on paintings, maps based on previously published sources, or "any other form in which a work may be recast, transformed, or adapted." Derivative works also include works "consisting of editorial revisions, annotations, or other modifications" if these changes, as a whole, represent an original work of authorship.

Preexisting Material (space 6a): Complete this space and space 6b for derivative works. In this space identify the preexisting work that has been recast, transformed, or adapted. Examples of preexisting material might be "Grunewald Altarpiece" or "19th century quilt design." Do not complete this space for compilations.

Material Added to This Work (space 6b): Give a brief, general statement of the additional new material covered by the copyright claim for which registration is sought. In the case of a derivative work, identify this new material. Examples: "Adaptation of design and additional artistic work"; "Reproduction of painting by photolithography"; "Additional cartographic material"; "Compilation of photographs." If the work is a compilation, give a brief, general statement describing both the material that has been compiled and the compilation itself. Example: "Compilation of 19th century political cartoons."

7,8,9 SPACE 7,8,9: Fee, Correspondence, Certification, Return Address

Fee: The Copyright Office has the authority to adjust fees at 5-year intervals, based on changes in the Consumer Price Index. The next adjustment is due in 1995. Please contact the Copyright Office after July 1995 to determine the actual fee schedule.

Deposit Account: If you maintain a Deposit Account in the Copyright Office, identify it in space 7. Otherwise leave the space blank and send the fee of $20 with your application and deposit.

Correspondence (space 7): This space should contain the name, address, area code, and telephone number of the person to be consulted if correspondence about this application becomes necessary.

Certification (space 8): The application cannot be accepted unless it bears the date and the **handwritten signature** of the author or other copyright claimant, or of the owner of exclusive right(s), or of the duly authorized agent of the author, claimant, or owner of exclusive right(s).

Address for Return of Certificate (space 9): The address box must be completed legibly since the certificate will be returned in a window envelope.

Figure A-18

FORM VA
For a Work of the Visual Arts
UNITED STATES COPYRIGHT OFFICE

REGISTRATION NUMBER

VA _____ VAU _____
EFFECTIVE DATE OF REGISTRATION

Month _____ Day _____ Year _____

DO NOT WRITE ABOVE THIS LINE. IF YOU NEED MORE SPACE, USE A SEPARATE CONTINUATION SHEET.

1 TITLE OF THIS WORK ▼ | NATURE OF THIS WORK ▼ See instructions

PREVIOUS OR ALTERNATIVE TITLES ▼

PUBLICATION AS A CONTRIBUTION If this work was published as a contribution to a periodical, serial, or collection, give information about the collective work in which the contribution appeared. **Title of Collective Work ▼**

If published in a periodical or serial give: Volume ▼ Number ▼ Issue Date ▼ On Pages ▼

2 **a** NAME OF AUTHOR ▼ | DATES OF BIRTH AND DEATH
Year Born ▼ Year Died ▼

Was this contribution to the work a "work made for hire"?
☐ Yes
☐ No

AUTHOR'S NATIONALITY OR DOMICILE
Name of Country
OR { Citizen of ▶ _____
{ Domiciled in ▶ _____

WAS THIS AUTHOR'S CONTRIBUTION TO THE WORK
Anonymous? ☐ Yes ☐ No
Pseudonymous? ☐ Yes ☐ No

If the answer to either of these questions is "Yes," see detailed instructions.

NATURE OF AUTHORSHIP Check appropriate box(es). **See Instructions**
☐ 3-Dimensional sculpture ☐ Map ☐ Technical drawing
☐ 2-Dimensional artwork ☐ Photograph ☐ Text
☐ Reproduction of work of art ☐ Jewelry design ☐ Architectural work
☐ Design on sheetlike material

NOTE

Under the law, the "author" of a "work made for hire" is generally the employer, not the employee (see instructions). For any part of this work that was "made for hire" check "Yes" in the space provided, give the employer (or other person for whom the work was prepared) as "Author" of that part, and leave the space for dates of birth and death blank.

b NAME OF AUTHOR ▼ | DATES OF BIRTH AND DEATH
Year Born ▼ Year Died ▼

Was this contribution to the work a "work made for hire"?
☐ Yes
☐ No

AUTHOR'S NATIONALITY OR DOMICILE
Name of Country
OR { Citizen of ▶ _____
{ Domiciled in ▶ _____

WAS THIS AUTHOR'S CONTRIBUTION TO THE WORK
Anonymous? ☐ Yes ☐ No
Pseudonymous? ☐ Yes ☐ No

If the answer to either of these questions is "Yes," see detailed instructions.

NATURE OF AUTHORSHIP Check appropriate box(es). **See Instructions**
☐ 3-Dimensional sculpture ☐ Map ☐ Technical drawing
☐ 2-Dimensional artwork ☐ Photograph ☐ Text
☐ Reproduction of work of art ☐ Jewelry design ☐ Architectural work
☐ Design on sheetlike material

3 **a** YEAR IN WHICH CREATION OF THIS WORK WAS COMPLETED This information must be given ◄ Year in all cases. | **b** DATE AND NATION OF FIRST PUBLICATION OF THIS PARTICULAR WORK Complete this information ONLY if this work has been published. Month ▶ _____ Day ▶ _____ Year ▶ _____ ◄ Nation

4 COPYRIGHT CLAIMANT(S) Name and address must be given even if the claimant is the same as the author given in space 2. ▼

See instructions before completing this space.

TRANSFER If the claimant(s) named here in space 4 are different from the author(s) named in space 2, give a brief statement of how the claimant(s) obtained ownership of the copyright. ▼

APPLICATION RECEIVED

ONE DEPOSIT RECEIVED

TWO DEPOSITS RECEIVED

REMITTANCE NUMBER AND DATE

DO NOT WRITE HERE OFFICE USE ONLY

MORE ON BACK ▶ • Complete all applicable spaces (numbers 5-9) on the reverse side of this page.
• See detailed instructions. • Sign the form at line 8.

DO NOT WRITE HERE
Page 1 of _____ pages

Continued

Appendix A

EXAMINED BY

CHECKED BY

☐ CORRESPONDENCE
 Yes

FORM VA

FOR
COPYRIGHT
OFFICE
USE
ONLY

DO NOT WRITE ABOVE THIS LINE. IF YOU NEED MORE SPACE, USE A SEPARATE CONTINUATION SHEET.

PREVIOUS REGISTRATION Has registration for this work, or for an earlier version of this work, already been made in the Copyright Office?
☐ Yes ☐ No If your answer is "Yes," why is another registration being sought? (Check appropriate box) ▼
a. ☐ This is the first published edition of a work previously registered in unpublished form.
b. ☐ This is the first application submitted by this author as copyright claimant.
c. ☐ This is a changed version of the work, as shown by space 6 on this application.
If your answer is "Yes," give: **Previous Registration Number** ▼ **Year of Registration** ▼

5

DERIVATIVE WORK OR COMPILATION Complete both space 6a & 6b for a derivative work; complete only 6b for a compilation.
a. **Preexisting Material** Identify any preexisting work or works that this work is based on or incorporates. ▼

6

See instructions
before completing
this space.

b. **Material Added to This Work** Give a brief, general statement of the material that has been added to this work and in which copyright is claimed. ▼

DEPOSIT ACCOUNT If the registration fee is to be charged to a Deposit Account established in the Copyright Office, give name and number of Account.
Name ▼ **Account Number** ▼

7

CORRESPONDENCE Give name and address to which correspondence about this application should be sent. Name/Address/Apt/City/State/Zip ▼

Be sure to
give your
daytime phone
◄ number

Area Code & Telephone Number►

CERTIFICATION* I, the undersigned, hereby certify that I am the
Check only one ▼
☐ author
☐ other copyright claimant
☐ owner of exclusive right(s)
☐ authorized agent of _____
 Name of author or other copyright claimant, or owner of exclusive right(s) ▲

8

of the work identified in this application and that the statements made
by me in this application are correct to the best of my knowledge.

Typed or printed name and date ▼ If this application gives a date of publication in space 3, do not sign and submit it before that date.
 date►

☞ Handwritten signature (X) ▼

**MAIL
CERTIFI-
CATE TO**

Name ▼

**Certificate
will be
mailed in
window
envelope**

Number/Street/Apartment Number ▼

City/State/ZIP ▼

YOU MUST
• Complete all necessary spaces
• Sign your application in space 8
SEND ALL 3 ELEMENTS
IN THE SAME PACKAGE
1. Application form
2. Nonrefundable $20 filing fee
 in check or money order
 payable to *Register of Copyrights*
3. Deposit material
MAIL TO
Register of Copyrights
Library of Congress
Washington, D.C. 20559

9

The Copyright Office
has the authority to ad-
just fees at 5-year inter-
vals, based on changes
in the Consumer Price
Index. The next adjust-
ment is due in 1995.
Please contact the
Copyright Office after
July 1995 to determine
the actual fee schedule.

*17 U.S.C. § 506(e): Any person who knowingly makes a false representation of a material fact in the application for copyright registration provided for by section 409, or in any written statement filed in connection with the application, shall be fined not more than $2,500.

July 1992—100,000 ☆U.S. GOVERNMENT PRINTING OFFICE: 1992-312-432/60,009

Continued

Sample forms and documents

Professional organizations

Advertising Photographers of America
(APA)
27 W. 20th St.
New York, NY 10011
(212) 807-0399

Associated Photographers International
(API)
5855 Green Valley Cir., Suite 109
Culver City, CA 90230
(213) 641-4495

American Society of Media
Photographers, Inc. (ASMP)
419 Park Avenue South
New York, NY 10016
(212) 889-9144

Picture Agency Council of America
c/o AllStock
222 Dexter Avenue North
Seattle, WA 98109
(206) 622-6262

Professional Photographers of America
(PPA)
1090 Executive Way
Des Plaines, IL 60018-1587
(708) 299-8161

Photo Marketing Association
International
3000 Picture Place
Jackson, MI 49201-8898
(517) 778-8100

Wedding Photographers International
312 Lincoln Blvd.
P.O. Box 2003
Santa Monica, CA 90406
(213) 451-0090

Index

Index

Index

Index

Index

About the Author

Geza Szurovy has operated his own photojournalism business since 1980. He is a pilot and award-winning author of aviation books, including *The Private Pilot's Guide to Renting and Flying Airplanes Around the World, Fly for Less: Flying Clubs and Aircraft Partnerships* and *Cutting the Cost of Flying*. He lives in Sudbury, Massachusetts.